Exposed Memories

Family Pictures in Private and Collective Memory

Exposed Memories

Family Pictures
in Private and Collective Memory

Edited by Zsófia Bán and Hedvig Turai

AICA
International Association of Art Critics
Hungarian Section

© 2010, Zsolt Kozma, English translation
HUNGART © Christian Boltanski
Published in 2010 by AICA, International Association of Art Critics, Hungarian Section
Dózsa György út 37, H-1148 Budapest, Hungary
The Hungarian version of this book was published by AICA, Hungary, 2008

Distributed by Central European University Press
An imprint of the Central European University Share Company
Nádor utca 11, H-1051 Budapest, Hungary
Tel: +36-1-327-3138 or 327-3000
Fax: +36-1-327-3183
E-mail: ceupress@ceu.hu
Website: www.ceupress.com

400 West 59th Street, New York NY 10019, USA
Tel: +1-212-547-6932
Fax: +1-646-557-2416
E-mail: mgreenwald@sorosny.org

The publication of this book was supported by the Open Society Institute.

Cover design and layout: Ágnes Eperjesi

ISBN 978-963-9776-70-8 cloth
ISBN 978-963-386-761-7 paperback

Library of Congress Cataloging-in-Publication Data
Exponált emlék. English.

Exposed memories: family pictures in private and collective memory / edited by Zsófia Bán and Hedvig Turai.
p. cm. Translation of: Exponált emlék: családi képek a magán- és közösségi emlékezetben.
"Supplemented with two additional essays, this volume is a selection of the presentations given at the conference Exposed Memories: Family Pictures in Private and Collective Memory, organized by the Hungarian section of the International Association of Art Critics (AICA) in conjunction with the International Association of Word and Image Studies (IAWIS) at the Goethe Institute in Budapest (November 10-11, 2006)"--Introd.
ISBN 978-9639776708 (hardbound)
1. Memory in art. 2. Arts and society. 3. Photography of families. 4. Photography--Social aspects.
I. Bán, Zsófia. II. Turai, Hedvig. III. Title.
NX650.M45E9713 2010
770.9--dc22
2010028062

Contents

Introduction

Within the recent general discussions of cultural and historical memory, in Europe the extension of the family known as the European Union has drawn special attention to the problems of belonging, homeland, exile, and homecoming, as well as language, trauma, and memory. When daily politics continuously insists on probing into who has the right to remember what, with whom, and where, it is no coincidence that we have chosen to examine the role of family pictures in private and collective memory. We believe that the notion of family best expresses the problems of belonging, be it belonging to a people, a nation, or any other type of family. The notion of family offers itself from multiple perspectives: family as homeland, family as space and time, family as burden, heritage, package, family as loss and absence, family as cliché, family as conversation, family as memory or the absence of memory, family as identity, family as history, or family as narrative, to mention only a few. The more we immerse ourselves in this topic, the more obvious it becomes that we are not always in a position to decide who or what belongs

where, or to what extent belonging is often purely a question of tradition, habit, or, at times, of prejudice.

Historic events and turning points often deeply interfere with the integrity and fate of families, and consequently, the (self-)representations of family are often involved with this larger context. One of the most intriguing fields in the research of cultural memory is, undoubtedly, the study of family pictures, a topic equally involving artists, historians, literary and art historians, sociologists, and anthropologists. Post-structuralism, feminism, and the notion of micro-history have all contributed to the rise in significance of personal genres in all disciplines. After "grand" history was revealed to be constructed along the lines of particular ideologies and interests, which meant that we could no longer take notions of objectivity and truth for granted, it seemed as if the private sphere, and within it the family picture, were able to promise a more legitimate truth.

According to Pierre Nora, how a society wishes to see its future also determines what it wishes to remember from its past, and this is what, in turn, offers meaning to the present, which connects both past and future. We can have no inkling of what future generations will have to know about our lives in order to understand their own; therefore we are obliged to salvage and archive everything (or at least to try). As Christian Boltanski, one of the artists Éva Forgács writes about, expressed, "[…] the effort still to be made is great. So many years will be spent searching, studying, classifying, before my life is secured, carefully arranged and labeled in a safe place—secured against theft, fire and nuclear war—from whence it will be possible to take it out and assemble it at any point. Then, being thus assured of never dying, I may finally rest."[1] We no longer possess the past but become one with it. Family pictures play a highly complex role in the process of remembrance, as they are able not only to capture memory but also, at times, to stand in for it.

Supplemented with two additional essays, this volume is a selection of the presentations given at the conference *Exposed Memories: Family Pictures in Private and Collective Memory*, organized by the Hungarian section of the International Association of Art Critics (AICA) in conjunction with the International Association of Word and Image Studies (IAWIS) at the Goethe Institute in Budapest (November 10–11, 2006). Given the topic's strong in-

terdisciplinary nature, the conference covered a wide range of disciplines with the participation of well-known local and international experts and artists working in this field. A number of exhibitions associated with the conference were also organized (Hungarian University of Fine Arts, Barcsay Hall; Studio Gallery; Institute of Contemporary Art, Dunaújváros), presenting artists in whose work the family features either as concrete story or as metaphor.

What prompted us to turn to this topic is a long and often painful series of memorial acts that have taken place in Hungary since 1989, acts that are meant to interpret and reinterpret the past, often focusing on topics and events that previously had been considered taboo for collective memory (such as the role of national politics in the Holocaust, Stalinism, or 1956). In 2005 we commemorated the sixtieth anniversary of the end of World War II, and a year before that we observed the sixtieth anniversary of the deportation and extermination of the Hungarian Jews and Roma, while 2006 marked the fiftieth anniversary of the revolution of 1956. These historic events are linked equally to private and to collective memory, and all of them have abundant visual documentation in private and public collections.

The first part, titled "Photo as Autobiography," contains pieces based on the analysis of photographs that develop family or community narratives. An example of the latter is the study by Marianne Hirsch and Leo Spitzer in which, taking the perspective of collective and transgenerational memory, the authors discuss photographs of the local Jewish population taken by street photographers in Cernăuți, Romania, before and during the war. Nancy K. Miller seeks to unravel the story of an American immigrant family, her own, with the help of photographic and material memories, and in the process her great-grandfather's cut-off *payess*, preserved through great vicissitudes, becomes a metonymy for unanswered (and unanswerable) questions. The telling of Jay Prosser's unusual, adventure-filled family history is based on a photograph that survived two boat trips between Singapore and India, as well as four years in a refugee camp. His piece discusses how photographs are able to address colonial issues both from a personal and social perspective.

The second part goes under the title of "Photo and Text," as it contains two studies that focus on the literary uses of the photograph. Heinz

Ickstadt's piece discusses works by two radically different American authors from this point of view. One is Richard Powers, in whose novel *Three Farmers On their Way to a Dance* the story is triggered by a photograph taken by August Sander that the author saw in the Boston Museum of Fine Arts. Even though this photograph is not a family picture, Powers' interpretation of it literally and metaphorically transforms it into one by using the photo to unravel the family history of the protagonist, as well as that other story/history that the author and the readers have in common. The other analyzed work is the autobiographical *Dictée* by Korean-American writer, filmmaker, and performer Theresa Hak Kyung Cha, who uses photography, along with other visual media, to undermine the linearity and coherence of the narrative. Her book is an experimental work juxtaposing visual and textual elements taken from Western as well as Oriental culture. This is how Cha, who arrived in the United States from Korea at the age of eleven, makes an attempt to initiate a polemic-provocative dialogue with the dominant culture, while at the same time seeking her own, lost mother tongue, culture, and history. Zsófia Bán offers an interpretation of German author W.G. Sebald's last novel, *Austerlitz,* the cult work of an author who acquired fame partly by his highly controversial use of images. Instead of being used for purely illustrative purposes, the images inserted in the text often are, or seem to be, family pictures meant to powerfully destabilize the narrative, as well as the meaning and documentary status of the images. This method is perhaps most conspicuously applied in this work by Sebald, set in the context of the Holocaust.

In the following section, titled "Private and Public Archives," the essay by Rob Kroes looks at the role photography played in the ways immigrants in their new American setting maintained relations with those who remained in the "Old World," as in the early years of immigrant history the decision to start a new life often meant a definitive and irrevocable break with the past. Géza Boros's essay is a gripping analysis of the post-1989 visual memory of the "kids of Pest" who fell in the 1956 revolution or were executed in its aftermath. Instead of the photographs taken during the course of the revolution, which often depicted them as armed fighters, family and private photographs are used on the tombs of these youth and the memorials erected for them. While searching for an explanation of this phenomenon, Boros also analyzes the changes in of-

ficial and private memorialization processes. András Bán provides an important summary of the history of collecting private photos in Hungary, its motives and drawbacks, while also raising the unavoidable problem of how, in today's media-saturated world, it is increasingly difficult, if not impossible, to conduct a systematic research of private photos. Suzana Milevska explores, through the works of Macedonian artist Liljana Gjuzelova, the contradictions between official and private archives, official and private histories—that is, borrowing a term from Hal Foster, she "an-archives" them.

The next chapter is devoted to the different types of family album. Logan Sisley considers the works of writers and artists who explore the visual representations of homosexuality within the frames of family albums. This cannot be done in any other way but by undermining the dominant narratives of the family albums, as these narratives traditionally exclude the presence of homosexuality, thus often elaborating a visualization of absence. The essay by Ágnes Berecz analyzes Ágnes Eperjesi's *Family Album*, in which, as a topos of contemporary art, the artist uses both real and fictive family albums to construct (auto)biographical and historical counter-narratives, alternative history. Ágnes Eperjesi's family pictures go back to pictograms printed on transparent packing materials, and she uses them as film negatives. Placing these in the enlarger, she generates scaled-up images, complementary colors, and inverted tonal values. With this method she examines the connection between photography and truth, as well as recycling and circulating consumer items and their pictures.

Finally, in the part titled "Object/Photo/Reality," Éva Forgács analyzes the works of two artists, Christian Boltanski and Ilya Kabakov, and how they went from questioning photography's reality value to letting something more real take the place of photography—the object itself. Boltanski, who originally created works of art from family albums, later turned to collecting personal objects that he arranged into albums or glass cases, in which the objects are equally parts and documents of a life, like photos themselves. Kabakov often collects residues of objects—in other words, trash—for the same purpose. Éva Forgács elaborates on how, in the works of Boltanski and Kabakov, objects assume the role of photos in transmitting personal narratives, and how this contributes to questioning reality in contemporary art. The closing essay by

Hedvig Turai is about an exhibition that originally was a collateral event of the conference on which the present volume is based. In *Home Museum* the artist duo Katarina Šević and Gergely László created an installation, a museum-like context where they exhibited the objects they found in the course of cleaning and repairing the Šević' Croatian summer house, which was destroyed in the civil war of the former Yugoslavia. The found objects are substitutes for the pictures in a family album, as well as the narrative of the story of the house, since cleaning and archiving can be understood equally as working through the past and working through the experience of war. The "house" can stand for a real house, as in this installation, as well as for a human being, a historical period, or the history of a country or a culture. The essays in this volume thus intend to investigate these many fascinating aspects and forms of family pictures.

Zsófia Bán and Hedvig Turai

Notes

1 Christian Boltanski, flyleaf of the artist's book *Recherche et présentation de tout ce qui reste de mon enfance 1944–1950* (Paris, May 1969). Reprinted in *The Archive: Documents of Contemporary Art*, ed. Charles Merewether (London: Whitechapel; Cambridge, MA: The MIT Press, 2006), 25.

PHOTO AS AUTOBIOGRAPHY

Incongruous Images

"Before, During, and After" the Holocaust*

Marianne Hirsch and Leo Spitzer

I. The Photo Donation
(U.S. Holocaust Memorial Museum, Washington, D.C., 1998)

In the summer of 1998, our parents/in-laws, Lotte and Carl Hirsch, visited the United States Holocaust Memorial Museum (USHMM) photo archive, where they had been invited to donate some of their family pictures from Czernowitz, the East European city where they were born, grew up, and survived the Holocaust.[1] The photos were intended to enhance the museum's small archival collection of images from that city and the Bukowina province of which it had once been the capital. Selected pictures would be cataloged by date, place, and type, and labeled with additional information provided by the donors. Some of the photos, Carl and Lotte were told, might be chosen for display on the museum's Web site.

* An earlier version of this article was published in *Exponált emlék: családi képek a magán- és közösségi emlékezetben*, ed. Zsófia Bán and Hedvig Turai (Budapest: Hungarian Chapter of International Association of Art Critics, 2008), the Hungarian language edition of this volume. This version also appeared in *History and Theory* 48 (December 2009) with a thoughtful response by Geoffrey Batchen.

3

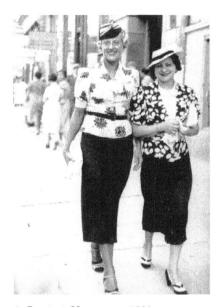
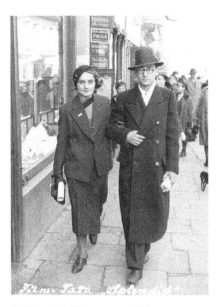

1. Cernăuți, Herrengasse, 1930s 2. Cernăuți, Herrengasse, 1935

It has been the goal of the museum's photo curators to document and display Jewish life in Europe broadly, before, during, and after the Holocaust, balancing the archive of atrocity photos that dominate the museum's permanent exhibition. Over the years, the museum archive has thus acquired many photographs through private donations as well as from images scanned from books and collected holdings in other institutions. In Washington, we observed Carl and Lotte's donation, and the oral history interview that accompanied it, with close interest, because we wished to gain some sense of how such a photographic archive is constructed, and of the assumptions and presuppositions that shape its development. Since both of us viewed the Washington D.C. museum as a site where an "official story" of the Holocaust (and of the Jewish life that was destroyed by it) was displayed for public consumption and archived for scholarly study, we wanted to learn more about how that story takes form, and about the role that visual images play in shaping it. According to what questions and suppositions are images selected for the archive, both by individual donors and by the archivists who receive, catalogue, and display them? And what role do private family photos play in the archive's composition?

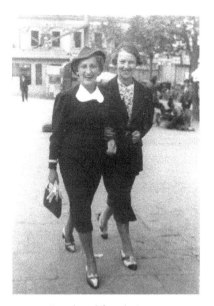

3. Lotte Hirsch and friend, Cernăuţi, Herrengasse, 1930s

Lotte and Carl approached the donation with divergent interests and investments. Carl, an engineer by profession, was systematic. He had researched the archive and its mission and carefully read the instructions sent to potential donors. At home, he had searched through his albums and photo boxes and chosen images that he believed would be of interest to the museum—a very small number. He picked out the only remaining, somewhat torn and faded, portrait of his parents—their wedding photo from circa 1910; a picture of his mother and her sisters dating from the 1930s; some school photographs from the elementary and high schools he had attended; and a few pictures of his labor Zionist youth group, Hashomer Hatzair—portraits of members as well as informal snapshots of summer outings and trips.[2] He selected no pictures of his brother and two sisters, or of other family members, and no informal snapshots of himself. He did, however, bring some twenty additional images to the museum, all of them connected to his institutional affiliations, schools, and job before the war. He labeled each photo with a brief description, dating it carefully, and identified all the depicted persons he could remember.

Lotte was much more hesitant, almost resistant. Why would a museum be interested in some poor-quality snapshots of her friends and relatives? Or in school pictures of her class in the Hoffmann Gymnasium? Who would ever care to look at what after all were private images, meaningful only to her and her family and friends? At home, she had gone back and forth examining the photo albums and boxes, choosing, discarding, but also considering backing out of the donation altogether. She did have just one photo she believed to be significant: a portrait, taken in the 1920s, of her father's Freemason lodge—of a group of affluent, well-dressed, rather plump men and some of their wives (no doubt invited for a special occasion), looking quite cheerful and self-satisfied.

5

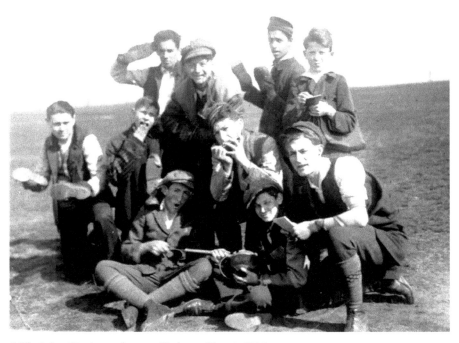

4. The Labor Zionist youth group *Hashomer Hatzair*, 1929

Eventually, she decided to bring this photo and about a dozen from her own collection to the museum: school photos of students and teachers; photos of outings at the local riverfront; photos of fun times with other young people. Finally, she added some of herself with relatives and friends taken by street photographers on Czernowitz's main street, the Herrengasse, as it was called in the era of Austrian rule. These were among her favorites, she said. (Figs. 1-3)

At the museum, the archivist began the donation interview with Carl. She asked him to provide his family history and to supply the names, birth, and death dates of his parents and grandparents. After doing so, Carl succinctly described his family's flight to Vienna when Czernowitz was threatened by Russian forces during World War I, the death of his father (a soldier in the Austrian infantry) at the end of that war, Carl's own evolution from observant Jewish practice to secularism, and his membership and involvement with the Zionist youth group Labor Hashomer Hatzair. (Fig. 4) He presented a brief account of

Romanian nationalism and anti-Semitism in the 1920s and 1930s and told how these increasingly impinged upon the lives of Jews in his native city and Romania at large. He explained about Czernowitz's large German-speaking Jewish population and their profound assimilation to the Austro-German culture they had acquired during the Habsburg era. He spoke of their continued identification with that culture and the German language even after Czernowitz was annexed by Romania (and renamed Cernăuți), and then the Soviet Union (and renamed Chernovtsy), and even after many tens of thousands of the city and province's Jewish inhabitants were deported or dispersed by the Holocaust.

The archivist then asked him to focus on his recollections of the war years in Cernăuți. Carl explained, with exact dates and precise details, about the first Soviet occupation of the city in 1940, and about the retreat of the Soviets and the return of Fascist Romanian forces with their Nazi-German allies in the summer of 1941. He also told of the Jewish ghetto that was established in the city, and of the deportations of Jews to Transnistria in October 1941 and the summer/fall of 1942. He explained that he and his family were able to evade deportation by acquiring special waivers to remain in Cernăuți—authorizations given to some professionals like himself (a civil engineer working for the Romanian railroad) identified as essential for the city's functioning.[3]

And then it was Lotte's turn. Except for inserting a detail or small correction on a couple of occasions, she had been listening intently, without interrupting. Carl had already explained so much, and with such authority; what could she be expected to add? But then she also told about her family, childhood, schooling, and university study of languages—and about the war years. The archivist prompted her further, but with questions different from those she had asked Carl. She wanted to know about Lotte's home life during the war, especially during those middle years of Romanian/German rule, marked by deportations and severe menace. "What did you do? How did you spend your days?" she asked. "I was home with my mother, father, and sister," Lotte responded, "and after Carl and I married in the ghetto, with Carl's sisters and mother as well." She gave a few German lessons to a Romanian officer, she added, and he brought them some food in exchange. It was actually not an unhappy time for her, she explained. She and Carl got together with whatever friends were left in the city, spent the night at each

other's houses so as not to violate the curfews, played cards and talked. But they also spent many of their free hours trying to sell household items in order to buy food—and then trying to find the food that they could barter or buy from the farmers that brought it into the city.

Lotte's narrative was not a smooth one. She made astute observations, but the questions she was asked did not seem to fit into any conventional and expected narrative frame, as Carl's had. The story of daily life under Fascist rule and persecution was not one she had spoken about at great length before. Would she have been more comfortable, we later wondered, telling her version of Carl's historical account, the more dramatic "master narrative" punctuated by anecdotes about decisive action, good fortune, dangers evaded? This narrative contained the core account of their survival that both of them had related to us on a number of previous occasions. And yet on this occasion, Lotte did convey the humiliation of wearing the yellow star—what it *felt* like to be marked publicly in that way. Through voice and affect, she clearly communicated her sense of sadness and loss. The home she had so cherished as a child had indeed turned into a place marked by danger and threat.

The photos visibly affected Lotte emotionally, and we were moved to be witnesses to the memories they so evidently evoked, as she contextualized them and placed each, briefly, into her life narrative.

The archivist selected some of the photographs and discarded others with confident gestures. What determined the choices, we asked her? An important material consideration, she responded, was the quality of a print. But more importantly, she was not interested in photographs that could have been taken anywhere (she rejected Carl's precious portrait of his parents). She preferred images of public and institutional rather than personal, familial life. She was thrilled by the image of the Masonic lodge group to which Lotte's father had belonged, and quickly called over one of the museum's resident historians working on a project on Freemasons to show it to him. And she also selected all the photos taken on the city's main commercial street, the Herrengasse. From every European city or town, she emphasized, she wanted to have at least one pre-Holocaust photo showing Jews in normal circumstances, walking comfortably and confidently down its main street.

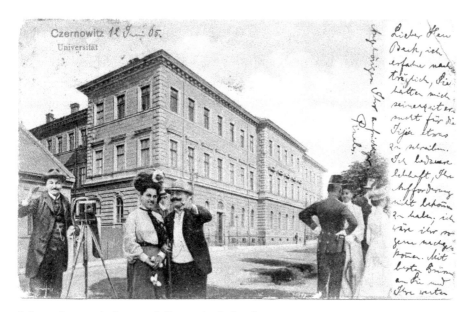

5. Street photographer's postcard. Czernowitz, before the war

Much, of course, could be said about all this: about the interview at the museum and the photographic selection process there—about the speed and confidence with which the archivist seemed to have chosen the photos for the archive, and about her preference for public and institutional over personal and familial images. Much could be said about the gendered nature of the questions she asked Lotte and Carl respectively, and the narratives they, in turn, provided. In the remainder of this essay, however, we want to focus on the street photos. In light of the archivist's desire to acquire photos of East European Jews in circumstances of pre-Holocaust "normalcy," it is fascinating to consider what these Czernowitz/Cernăuți street photographs *do* and *do not* in fact reveal to us—about the place, about Jewish life in that city before and during the war, and about the role of family photos in individual, social, and cultural memory. A close look at these vernacular photos, we suggest, can supplement and at times even challenge the written and oral accounts of witnesses and the interpretation of historians and of descendants.

9

II. Looking at Street Photos

As in so many other European and American cities in the decades between World Wars I and II, street photographers on Czernowitz/Cernăuți's main pedestrian shopping and coffee-house streets photographed passers-by and strollers, earning money by selling small prints of the images taken. The photographs were made with portable, compact, tripod-mounted box cameras using foldable optical viewfinders and single-speed shutters tripped by a non-removable cable. The image was exposed on 2.5 x 3.5-inch direct-positive paper (sometimes on postcard stock with an imprint of a photographic studio, Fig. 5) that was developed on the spot in a tank attached to the camera. This relatively quick procedure—a predecessor of "instant" Polaroid technology—permitted photographers to offer the public inexpensive, finished, souvenir pictures to take home or, in cases where the photographers were sponsored by a studio, the opportunity to order enlargements or more formal posed portraits.[4]

Numerous street photographs exist in the family albums and collections belonging to Jewish Czernowitz/Cernăuți emigrants or their present-day relatives. Over the course of the past few years (through word-of-mouth interest and an Internet listserv request) we acquired copies of many such images—some from the 1920s, the majority from the 1930s, but also a few that particularly stand out, from the World War II years, the early 1940s. Like the archivist in the USHMM, we assumed that the images would confirm our understanding of Jewish life in Cernăuți before and during the war. In fact, however, it took persistent looking and no small amount of self-scrutiny for us to allow the photos to testify to the more complicated past to which they wanted to bear witness.

Certainly, in almost all the street photos of passers-by and strollers, the persons centrally depicted seem to project a sense of confidence and comfort. (Figs. 1-3) In the vast majority of the street photos we acquired in our research, that characteristic seems as consistent as the fact that the people pictured are usually walking, on the move—subjects of a quickly snapped photo, not a posed one. The street photos are telling objects, portraying how individuals perform their identities in public—how they inhabit public spaces and situate

themselves in relation to class, cultural, and gender norms. Indeed, the desire to recall and display such a performance may be one factor explaining why persons bought and kept the original photos (or their enlargements), and why they exhibited them in family albums. When they are then transferred from a personal/family holding to a public archive—as in Lotte and Carl's Holocaust Museum donation—these images, at the juncture of private and public, of domestic and urban space, bridge a gap between memory and history.

Conveyed within these street photos is the essence of all photography: the photographic "capture" of an image at a particular moment in time—the fact that a photo (in the pre-digital era) is assumed to "adhere to" its referent and as such, as Roland Barthes has observed in *Camera Lucida*, "in Photography [we] can never deny that *the thing has been there*," that the image depicts something "'that-has-been'. . . absolutely, irrefutably present" before the camera.[5] Hence the documentary value of photographs to an institution like the Holocaust Museum that aims to construct an authoritative historical archive while also hoping to reactivate and re-embody it as memory. Each of the street photographs also reflects a place and a space—an urban street location depicting buildings (in often recognizable architectural style), as well as storefronts, display windows, and commercial signs. These are background to the street strollers, to be sure, but they also carry information about the larger social context in which life in this city took place. This "information," which Barthes called the "studium," contributes to historical understanding.[6]

At the same time, the connection between the viewer and the individuals depicted in the images—whether these viewers are contemporaries of the subjects in the photo, familial descendants, or more distant, unrelated, observers—provokes the work of memory in a way we have termed "postmemory": through the inherited remembrance of subsequent generations.[7] In fact, like all photographs, these street photos also reflect something "already deferred" (to quote Barthes again), not only the instant of time when they were snapped but the change-over-time central to their historicity—change between photos of the same subject, as well as of different subjects on the same street, taken at different moments in time; and change between the time when these photos were actually snapped and the present time when we, as viewers, look at them.[8]

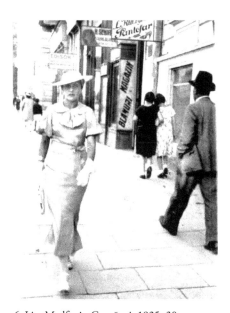

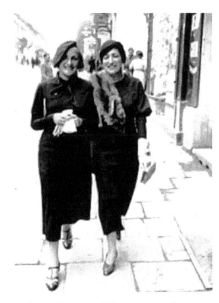

6. Lisa Madfes in Cernăuți, 1925–30

7. Lotte Hirsch with her sister in Cernăuți, 1930s

People who look at these photos, whether in private collections or in public museum holdings, do, of course, bring knowledge to them that neither their subjects nor photographers would have possessed. Not only might these viewers be able to contextualize the images historically, inserting them within a broader tapestry of cultural/collective or personal/familial remembrance, but they also bring to them an awareness of future history—of events yet to come that could not have been known to the subjects of the photographs or their photographers at the time the photos were taken. This is at the heart of the Holocaust Museum archive's desire for them: in the archive's conception, they reveal a normalcy and a social integration that was then violently disrupted and destroyed with the beginnings of persecution, ghettoization, and deportation. Familial descendants might recognize in the photos some of the fabric of family life that had been passed down through stories and behaviors. Extra-familial viewers might connect to them in a different way, through their own repeated exposure to a shared transgenerational archive of private and public street images that provide visual glimpses into urban life of the past. The very conventional nature of street photographs, and their place in the family al-

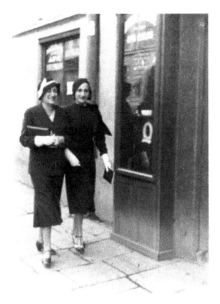 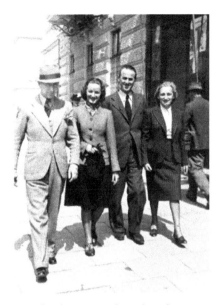

8. Lotte Hirsch with a friend in Cernăuți, 1930s

9. Carl and Lotte Hirsch on the right, in Cernăuți, 1930s

bum, invites an "affiliative" and identificatory look on the part of viewers.[9] Through such a look, viewers can project familiar faces and scenes onto them, adopt them into their own repertoire of familial images, and, in this way, use them to re-embody memory in a "postmemorial" way.

When viewed as nothing more than historical documents, however, the street photos from Czernowitz/Cernăuți are quite limited. On first glance, we might in fact see them as the archivist had hoped—as images of urban Jews in apparent comfort, strolling down a busy main street of an Eastern European city in the years before the outbreak of World War II, seemingly belonging to the place, indistinguishable from other persons who share their economic background. In Lotte Hirsch's collection of street photos, and in all the others we have amassed and viewed, the clothing worn by the strollers—generally fashionable and frequently elegant if not ostentatious—suggests their class situation and affluence, their membership in the city's bourgeoisie, and their public assertion of this fact. (Figs. 6-9)

Indeed, in their seemingly casual walk down the city's main avenues, and in their apparent willingness to let themselves be photographed and to

13

purchase the prints, the persons photographed seem to be publicly display-
ing their freedom to inhabit and to claim public spaces and to move through
them, *flaneur*-like, at ease and in leisure within the urban landscape, de-
claring their unmarked presence there, glancing about but also ready to be
looked at and to be seen.

And yet what remains invisible in these photos, or hardly perceptible
behind the palpable display of Jewish bourgeois comfort, is the assimilationist
trajectory that this class identification manifests and represents. Only through
a comparison and contrast—with "shtetl" Jews residing in Cernăuți's nearby
villages or with less affluent working-class Jews; or with impoverished non-Jews
relegated to the background and perhaps to invisibility in the photos—can
one begin to gain a concrete, visual sense of the class mobility and differentia-
tion that Habsburg-era Jewish emancipation had engendered and enabled here.
These are the historical, economic, and cultural layers that the snapshot of one
moment in time cannot possibly reveal. To access these layers, we must bring
other sources to bear on images—sources, however, that, because of the limita-
tions of their own medium, may provide only partial knowledge about the past
circumstances they record.

Thus, perhaps even less apparent in the street photographs than the pro-
cess of class aspiration and Jewish assimilation is the fact that the city through
which the strollers move is no longer Czernowitz, the "Vienna of the East,"
the liberal, predominantly German-speaking city with which the large Jewish
bourgeoisie there had so strongly identified. Physical evidence of the trans-
formation of the Austrian Czernowitz into the Romanian Cernăuți, to be
sure, can be detected in some of the photos: street names have been changed,
and they, as well as the store signs and placards, are written in Romanian,
not German. The ideological environment accompanying the Romanian take-
over, however, is hardly evident—the reality that, not long after the political
transfer to Romania at the end of World War I, the region's new rulers in-
stituted a strict policy of Romanianization that had immediate, dire conse-
quences for Czernowitz Jews. Under its rubric, Romanian was instituted as
the language of transaction in business and governmental affairs, and as the
primary language of instruction in state schools. Romanian-born nationals
were also given preference in professional and public appointments and promo-

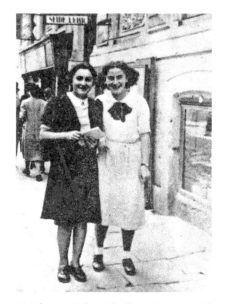

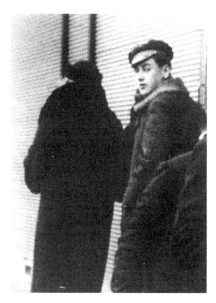

10. The poet Selma Meerbaum-Eisinger with a friend in Cernăuți, before World War II

11. Paul Celan, Cernăuți, 1937

tions, and Romanian cultural institutions and nationalist values were spot-
lighted to the detriment of others. Jews were relegated to the status of Ro-
manian "subjects," not "citizens," and many of the emancipatory civil and
political rights that they had acquired were taken away from them. Most
ominously, the street photos do not even hint at the existence and rapid
and virulent growth of Romanian anti-Semitism and fascism in the decades
of the 1920s and 1930s—the increasing restrictions, quotas, discriminatory
exclusions, harassment, and violence that Jews came to face and endure un-
der Romanian rule. (Figs. 10-11) It was, for example, outside of the Café
l'Europe on the Strada Iancu Flondor (as the Romanians had renamed the
Herrengasse)—almost directly across the street from where photographers
snapped pictures of strolling passers-by—that an incident occurred in the fall
of 1926 that fed right-wing Romanian anti-Semitic hatred, and that resulted
in the assassination of David Fallik, a Jewish student.[10]

The photos, moreover, cannot disclose to us the contradictions at the
heart of the city strolls: that the middle-class Jews depicted within them con-
tinued in large measure to live and walk through the street, as though they were

15

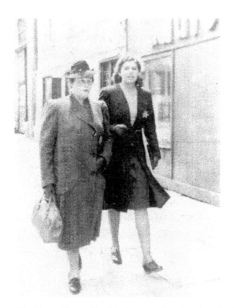 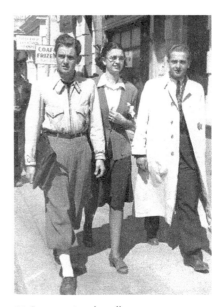

12. Ilana Shmueli with her mother in Cernăuți, 1943

13. Jews wearing the yellow star, Bertold Geisinger on the left, Cernăuți, Herrengasse, 1 May, 1943

really still in Habsburg Czernowitz and not in Romanian Cernăuți. In all likelihood, the conversations they had with each on their street walks, in the stores, at the cafés, like those at home, were in German and not in the mandated Romanian. In not being able to reveal their subjects' adherence to the language and life-ways of the past, the photos cannot expose either the nostalgic yearning for a lost world of yesterday or the resistance to Romanianization and the restrictive political and ideological environment that was, in effect, taking place even at the very moment that they were being snapped.

"In spirit," the poet Rose Ausländer wrote of this interwar period, "we remained Austrians; our capital was Vienna and not Bucharest."[11] The poets—Paul Celan, and Selma Meerbaum-Eisinger—all wrote in German throughout the period of Romanian rule. With the benefit of historical contextualization, therefore, the pre-Shoah "normalcy" and "comfort," and the documentation of Jewish "belonging" that the Holocaust Museum archivist wanted the street photographs to display, is significantly compromised.

Moreover, nowhere does the limitation of the chronological schema of "before, during, and after the Holocaust" that structures the museum archive's

16

selection and display appear more problematic than when we consider the Cernăuţi street photographs from 1942 and 1943. In fact, these photos challenge the visual record that has traditionally shaped the museological exhibition of this period. And, we want to suggest, they also fracture the family album's affiliative look.

Depicted above are two photos (Figs. 12-13) that exhibit Jews wearing the yellow star. Yet in every other way these images look very much like the street photos from the prewar era. However, in the fall of 1941, some two years before these photos were snapped, about two-thirds of the city's Jewish population—around 40,000 people—were deported to the ghettos and forced labor camps in Transnistria, where about half of them perished. Those who were still able to remain in the city, like the subjects of these photos, endured severe restrictions and strict curfews and were obliged to wear the yellow star. Men were routinely taken off the street to do forced labor. In the summer/fall of 1942, there was a second wave of deportations to Transnistria or further east, across the Bug River, into German-administered territories, and to almost certain death. Therefore, by 1943, when these street photos were taken, it was not at all clear that there would not be further deportations or "cleansings" of Jews.

In all likelihood, during such a time of extreme oppression and totalitarian persecution, photography itself—and public photography especially so—came under suspicion as a potentially threatening instrument of surveillance and exposure. The street itself becomes quite literally, in the terms Walter Benjamin used to describe the ominous Paris photographs of Eugène Atget, "the scene of the crime."[12] And yet these street photos seem to refuse to testify to the alarming context in which they were taken and which we, as postmemorial viewers—viewers in subsequent generations—stubbornly want to expose in them. As in prewar times, the Jews they depict are walking through the city—ostensibly on the former Herrengasse—and are having their pictures taken by a street photographer. Most curiously, they also purchased the photos after their development. Their stroll seems "normal," as though the temporal and political moment in which their photos were snapped, and the mark of "otherness" that they were publicly forced to display with the yellow star, were hardly relevant.

The two photos (Figs. 12-13) are certainly different: Ilana Shmueli (now an Israeli writer and poet) and her mother do perhaps look somewhat appre-

hensive; only the young Ilana is looking at the photographer while her mother looks straight ahead, seemingly avoiding the photographer's gaze. This photo shows the two women on a bare and isolated street, perhaps at a time of day when few others were out walking around. They appear to be, in every sense, exposed. In contrast, the three young people in the Geisinger/Stup photo look more carefree: two of them are smiling, and the third, Bertold Geisinger, on the left, while looking somewhat puzzled at the photographer, does not appear to be intimidated. In this image, the street is busy and the photo reveals a great deal of the contextual information that we seek in such images—street signs in Romanian; fashionable clothes, affect, and gesture—that truly present a snapshot of a moment. And yet both photos raise the same set of questions: How could their subjects walk down the street during this terrible time with such apparent ease and freedom? Why did the photographer, surely not Jewish, take pictures of Jews who were so publicly marked by the yellow star? Was his interest merely in selling the print—a monetary one only—or were there other motivations as well? How did he look at his subjects; how did he see them? Did he view his own role as that of a witness to victimization or as a disengaged bystander distanced from the fray? And why, in turn, did the walkers stop to buy the street photo? Can we interpret their purchase as an act of defiance or resistance against the humiliation to which they were subjected? Or did they buy it in the same spirit that earlier street photos had been bought, with a sense of a future—with the intent or will, in other words, to archive it within their family album or collection and hence to transmit their story, this particular story, to generations yet to come?

Looking at these photos now, we need to be sensitive to Michael André Bernstein's warning that reading the past backward through retrospective knowledge can be a dangerous form of "backshadowing"—in his words, "a kind of retroactive foreshadowing in which the shared knowledge of the *outcome* of a series of events by narrator and listener is used to judge the participants in those events *as though they too should have known what was to come*."[13] Yet the task of looking at photos from the past requires the ability to expose and maintain an awareness of the disjunction between the incommensurable temporalities of then and now. What, in this sense, can these truly incongruous photos tell us about the past, about our present relationship to it, and about photography's evidentiary value?

We again see that, as historical documents, they raise more questions than they answer. They do indeed testify to differences between Cernăuți and other East European cities like Łódź or Warsaw, where no such commercial photos of Jews walking on streets outside of the ghettos could have been snapped at this time. Like wartime diaries and survivors' memoirs, they can also tell us something about moments of relative normalcy that exist even in extreme circumstances, and provide us with glimpses into tranquil instances that helped to keep some hope of survival alive.

But it is as memorial objects that these street photographs pose the greatest difficulty. If these photos were bought and placed in family albums in the effort to transmit history and memory, they challenge the postmemorial viewer by resisting and defying the affiliative look that characterizes family photos. On the one hand, they appear to fit into the family album like the street photos from an earlier period. On the other, we would argue, our perception of and apprehension regarding the yellow stars arrest and confound our look, rendering us unable to integrate the "Jewish star" into the rest of the picture that we see. In each photo, the star is Barthes's punctum as detail, but a detail that, once perceived, annihilates the rest of the image. In Barthes's words, it "rises from the scene, shoots out of it like an arrow, and pierces [the viewer]."[14] The total image, in its apparent normalcy, cannot hold or absorb that detail: we either separate that detail out, or we refuse to see it at all. In Benjamin's terms, the star is the "shock" that "bring[s] the mechanism of association in the viewer to a complete halt." Only captions, Benjamin insists, can enable speculation and understanding. Without them, images remain "bound in coincidence."[15]

The Geisinger/Stup photo is (Fig. 13) instructive in this regard. While, as the caption added by Lilian Madfes (who gave us the photo) states, the men visibly wear the star, the woman in the middle, smiling and not looking at the photographer at all, wears something that looks like a large white kerchief in the same spot on the left where a star would have been displayed. Is she perhaps not Jewish and not in fear of being seen without the star? Or might the star be covered by her hand, perhaps for the instant the photo is snapped, or by the kerchief itself? At the center of the photo, wearing a bright white blouse, she is the figure that immediately attracts our gaze, and the kerchief provides us with an alternative focus within the image—an alternative punctum that permits us

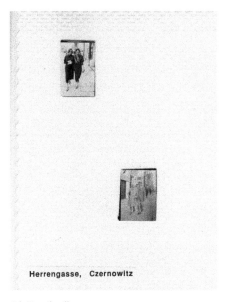

Herrengasse, Czernowitz

14. Family album

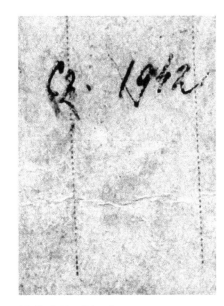

15. Backside of the photo

to block the stars from view long enough so we can take in the entire scene. Our look follows the trajectory of the color white that dominates the photograph: when our eyes move from the white raincoat, to the kerchief, to the white socks, they are momentarily able to bypass the two stars—momentarily, because, unavoidably, the stars finally attract and absorb our gaze, making it difficult to see anything else. The stars, invisible at one moment, become hypervisible, and thus shocking and arresting, at another. It is this visual oscillation between the wildly divergent details of the image that allows us, finally, to look at this picture and to adopt it into the family album. And it allows us to accept the will to normality that drives these city strolls in moments of extremity.

An image from our own family has evoked a similarly oscillating look for us. (Fig. 16) It is a tiny street photograph of Carl and Lotte strolling on the Herrengasse (Strada Iancu Flondor, as it was then called), one that has always been in one of our Hirsch family albums.[16] (Fig. 14)

"Here we are, during the war," Carl said to us some years ago, when we looked at this small photo together. We had always wondered how Lotte and Carl could walk down the street during the war with such an air of normality.

20

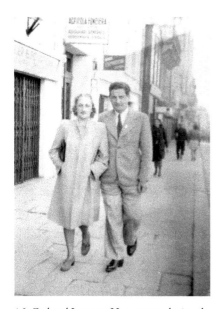

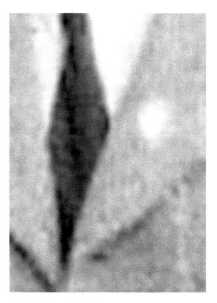

16. Carl and Lotte on Herrengasse during the war, with the light spot on Carl's left lapel

17. Unidentified light spot

But we did not become aware of the photo's radical incongruity until we pulled it out of the album and turned it over, verso, and saw that Carl's handwriting on the back side dates it precisely: "Cz.1942." (Fig. 15) In that year, Jews in Greater Romania were required to wear the yellow star and suffered major hardship and persecution. But no star is visible in the image, nor does the affect that one would expect from photos taken in Cernăuți during that devastating time seem to be present within it. When we began to write about wartime in that city, we digitally scanned and enlarged the little street photo, blowing it up several times, searching for what it might help us to learn about the wartime in Cernăuți, and what might not be visible to the naked eye.

Amazingly, when it came up at about 4 x 6 inches on the screen, the image and the story it told seemed to change dramatically—at least at first glance. All of a sudden, it looked like there was something on Carl's left lapel that had not been noticeable before. (Fig. 17) A bright light spot, not too large, emerged in just the place where Jews would have worn the yellow star in 1942. Perhaps the picture was not as puzzling as we had thought. We printed the enlargement, took out magnifying glasses, went up to the window and used the best lamps in

our study to scrutinize the blow-up. We played with the enlargement's resolution on the computer in Photoshop. This *must* be the yellow star, we concluded; what else could he be wearing on his lapel? We blew the picture up even more, then again, and even more—yes, of course, it had the shape of the Jewish star. Or was it?

We began to reread the photograph's content, its message, against Lotte and Carl's facial expression and body language—which were now also much more clearly visible. Still, the incongruity between their appearance and bearing and what we knew about the events of the time did not diminish. All of our frenzied sleuthing merely opened more questions, related to the ones posed by the other two wartime street photos: if Carl Hirsch is wearing a star, then why is Lotte not wearing one? If they went out without it, illegally, why did they stop to buy the photo? Weren't they afraid of detection? Or could it be that there is, in fact, no star in this little street photo? What if the spot on the lapel is dust—nothing more than a small dot of dirt on the camera lens that blocked out a minute detail on the developed photo? Or what if the date on its verso side is incorrect? What if the photo was really snapped in the later months of 1943, after Romania no longer required Jews to wear the yellow star? These questions, unfortunately, have no definitive answer. Certainly, the mystery associated with this little photo again illustrates the contradictions embodied in images of Jews walking down East and Central European city streets during the war—the oscillating look they elicit, and the difficulties we have in integrating the yellow star into the affiliative and narrative context of the family album.

Why these difficulties? Diaries, testimonies, and memoirs, including the stories of Lotte and Carl that we have heard repeatedly, should have precluded our surprise at seeing these ordinary strolls through the streets of Cernăuți in extraordinary times. The prewar street photos and the wartime ones resist not only what we think we *know* about this past but what we think we can and should see in any visual records from and about the time. The prewar images disguise the persecutions that led up to the war, and the sense of danger and threat that was already present in the city though not captured in the images. Similarly, in testifying to a will to normality and ordinariness during wartime extremity, the wartime photos challenge the visual landscape of atrocity that dominates the memorialization of the Holocaust.

Both thus enable us to consider the specificity of photography, especially vernacular street photography, as a medium of historical interpretation. While testimonies and diaries record subjective reflections and private experience, photos taken in urban spaces bear witness to public acts and encounters. The incongruity we find is thus not in the images themselves, but in the events these images record and prompt in those who look at them—the events of their production, their purchase, and the retrospective acts of looking to which they give rise. Perhaps, ultimately, they tell us more about what we want and need from the past than about the past itself.

III. The Photo Selection
(Bukowina Jewish Museum of History and Culture, Chernivtsi, 2008)

"What about the photos of Jews on the Herrengasse wearing the star in 1942–43?" we asked Natalya Shevchenko, the curator of the new Bukowina Museum of Jewish History and Culture, when we discussed with her the composition of the case that was to contain the Holocaust displays. It was May 2008 and we were in Chernivtsi to consult about this museum, which was scheduled to open in the fall on the occasion of the city's 600th anniversary celebration. However, the museum had been planned not by the municipal government, but by the Jewish Federation of Ukraine in Kiev, and the Holocaust display was an afterthought. Initially, the planners had intended to feature 200 years of Jewish life in the region up to the start of World War II but did not want to include the war years in the exhibition, and certainly not the Holocaust, in order, as they put it, to "focus on life and not death." For them, the focal era to be displayed was the "before": the thriving Hasidic life in the villages, as well as the development of secular culture in the city, highlighting the contribution of Jews to civic, political, and artistic growth. But Czernowitz survivors around the world were outraged to learn through the Internet that the museum was intending to display "pictures of family reunions, weddings, smiling faces," while totally excluding "shootings, deportations, and mass emigration—the most fateful aspect of our history," as one of them noted. Ultimately, in response to these objections, planners were convinced to include one case on the Soviet occupation

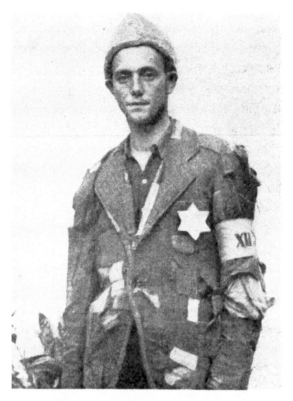

Zurück aus Transnistrien

18. "This is the one we must show"

of the city in 1940–1941 and another on the Holocaust years. We quickly discovered in our conversations with the historian in charge of this display and with the museum curator that these two cases were, for them, the most difficult to conceive.

"The Holocaust display will have three parts," Oleg Suretsov, the historian, told us through our translator, Natalie. "We begin with the summer of 1941, the Einsatzgruppen killings in the villages, the shootings by the Pruth River, the yellow star. Then we have the Cernăuți ghetto and the deportations in the fall of 1941. And then, life in Cernăuți between 1942 and 1944 for those who were spared. We plan to show one or two deportation photos, but Transnistria itself will not be included." Oleg continued to show us a few documents that had been selected for the display cases: a ghetto ordinance and some identification cards marked by a yellow star. "There are so few images and objects from that period: we don't know how to make the exhibit compelling," he added. What, we wondered, could be more stunning than the street photos displaying the Jewish star from 1943? "See, here are two of them." We had brought the photos of Ilana Shmueli and Bertold Geisinger with us. "The stars are very visible, and yet these Jews are strolling down the Herrengasse (Strada Iancu Flondor) as they did in previ-

24

ous times. Don't you find these fascinating testaments to the will to normality in times of extremity? Surely your visitors will be moved as well," we insisted, sharing some of our speculations about these images.

It was hard to read Natalya's expression as she shook her head, hurriedly searching through her files. She pulled out a picture of a young man with a depressed look in his eyes, dressed in tattered and patched clothing, wearing a large yellow star. (Fig. 18) The background was blank, but the image was labeled "Return from Transnistria." "*This* is the one we must show," she said. "Look at the others—they are smiling. They give the wrong impression."

We knew this image well, since it had first been reproduced in Hugo Gold's massive two-volume *Geschichte der Juden in der Bukovina*. As one of only a handful of photographs identified as being from Transnistria, this picture has been invested with a great deal of historical and symbolic importance. Besides this image, the archives contain only a few photos of the deportation marches, a few of the crossings over the Dniester River into Transnistria, a number of images of the Jagendorf foundry in Moghilev (but none of the other ghettos or camps), and a few photos of repatriated orphans at the end of the war. Nothing in this image of the young man, however, links it to its attributed source, and, in fact, we have always been skeptical of its label. The most obvious problem is the yellow star: Jews in Romanian-administered territories were no longer required to wear the yellow star after 1943, and repatriations from Transnistria did not begin until the early fall of 1944. The armband, marked "XII," also does not match historical accounts of the Transnistria deportations or repatriations.

Indeed, it may be its very simplicity and lack of specificity that enabled the young man's photo to acquire the representative status that appealed to the Chernvitsi curator and made it an appropriate icon for this very small museum exhibit. The look in the young man's eyes, the yellow star, and the tattered clothing all evoke the extreme hardship, humiliation, and suffering associated with "deportation" and "camp life." Its iconic status overrides the mismatch between its label and the factual information it carries. The Cernăuți street photos may be too complicated and ambiguous, too incongruous, to serve as icons of the "Holocaust experience" for which the historian and the curator were searching. The fuller and more layered story that they tell might, indeed, "give the

wrong impression" to hurried visitors looking to be emotionally touched by an exhibit case called "The Holocaust."

The historian Sybil Milton has shown that many, if not most, Holocaust photos have come down to us like this one, without specific information about the photographers, or about the context, place, or exact date of production. Photographs are often archived or exhibited with very incomplete or inadequate attributions, mostly indicating current ownership, rather than the original site where they were taken. "Although more than two million photos exist in the public archives of more than twenty nations," Milton writes, "the quality, scope, and content of the images reproduced in scholarly and popular literature has been very repetitive."[17]

With their preference, the Chernivtsi curators, like the archivists at the USHMM, place themselves within a well-known trend. They display images that readily lend themselves to iconization and repetition. But while this choice may allow them to stir viewers' emotions and to gain their sympathetic attention, it also impedes challenges to the well-known narratives about this time. It restricts their visitors' engagement with the Holocaust's more complex—and less easily categorized—visual and historical landscape. And, in so doing, it delimits the rich interpretive possibilities that this vast archive of private and public photographs can open and enable.

Notes

1 For historical and cultural background on Czernowitz, see Marianne Hirsch and Leo Spitzer, *Ghosts of Home: The Afterlife of Czernowitz in Jewish Memory* (Berkeley: University of California Press, 2010); Andrei Corbea-Hoisie, ed., *Jüdisches Städtebild Czernowitz* (Frankfurt am Main: Jüdischer Verlag im Suhrkamp, 1998); Hugo Gold, *Geschichte der Juden in der Bukowina*, 2 vols. (Tel Aviv: Olamenu, 1962); Herald Heppner, ed., *Czernowitz: Die Geschichte einer ungewöhnlichen Stadt* (Cologne: Böhlau, 2000); Florence Heymann, *Le crépuscule des lieux: Identités juives de Czernowitz* (Paris: Stock, 2003); Hermann Sternberg, *Zur Geschichte der Juden in Czernowitz* (Tel Aviv: Olamenu, 1962).

2 For this Zionist youth group, see Jaakow Posiuk-Padan, "Die Geschichte des 'Haschomer Hazair' in der Bukowina," in Gold, *Geschichte der Juden in der Bukowina*, vol. 2, 145–152.

3 For the deportations and Transnistria, see Ihiel Benditer, *Vapniarca* (Tel Aviv: Jack Blitzs-

tein, 1995); Matatias Carp, *Holocaust in Rumania: Facts and Documents on the Annihilation of Rumania's Jews, 1940–44* (Budapest: Primor, 1994); Felicia Carmelly, ed., *Shattered! 50 Years of Silence: History and Voices of the Tragedy in Romania and Transnistria* (Toronto: Abbeyfield Publishers, 1997); Julius Fischer, *Transnistria: The Forgotten Cemetery* (New York: Thomas Yoseloff, 1969); Matei Gall, *Finsternis: Durch Gefängnisse, KZ Wapniarka, Massaker und Kommunismus. Ein Lebenslauf in Rumänien, 1920–1990* (Konstanz: Hartung-Gorre Verlag, 1999); Marianne Hirsch and Leo Spitzer, "'There Was Never a Camp Here': Searching for Vapniarka," in *Locating Memory*, eds. Annette Kuhn and Kirsten McAllister (New York: Berghahn, 2007); Radu Ioanid, *The Holocaust in Romania* (Chicago: Ivan Dee, 2000); Nathan Simon, *"Auf allen Vieren werdet ihr hinauskriechen": Ein Zeugenbericht aus dem KZ Wapniarka* (Berlin: Institut Kirche und Judentum, 1994); Avigdor Shachan, *Burning Ice: The Ghettos of Transnistria* (Boulder, CO: East European Monographs, 1996).

4 For explanations of the technology of street photography, see "Scott's Photographica Collection: Chicago Ferrotype Company, Mandelette Postcard Camera," http://www.vintagephoto.tv/index.shtml, accessed August 1, 2010.

5 Roland Barthes, *Camera Lucida: Reflections on Photography* (New York: Hill and Wang, 1981), 76–77.

6 *Ibid.*, 25–27, 41.

7 For postmemory, see Marianne Hirsch, *Family Frames: Photography, Narrative and Postmemory* (Cambridge, MA: Harvard University Press, 1997); M. Hirsch, "Surviving Images: Holocaust Photographs and the Work of Postmemory," in *Visual Culture and the Holocaust*, ed. Barbie Zelizer (New Brunswick, NJ: Rutgers University Press, 2000), 215–246; M. Hirsch, "Marked by Memory: Feminist Reflections on Trauma and Transmission," in *Extremities: Trauma, Testimony, and Community*, eds. Nancy K. Miller and Jason Tougaw (Urbana: University of Illinois Press, 2002), 71–91. See also Andrea Liss, *Trespassing through Shadows: Memory, Photography, and the Holocaust* (Minneapolis: University of Minnesota Press, 1998).

8 Barthes, *Camera Lucida*, 77.

9 Hirsch, *Family Frames*, 93–94, 254–256.

10 See Berthold Brandmarker, "David Fallik," in Gold, *Geschichte der Juden in der Bukowina*, II, 174–175; *Romanian Ministry of Foreign Affairs Archives*, RG 25.006M, roll 4, "Chronology of Anti-Semitism in Romania, 1926–1927," 18 (on microfilm, United States Holocaust Memorial Museum); Irina Livezeanu, *Cultural Politics in Greater Romania: Regionalism, Nation Building, and Ethnic Struggle, 1918–1930* (Ithaca, NY: Cornell University Press, 1995), 79–80, 85–86; Hirsch and Spitzer, *Ghosts of Home*, chaps. 3–4.

11 Rose Ausländer, cited in *Unerkannt und (un)bekannt: Deutsche Literatur in Mittel- und Osteuropa*, ed. Carola Gottzmann (Tubingen: Francke, 1991), 209.

12 Walter Benjamin, *Illuminations* (New York: Schocken, 1969), 226.

13 Michael André Bernstein, *Foregone Conclusions: Against Apocalyptic History* (Berkeley: University of California Press, 1994), 16.

14 Barthes, *Camera Lucida*, 26.

15 Walter Benjamin, "A Short History of Photography," in *Classic Essays on Photography*, ed. Alan Trachtenberg (New Haven, CT: Leete's Island Books, 1980), 215.

16 A more detailed account and analysis of this image can be found in Marianne Hirsch and Leo Spitzer, "What's Wrong with This Picture? Archival Photographs in Contemporary Narratives," *Journal of Modern Jewish Studies* 5:2 (July 2006): 229–252.

17 Sybil Milton, "Photography as Evidence of the Holocaust," *History of Photography* 23:4 (Winter 1999): 303–312. Note that Milton's count emerges from the 1980s, before Soviet and other Eastern European archives were opened.

Beguiled by Loss

The Burden of Third-Generation Narrative

Nancy K. Miller

> From this story it may be seen what the nature of true storytelling is. The value of information does not survive the moment in which it was new. It lives only at that moment; it has to surrender to it completely and explain itself to it without losing any time. A story is different.
>
> Walter Benjamin, *The Storyteller*

This family portrait was taken in a photographer's studio on the Lower East Side of Manhattan shortly after the arrival of my grandparents from Russia in 1906. (Fig. 1) The photograph joins a family that had been separated by successive immigrations, a pattern common to many Eastern European families in this period. First, in 1899, my great-grandfather Chaim Hirsch Kipnis (bearded and hatted), a carpenter; then, in 1903, soon after the famous Kishinev pogrom of that year, my great-grandmother Sure, seated to his left; and along with their parents, lined up behind them, two adult children, Zirl, a seamstress, and Itzock, a laborer. (The tall man in the middle of the back row remains unidentified, but his strangely shaped head resembles that of his mother.) At the opposite end of the row, my

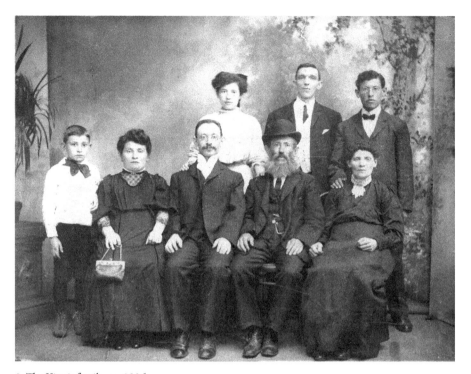

1. The Kipnis family, ca. 1906

grandmother Sheyndel (pregnant with my father), my grandfather, Rafael, and Uncle Shulem (aged 9), who immigrated in 1906, presumably due to the widespread and well-documented Russian pogroms of 1905.

I offer this information with relative confidence because in most cases I have attained it from archival documents, primarily the ship's manifests, which provide the name, age, and profession of the passengers. About the photograph itself, however, except for the location of the photographer's studio on the Lower East Side, I have mainly guesses. I have deduced the date of 1906 from the combination of those kernels of acquired knowledge in relation to an earlier photograph taken in Kishinev, relying on the approximate age of my uncle, who was born in 1897.

Placing these facts and guesses in a story of my invention, let's say that the photograph of my grandparents and my uncle was taken in 1903, on the occasion of the departure for America in August of my great-grandmother and

two (or three) of her nine children. Perhaps my great-grandmother wanted a memento of those who remained behind—her son and grandson. Is this imminent family separation why the threesome, formally posed on their straight-backed chairs that branch out behind them like instruments of torture, looks so lost? By 1903, pictures could be taken quickly enough not to require a serious expression to be rigidly held. Can we legitimately read the aftermath of the recent pogroms in the fixed gaze of these unsmiling faces? It's impossible to know whether the stares express what we've come to think of as the effects of traumatic experience, or simply the formal photographic codes of the era. Both conjectures are equally plausible.

Here is a published version of what my grandparents and great-grandparents might have seen before having their portrait taken. This is an excerpt from an account by the Russian writer V.G. Korolenko called *House Number 13: An Episode in the Massacre of Kishinieff,* published in London in 1904. Arriving on the scene two months after the event, the writer describes the disaster based on the testimony of the survivors of House No. 13 and their neighbors in "lower Kishinev," a poor Jewish area near the Byck River.

> Meanwhile the three victims were crouching on the roof [...] in the middle of the town, visible to hundreds of people, and absolutely defenceless. Then the murderers emerged from the same opening by which the victims had escaped. The Jews began to run round the roof, which made the angle of the square [...] The rioters followed at their heels [...] The wounded Macklin and Berlatsky lay writhing with broken limbs on the pavement, where the cowardly crowd of voluntary executioners finished them off with crowbars, amidst the derisive laughter of the onlookers, who covered the bodies with feathers. Later on in the day casks of wine were broached and allowed to run to waste over the square; and the unfortunate victims were literally smothered in this mass of wine, mud, and feathers. Some assured us that Macklin lived for several hours.[1]

Given the geography of the city, divided into precincts that corresponded to economic and ethnic divisions, it is difficult to imagine anyone, certainly any

Jew in this crowded community, who would not have witnessed or had intimate knowledge of the devastation that took place over two full days and resulted in the massive demolition of Jewish neighborhoods. The pogroms, most historians agree, led large numbers of panic-stricken Jews to leave immediately, heading en masse for the United States.[2] My great-grandmother, great-aunt, and uncle belonged to this wave of Eastern European immigrants.[3]

Internationally reported and consecrated in the famous poem *City of the Killings,* composed in the direct aftermath of the event by the great Hebrew poet Bialik, the Kishinev pogrom of 1903 is considered a turning point in Jewish history. The Easter massacre changed the lives and minds of Jews in Russia and the international community, consolidating among other things, the argument for Zionism. Ultimately, thanks mainly to Bialik's poem, which drew on the oral testimony of witnesses and survivors, the Kishinev pogrom has become "engraved," as Dan Laor, a recent critic who returned to visit the site, has argued, "in…collective memory."[4]

Bialik's narrator urges the poem's readers to become witnesses to the event *after the fact*: "Behold on tree, on stone, on fence, on mural clay,/The splattered blood and dried brains of the dead."[5] But if the events of Kishinev are inscribed in the collective memory of Jews, now through literature and history, how did they affect my ancestors at the time? How did that event live on in their memory? What might have been their specific losses? Many children and infants were killed during the rioting. Could my grandmother, who, according to my father's birth certificate, had given birth to three children before my father, have lost a baby or a child then? Did my grandfather, whose profession was identified on the ship's manifest as "bookkeeper," lose his job? Were they indeed present at that historic event? My father never transmitted any of his parents' memories, stories, or history to me beyond the all-purpose signifier "Kishinev," which I took to mean our family's roots.

Like many third-generation descendants of the Russian Jews who emigrated to America in the early twentieth century, I grew up with an almost complete silence about our family history. Here is my one scrap of storytelling, passed on to me by my uncle Samuel's granddaughter Sarah Castleberry and that she shared with me recently by e-mail.

Grandpa told us that when he was young the Cossacks would come to their town and give the children a ride. At that point they were very friendly. His dad [my grandfather] had a tobacco store, and I guess they were people of means. The very same men who gave them rides came through the town killing and looting. He used to say they came in the front door and he and his family fled through the back. They went to the Black Sea and on to England. Then to the States. Of course, they lost everything but what they could carry.[6]

What did they carry?

Since the death of my parents, I've been trying to imagine a generational story based on a handful of photographs, documents and objects salvaged from an immigrant past: a cigarette case, a few pieces of silverware, a broken cardboard box containing finely spun, tightly curled, locks of honey-colored hair.

When I began to reconstruct my family immigration narrative over the last few years, I focused on the large family portrait. Although the photograph had been in my possession since 1990, I did not learn until ten years later that the hitherto mysterious bearded patriarch was my great-grandfather, nor indeed was I aware of the identity of the others in the portrait, with the exception of my grandparents and uncle.[7] So this was the Kipnis family reaching back into past generations. Who were they? Why was my great-grandfather wearing his hat indoors? What was the meaning of his full beard? Was it the style of the day for men of his generation (Charles Darwin sported such a beard)? Was he religious, I wondered, with special fascination, whether if I stared long enough, I could perceive tight strands of hair curled back and around my great-grandfather's prominent ears. I focused on the possibility of his invisible payess as the metonymy for a web of unanswered questions about what this family's story might have been, particularly in relation to degrees of religious observance or rejection. For example, my great-grandfather came from Bratslav, a village (now in Ukraine) north of Kishinev (now in Moldova) that was famous for an eighteenth-century Hasidic rabbi who created a religious community there. Perhaps my grandfather, clean-shaven except for his mustache, refused to follow in his father's path and moved to Kishinev, a growing city on the brink of moderniza-

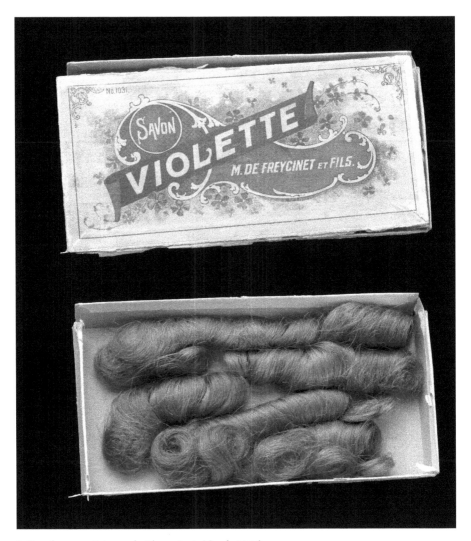

2. Soap box containing curls. Photo: Lorie Novak, 2006

tion, after his father left for America, hoping for a more emancipated style of life in Russia, before finally emigrating to America himself. I liked the idea of a break with tradition that ended with me—the entirely secular person I am.

I started with a question of hair—the sidelocks whose existence I imagined in the shadowy recesses of the photograph—but soon I became fascinated by a hair-related object with even less information attached to it than the photograph.

Unlike my great-grandfather's invisible and possibly imaginary payess that I tried to distinguish in the photograph, this hair is real. The only problem is, I don't know to whom the hair belongs, man or woman.[8] Nor do I know the status of this strange memory object—these pieces of severed hair—and what the act of first cutting and then saving them could have meant to the story of the family. In what kind of story would these two acts find meaning?

I asked the scholar Susannah Heschel for her view. In the Jewish tradition, hair is supposed to be burned, not preserved, she explained. "Who saved the payess," she wondered rhetorically in an e-mail to me. "Presumably his wife, perhaps as a nostalgic remembrance of the old ways together, the commitment to Orthodoxy, perhaps the wedding of two young people from religious homes, now repudiated—though not without some sadness." My grandfather Rafael, rebelling against his black-suited and bearded father, when the latter left the family for America? Or when he married Sheyndel?

I like the idea of inheriting a rebellion against Orthodoxy, but there's a slight hitch. There are two almost identical sets of curled hair. How can I make sense of them? Father and son? Twin boys? Maybe they are a bride's sausage curls, sacrificed before taking on a wig as a married woman. The possibilities proliferate once I allow for the ambiguity of gender. But I've come to believe that looking to the origin is taking the problem in the wrong direction. If I don't know from whose head this hair has been passed on to me, perhaps I will do better with its original owner. Who saved the hair?[9]

I note that my grandmother—if she was indeed the saver—chose a box from a brand of fancy soap, as the container for the precious trace of a past existence. And not any soap, but French soap perfumed with violets, which connotes an ideal of luxury from a world of elegance. But when and where did the box enter her possession? The iconography of its label corresponds to a fin-de-siècle style, but I doubt that the box crossed the ocean. Perhaps my grandmother preserved the curls for safekeeping later in life, when, as a widow, she organized her photographs and souvenirs. The idea of French soap corresponds to an ideal of personal style I know that my grandmother aspired to. It was said (by my mother, a somewhat hostile witness) that in her youth she rejected a suitor because she didn't like the cut of his boots, and that as she grew older, she continued to dye her long hair a deep auburn. Why not imagine her looking

3. The Kipnis family, Kishinev, 1903

back with nostalgia on her lost beauty?

I share my grandmother's taste for scented French soap. But that doesn't explain my obsession with this strange memory object. (I've just spent a ridiculous amount of money for an archival container so that I can continue to preserve the hair and the box.) At least metaphorically, I seem to want to reattach myself to a tradition from which I have in my life chosen to sever myself, or at least to create a connection to a narrative that has been lost. Let's return now to the photographs to add to the story.

The 1903 photograph, like the photograph from 1906, is glued onto a piece of cardboard, and beneath the image is the name of the photography studio: F. Varshavsky, Kishinev. (Fig. 3) The address on the back says Charlamov Street, the former house of Sumovsky. (Fig. 4) The name is accompanied by a logo that reads: "Silver Medal of the Russian Technical Society, From the Emperor."[10] Varshavsky was one of many studio photographers in Kishinev who advertised their services this way on the back of stock cards.[11] Like the symbols on the cards, the props and posing chairs were standard issue, made available by suppliers worldwide. These "cabinet photos" varied little in style. The only distinguishing characteristic was the little stamp on the front, through which the individual photographer could hope to make himself known. If the card, its symbols, and its props were generic, common to an early twentieth-century moment and mode, what of the individuals captured in the equally conventional poses? What would it take for an image to break out of

4. The backside of the photo,
F. Varshavsky's photography studio, Kishinev

the boundaries of visual cliché in these circumstances? Or, turning to the vocabulary we've inherited from Roland Barthes's *Camera Lucida*, what happens when I focus on what *specifically* in these images grabs my attention, drags me viscerally back into this vanished world to which I belong despite the gaps in the chain of communication; what for me creates the famous effect of the punctum?

What have these eyes seen? was the first question I asked myself. I tried to read the traces of traumatic sight in the pained expression of their gaze. Their eyes look empty and uncommunicative. Yes, I thought, they look shocked or frightened. But maybe they were just not happy to have their picture taken, or felt intimidated by the photographer and his equipment. And actually, my grandfather looks almost serene—or is it resigned—in both photographs. Did I want my ancestors to have a traumatic past to acquire some victim credentials, to prove that Jews suffered before the Holocaust? Or that these people were smart enough to get out before it was too late? I started to fear that I *wanted* my ancestors to have been affected by the horrors of the pogroms in order to explain the peculiar history of estrangement in our family. Why did my father never mention his grandparents? Why did I never meet my uncle? Why did my mother seem to hate my grandmother? Maybe the trauma had filtered down through the generations to produce my tendency toward depression. The questions themselves were discouraging.

The eyes alone didn't give me much information, so I looked at the hands—which immediately told me something important about degrees of

connection and separation within and between the generations. I'm going to focus on just two configurations. In the 1903 photograph, I'm struck by the point of contact between my uncle and my grandfather: the slightly terrified six-year-old folding his hand over his father's fist. By contrast, my grandmother seems indifferent to the boy, her hands clasped over each other in her lap, closed off from all contact. Three years later, the nine-year-old, taller, with a little more hair, and looking slightly less fearful, leans into his mother's shoulder, without appearing any closer to getting her attention, despite the physical contact. My grandmother still occupies her own sphere of isolation.

Gazing straight ahead, my grandmother further distinguishes herself from the family group by the fact that she alone holds an object in her hand, a purse whose shiny surface draws the viewer's eye—my eye; for me, now, finally, this is the punctum, the physical detail that crystallizes my emotional reaction. Wearing a dress that emphasizes her short torso and gives her strangely truncated arms, my grandmother, in a complicated maneuver, tries to keep the purse from falling from her fingers as she pulls her dress down over her pregnant belly. Her index and third fingers catch the purse's chain and the pleated panel of her dress together. Maybe Sheyndel (soon to be Sadie) is hoping that she won't lose this baby, conceived almost exactly at the time of the departure from Russia. Maybe she wants to stand out in her elegance (she's also wearing earrings and a pin—could that be a tiny diamond?—at her throat). The purse is the mark of individuality that tells me something specific about my father's mother and something that corresponds to the stories I was told.

The purse also emphasizes my grandmother's distance from her mother-in-law. At opposite ends of the front row, the two women are separated by their husbands. Sure (soon to be Sarah) receives a comforting hand on her shoulder from her son, Itzock (eventually, Isidor), whose hand sticks out from the much-too-long sleeve of his jacket, and receives the weight, if not the affection, of her husband's elbow. Sheyndel has dressed for the occasion but seems determined not to be part of the picture. Was it the photographer who created this asymmetry between the families? Or did the family choose to keep its separations alive?

Below is a picture of my grandfather, my uncle and his son Julian, and my great-grandfather, taken in the late 1920s (my great-grandfather died in 1928. (Fig. 5)

My father isn't in the picture of the male generations, and I have no idea why. But I show this picture to indicate two points about the possible lines of force within this family. My great-grandfather looks exactly as he did in the 1906 photograph. He is still wearing a hat indoors, and though his grizzled beard has grown whiter, its cut is the same; so are the pocket watch and the suit. My grandfather, by contrast, now has neither beard nor mustache. And my uncle is smiling. This family has moved into the cheerful Americanization plot, with the exception of my great-grandfather, who continues to frown, an unchanged, unassimilated man. (I've found no comparable group portrait of the women in the family.)

Of the family members in the photographs, my grandmother is the only one I knew when I was growing up. She was adored by her son—my father, who took care of her in her twenty-year widowhood—and resented by my mother. My mother's greatest condemnation of me was to say that I was cold and selfish like Grandma Kipnis, and that I would, like her, die without any friends. Is it any wonder that it's taken me all this time to come around to wanting to find out

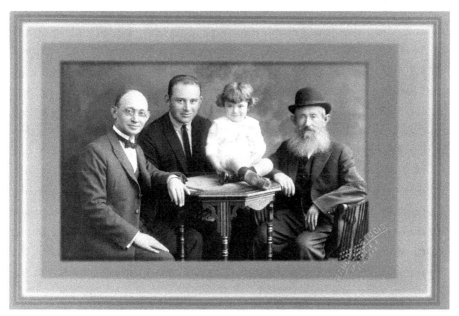

5. Family photo taken in the US, with the author's grandfather, uncle and his son, and her great-grandfather, late 1920s

6. Tombstone, Long Island, 2005.
Photo: Nancy K. Miller

more about her? Now she beckons to me with her gesture of holding on, holding to herself, as she displays her purse.

In the conclusion to *The View from Castle Rock*, Alice Munro's collection of stories based on her family's history, the author tries to understand her compulsion, and that of her contemporaries, to follow all leads in a quest to understand a familial past, a journey that often leads to a cemetery: "We are beguiled. It happens mostly in our old age, when our personal futures close down and we cannot imagine—sometimes cannot believe in—the future of our children's children. We can't resist this rifling around in the past, sifting the untrustworthy evidence, linking stray names and questionable dates and anecdotes together, hanging on to threads, insisting on being joined to dead people and therefore to life."[12] The past lives of the dead are paradoxically enlivening.

Soon after discovering the existence of my great-grandparents, I located their tombstones in a crowded Long Island cemetery. There's no way to know what memories they took with them to their graves—whether their years of Americanization erased the horror scenes of pogroms, or whether the events of their young adulthood persisted as troubling memories in late life. Nor, as I've said, have I solved the riddle of the locks of hair, my grandmother's keepsake. I still don't know what the hair's severed state represents. Most of all, I don't know what to do with the locks. How can they be passed on? No one comes after me. I am, as Barthes says in *Roland Barthes*[13] about his relation to a generational family photograph, a being at the end of the reproductive line, a being, as he puts it, "pour rien" (left untranslated in the English translation): for nothing.

Nonetheless, I take the fact that *somebody* related to me saved this object, along with the photographs, random receipts, and documents, as the burden of my legacy and its future destiny—the contents of an album never assembled.

40

Perhaps they will all make sense only when returned to the frame of collective experience to which they bear evidence, a chronicle beyond anecdote that does not include me, except, of course, for my belated acts of authorship.[14] For new knowledge about this past, however, I'm condemned to *interpret* what remains from the record, to compose a fiction about what I long to know as fact.

By taking these photographs out of the family and into public space, I can stake out a place for myself in the chain, a return to a lost history beyond individual memory but not beyond narrative. At the end of the line of silent witnesses, I've become the storyteller.

Notes

1 V.G. Korolenko, "House Number 13: An Episode in the Massacre of Kishinieff," in *The Contemporary Review*, 85 (February 1904): 276.

2 Edward H. Judge, *Easter in Kishinev: Anatomy of a Pogrom* (New York: New York University Press, 1992), 142., and Monty Noam Penkower, *The Emergence of Zionist Thought* (New York: Peter Lang, 1991), 16.

3 Some historians, like Steven J. Zipperstein, argue that motives other than the pogroms drove the emigration pattern, and that the "pogrom metaphor" overestimates the causal relation. Steven J. Zipperstein, "Old Ghosts: Pogroms in the Jewish Mind," in *Tikkun*, 6:3 (May 1991): 49–52, 85–86.

4 Dan Laor, "Kishinev Revisited: A Place in Jewish Historical Memory," in *Prooftexts*, 25:1–2 (Winter/Spring 2005): 30–38.

5 Quoted in Dan Laor, "Kishinev Revisited," 30.

6 A letter in Yiddish to my uncle, written in the late 1920s or early 1930s to this same uncle by my grandmother's sister Dvorah, alludes to the suffering of our family. Dvorah, who emigrated to South America, describes a health crisis: "It has already been eight years that I don't feel well, and hardly a day goes by that I shouldn't feel pain, *but everything seemed like good times compared to what we lived through in Russia*" (my emphasis-N.M.). My great-aunt's comment precedes a four-page description of an operation that as a means of comparison provides a poignant clue to Jewish Russian experience.

7 I've speculated about my family history in the epilogue to *But Enough About Me*, and more recently in relation to the autobiographies of Mary Antin and Amos Oz, with whom my ancestors

share geographical roots. Nancy K. Miller, "I Killed My Grandmother: Mary Antin, Amos Oz and the Autobiography of the Name," in *Biography: An Interdisciplinary Quarterly*, 30:3 (Summer 2007): 319–341.

8 On the importance of gender to interpreting objects like these, see Marianne Hirsch and Leo Spitzer, "Testimonial Objects: Memory, Gender, and Transmission." *Poetics Today* 27:2 (Summer 2006): 353-383. I've described my speculations about the hair in Nancy K. Miller, "Family Hair Looms," *Women's Studies Quarterly*, 36: 1&2 (Spring/Summer 2008): 162-168.

9 In Victorian England it was commonplace to save hair. "It became the corporeal auto-icon par excellence, the favored synecdoche—the real standing for the symbolic—perhaps not eternally incorruptible but long lasting enough, a bit of a person that lives eerily on as a souvenir." Thomas Laqueur, in Geoffrey Batchen, *Forget Me Not: Photography and Remembrance* (New York: Princeton Architectural Press, 2004), 65. In the Jewish tradition, the question of hair and memory, however, requires another scrim of interpretation: that of religious observance, further delineated by gender.

10 "Negatives are kept," the photographer announces on the back of the cardboard holder. The studio conveys a message through several juxtaposed, visual, and artistic codes: the photographer's art, a tripod box camera with a cloth draped over it; a painter's palette with a set of brushes, surrounded by flowers—perhaps suggesting the natural beauty of life itself; and finally, if ambiguously, a curtain-like structure suggesting a stage set. I will reveal you to the world the way you would like to be seen, F. Varshavsky seems to promise through his logo.

11 An exhibit at the National Museum of Moldovan History in May 2004 displayed some of the 14,000 photographs in the museum's collection. The catalog from the show provides a brief history of photography in Elena Plosnita, ed., *Fotographia basarabeana* (Chisinau: Cardidact, 2005).

12 Alice Munro, *The View from Castle Rock* (New York: Knopf, 2006), 347.

13 *Roland Barthes by Roland Barthes* (Berkeley and Los Angles, California: University of California Press, 1977).

14 All these stories will come together in my forthcoming family memoir, *How I Found My Family in a Drawer* (Nebraska: University of Nebraska Press).

I would like to thank Marianne Hirsch and Leo Spitzer for their inspirational work in the field of family photography and narrative genealogy, and for their support of my project. I am also indebted to Susannah Heschel for sharing her vast wisdom on Judaica with me. I thank Lara Vapynar for translating from Russian, and Miriam Hoffman for translating from Yiddish. Finally, I am grateful to Lorie Novak for photographing my objects with characteristic elegance and bringing my images to digital clarity.

The Baghdadi Jew and His Chinese Mistress

Jay Prosser

The first photograph we have of my mother has the aura of a family relic. (Fig. 1) For me, this is primarily because it is the first photograph of my mother. On the lower level between her parents, sitting in the lap of her father, the child still so recognizably my mother has her hands clasped in front of her.

But even objectively the image is an artifact of times past—imperial journeys, conjoining worlds. Her father, with his thick but neatly trimmed beard, and his strong nose, wearing the *kurta* shirt customary in Arab countries and among Muslims in North India, looks every inch the Jew whose family came from Baghdad, who was himself born in Bombay, and who made the next push to bring the family's spice trade to Singapore. To his right sits a Chinese woman—his wife, my grandmother. In her half *cheongsam* or *samfu* and black pajama trousers, with her hair pulled back completely from her face, she wears the costume of the *saw hei*, the women who emigrated from the southeast coast of China in their thousands to work in domestic service in the satellites of empire, among them Singapore, and in her case for my grandfather. The heavy fold down the center of the photograph dramatizes the visible difference between worlds, his Iraqi Jewishness, her Chineseness,

43

1. The first photograph of the author's mother, sitting on the lap of her father, ca. 1941

their disparate provenances in the East. Are these people a family unit, and is this really a family photograph? How did they come to be so; how did it come to be so? My mother describes herself in this photograph as having a Chinese haircut, and though the quality does not allow us to detect it, she thinks there may be a pacifier in her baby sister's mouth—a Chinese practice that she says Jewish children did not engage in.

The second most extraordinary thing is the moment of the photograph. The image has a transcendent historical quality—it could really be any moment from the late nineteenth century almost to, in some places, the present day. There is little clue from the image or clothes, but working from my mother's guessable age, about three, we think it was taken at the end of 1941, just two or three months before the fall of Singapore and her family's evacuation for India in February 1942. They got the last boat out from Singapore ten days before the Japanese crossed the causeway onto the island. As it offloaded its incoming British troops, their ship sustained a direct hit between the chimneys, and

2. Photo taken at a refugee camp, with the grandmother of the author in the middle, mother on the left, after 1941

still loaded up the evacuees under cover of the same darkness. They dodged the Japanese bombs all the way to Bombay. What is surprising is that the photograph has not been more affected by history, that it has survived at all. The photograph as an object is a testament to survival. It lasted four years in a refugee camp in India, the return boat journey, and more camps in Singapore, then thirty-odd years in the heat and humidity of a Singapore flat, before ending up in Dallas with one of my aunts, the baby in the photograph. Very few photos of my mother's family remain from before the war. Given there was so little time to pack and little space, why take this photograph to India, and indeed, why have the photograph made in the first place in such tempestuous times?

The photograph has the air of a document, an official identity paper. With their anxious faces, all unsmiling and staring out at the camera, these people already look like refugees. And yet, for a period of discomposure, what is striking is the composition. Created by a professional photographer in a studio, the only photo of my grandparents together and the only one of my grandfather

45

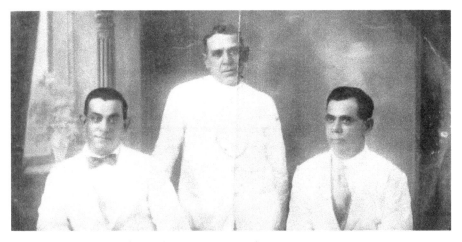

3. Group photo, the grandfather of the author on the left, 1910s

in a studio at all, it is emphatically a formal and family portrait. There is sym-
metry in the arrangement—the youngest daughter with mother, the older one
with him, and the eldest in middle. A lot is happening with arms here, surely to
give shape and unity to the group. My grandmother's in a relaxed circle support
the baby's that plop onto hers. The eldest child's hang invisibly but presumably
at her sides, formally. My mother's are clasped in a precocious primness. My
grandfather's hand is placed on his hip in a most unnatural sitting position. I
can imagine the photographer telling him to angle out his elbow, to balance out
the postures, particularly hers holding the baby on the opposite side. The group
is an equilateral triangle.

It is not so much in spite of but because of the differences in face and
dress that the photograph works so hard to create a family unit. Sally, the eldest
child right in the middle of the fold that actually conjoins, is half-Chinese, half-
Baghdadi Jewish. Yet Sally was not my grandmother's child but the daughter
of Jacob's first wife, who had died five years earlier, in 1936. Like my grand-
mother, she was a China-born Chinese, and the year before she died, my grand-
mother was called to look after her. My mother—my grandparents' first child,
conceived in February 1938—and subsequently June, the baby, were born out
of wedlock. Crucially, in the photograph my grandmother was still dressed in
the uniform of the domestic help. Yet though she was not married, the image

46

does the work of transitioning her from employee to wife. On his right hand, level with him (unlike the children), the photograph evidences her equation.

Does the photograph do legal work in the absence of documents? Given the fact that they were not married, the timing of the photograph and the fact that they took it to the docks and to India, I think they might have thought of it as helping establish her status as wife and as a key to her evacuation. No Chinese were evacuated from Singapore, and under the Japanese they were targeted for persecution and starvation. My grandmother's legal status was doubly unstable. Not only was she unmarried, but she was also most likely an illegal immigrant to Singapore. There are no entry documents for her arrival in Singapore, which probably occurred in 1935, a year of unrest in China, with Mao's Long March and the growing Japanese occupation there. In China she left behind a dead husband and a daughter. She was herself the foster daughter of a fisherman-farmer who found her as an abandoned baby, so there are no legal documents for her there either and surely no photographs. This is not only the first photograph we have of my mother, but of my grandmother too. No wonder it carries such an aura.

Compare her place in the family in the first photograph with this photograph taken in India just a few years later. (Fig. 2) With him out of the picture (we do not know who took this photograph or indeed how they came upon a camera in a refugee camp), it shows Sim Koh-Wei, now Esther, mother of now three children. Two children, the oldest and youngest, are not hers but local Indian children. And to her left, holding a baby boy who is not hers, is someone not a child at all in their eyes but their home help, a local girl who helped out in the small house they were given. Definitely not the maid by her side, my grandmother has undergone something of a transformation. With her hair loose and slightly curled, wearing a top too tight for half *cheongsam* and with cinching round the waist, in this image she is distinctly 1940s, not so much Westernized as her amalgamating self. My mother is the child on the far left still posing with her hands.

We have documents of my grandparents declaring they were married by Jewish custom that summer, in 1942, in Bombay. When I was there a couple of years ago, searching among the *ketubah* in the synagogues, I found no record of that, and I think it likely this declaration was important at the moment they

4. Grandfather and grandmother in their Singapore flat, 1972–73

were making it, in 1957, in preparation for the Singapore Citizenship Ordinance that same year, which finally granted citizenship to alien-born Chinese, among them my grandmother. Declaration of marriage to a Singapore citizen was a kind of underwriting of her legal belonging. The *ketubah* we have for their marriage is dated 1965. Photographs of my grandparents' wedding in the synagogue in Singapore (Fig. 5), here with Sally, show they were able to join their hands, he at seventy-five, she approaching sixty, some thirty years into their common-law marriage.

If her evacuation from Singapore and transportation to India is miraculous, his is mysterious. He is the only Baghdadi Jewish adult male I have come across who managed to escape Singapore. Problems of classification pervade the story of Middle Eastern Jews. For the Japanese all Jews were whites and European and subject to persecution. Within days most were interned in Japanese concentration camps. My grandfather's brother was bombed in the first days of the war; his cousin, who refused to register, was taken a few days

5. Wedding, 1965

after the invasion and never returned. The cousin's son still has visions of him being shot and buried under the Esplanade in Singapore, now a theater they call the Durian, which hosts Singapore's glitziest shows.

The British were in a similar quandary over classification. Eastern Jews were Asiatic or Orientals, and Baghdadis, in association with Ottoman Turks, were especially inimical. Just before the war, Singapore's British governor issued a directive that Jews born in the Straits Settlements or Ottoman Empire were prohibited from military service or joining the Singapore Volunteer Force, suggesting a potential fifth column. Evacuations were for Europeans and not Eurasians or Asians. A ship of Ashkenazi Jews leaving Germany and with permits to Australia was swiftly processed by the British through Singapore. In the chaos of the last days, in the struggle for permits and tickets, distinctions were sometimes made on grounds of color alone, dividing people who looked European from those people who didn't.

The puzzle in the photograph is that my grandfather patently does not look European. (Fig. 1) Indeed Jacob Elias—Yacob Issac Ezekiel El-Yas—never looked so much the Jew from Baghdad via India. I have suggested something of my grandmother's transformation. The same goes for my grandfather. He never grew a beard again. Older, he was clean-shaven and

49

6. The mother with her first son on her lap, and the grandparents, 1965

wore jackets and trousers, shirt outside because of the heat. A small man, he took care with his dress. It is not as if the evacuation trip to India was the turning point either, East to West. Even as a young man in India, and here in Singapore in the 1910s (Fig. 3), he was dapper, with a crooked smile and crooked bow tie. Most Baghdadi Jews were very much assimilated by this stage, and had shed robes and beards, though the older cousin's Nehru collar suggests the trajectory through India. The style of this photograph in comparison with the first photograph itself reveals cultural differences. There is a softening here—the arrangement, some props in the background, one person looking off to the side—that aspires to a Victorian interior studio portrait. It is a strong contrast with the direct eye contact, flattened postures, lack of props, and lack of softness of the first photograph. The first photograph, by comparison, reminds me of the funerary, ancestral Chinese portraits, placed in temples, before which descendants burn incense. All photographers at the time were Chinese, my mother says, but the styles come from and want different cultural contexts. There is something frozen as well as formal about my photograph, already ghostly.

The beard my grandfather never grew recalls the history of Oriental Jew-ishness via Arab countries. The closest he got to facial hair again was via an American Ashkenazi Jew, as other photographs show him, ever the joker, sport-ing a Groucho Marx beard, nose and moustache. I am not at all suggesting he is hamming in the first photograph (he was a great performer), but their boat, the *Felix Roussel*, is said to have taken only "women and children plus unwanted civilians." The beard makes him look older—older even than at his wedding. He is the paterfamilias returning to India and perhaps the more unwanted. The whole presentation, with the old man, the patent non-Britisher, the Jew from the Ottoman Empire, from India, the patriarch of a mixed but adhesive fam-ily—the photograph tells me a story of how they made their escape.

For me the photograph is amazing because I barely recognize my grand-parents here. How I remember them is sitting on the veranda or in the main room of their flat in Singapore, in my eyes not an inch of separation between them. She would wear a Jewish *lapar* (baggy housedress) and *shadai* or Star of David, go to synagogue, and fast on Yom Kippur even until death. He was the maverick staying at home with his Chinese, Indian, Muslim, Christian, and Jewish friends, in his *sarong* and his singlet, sitting me on his knee to sing, his repertoire mostly Hindustani music. Doubtless to me the reach of their worlds seems bound because it produced my mother. Here (Fig. 6) she is with her hands now holding her first son.

PHOTO AND TEXT

.

History, Narration, and the Frozen Moment of Photography

in Richard Powers' *Three Farmers on Their Way to a Dance* and Theresa Hak Kyung Cha's *Dictée*

Heinz Ickstadt

That photography goes hand in hand with narration hardly needs to be explained. We take photographs in order to be able to remember an event, a person, a moment. And *when* we remember, we reconstruct the story of that long-past—perhaps also long-forgotten—moment, made present and alive again by the impact of the picture. It leads us out of its frame, out of its "frozen" timelessness, back into time, into story, circumstance, or back to the person we once were or whom we once loved—the sepia tone of the picture reminding us of how much time has passed since then; how much of *our* time: *Here* is the childhood face, *there* the house and street that have long since disappeared. The past brought, in this way, back to life is thus always a *memento mori*—a re-embodiment of mental images of people we once saw and touched now long gone;

and thus, implicitly, also a memento of our own inevitable dying, of our own passing into oblivion—unless there is someone to develop the stories hidden in the pictures by remembering them. This is indeed their *raison d'être*: they at once embody and create memory, hide and generate narrative. The photographic image always needs a "reader" who remembers and narrates, who makes its muted story heard and felt.[1]

In the early and mid-1980s, Richard Powers and the Korean-American writer, filmmaker, and performance artist Theresa Hak Kyung Cha published texts that make use of the photographic image in distinctly different ways. In both cases, a photograph is connected with a search for identity as well as with an effort to connect the present with the past. In Cha's case, the picture of the mother—the cover picture of *Dictée*—marks a personal loss but also a history of colonial repression. The nameless speaker has to remember and in remembering also to destroy that history in order to find "self" in the rediscovery of her lost maternal origin.

The complex narrative of Powers' *Three Farmers on Their Way to a Dance* (1985) is an imaginative interpretation of the photo displayed on the book's cover—August Sander's photograph "Young Westerwald Farmers on Their Way to a Dance," which Sander took in late 1913 or early 1914. (Powers dates it to May 1914, just before the outbreak of World War I.) Powers came upon it quite unexpectedly at a photo exhibition at the Boston Fine Arts Museum. Its very impact, "the great amounts of historical narrative that photo ignited in my brain," made him quit his job and write the novel (his first). The young men's direct gaze at the spectator seemed to invite, even challenge, him to interpret their history. It is a history yet unknown to them but apparent to him; positioned in the contemporary present, he knows the nature of the "dance" the future has in store for them. In their eyes, however, the author (as well as the narrator of the novel) believes he can recognize their terrified awareness of what was soon to come—together with an urgent appeal to the observer that he, positioned in the future, unfold the narrative contained in this awareness, so that, by connecting the present with the past, the past could "intersect" and interfere with the present.[2]

In this way, the novel itself is a narrative "dance" between stories situated on different time levels and told in different voices and from different perspec-

tives: "the past looking full-faced into the present and recognizing it."[3] Powers calls this "remembering forward" and "trying to open a conversation" between different time periods, discourses, or areas of experience normally sealed off from each other.[4] Although Sander's picture is not a family photograph, Powers' interpretation of it makes it one. By having one of his protagonists recognize himself in one of the photographed figures, Powers makes him trace the tentative lines of a (his) family history—a history he most likely makes up but that is also part of a collective experience the author shares with his readers. Perhaps it is significant in this connection that Sander meant his photograph to be part of a lifetime project he called "Man of the Twentieth Century," in which he wanted to visually record a broad variety of German social types, "a massive, comprehensive catalogue of people written in the universal language—photography."[5] Because of twelve years of Nazi censorship and the destruction wrought by World War II, Sander was never able to finish it. However, some of the photographs he had collected for his *magnum opus* later became part of the most famous photo exhibition of the 1950s, Edward Steichen's "The Family of Man."

The novel's twenty-seven chapters fall into nine triadic chapter blocks whose first, second, and third chapters each belong to a separate and stylistically distinct—if thematically related—strand of the book's narrative. In one of his several comments on the novel, Powers speaks of "three very distinct profiles of prose, each matching the book's three different frames."[6] The first of these narrative strands (or frames) is told by an I-narrator at one point cryptically named P ("the...letter P, my last initial"[7]). The second unfolds the life histories of the three farmers in Sander's picture (named, by an omniscient narrator, Hubert, Adolph, and Peter—three young men of mixed cultural origin, living in and moving through the border zone of Germany, Belgium, and the Netherlands). The third frame, told in the third person, is concerned with Peter Mays, who may be P's, the first narrator's, alter ego (or that of their author: Powers), "thereby providing a Peter for each story."[8]

Obviously, the novel is thus also narrated on two temporal levels. The first deals with the historical and cultural context of the Sander photograph, i.e. the period shortly before and during the first years of World War I. The second is that of the contemporary present, presumably the early 1980s, when the I-narrator sees Sander's photo in Detroit and becomes obsessed with it,[9]

determined to "develop" the history of the photograph as well as the lives of the three young men represented in it: "To identify those would-be dancers, I had first to submerge myself in their dance."[10] He is thus increasingly drawn into tracking the family history of people he believes to be connected with those young men shown in Sander's picture (like his office's "immigrant cleaning woman," Mrs. Schreck, who may be distantly related to the picture's Peter). In his pursuit of the past, he also frequently assumes the authorial voice of an impartial chronicler (or amateur historian) of that earlier period. From newspaper headlines and articles, he reconstructs the marginal episode of Henry Ford's egomaniac and futile attempt to end World War I single-handedly, or the circle of celebrities surrounding him (including Sarah Bernhardt). But he also meditates on modern history, science, and the arts in general, and engages in reflections on aesthetic theory (especially on Walter Benjamin's famous essay on art and photography in an age of mass production), as much as he explores the life and work of August Sander in detail. It is, possibly, this I-narrator of the first narrative frame who also discovers (or invents), in the guise of a third-person narrator, the life (and death) stories of the three farmers (told in the second frame) by imaginatively projecting himself into the circumstances and choices of their lives.

However, the contemporary narrative also runs on another track by following the story of Peter Mays. Although he starts *his* search for identity at another end, he also encounters Sander's photograph of the three farmers and believes he recognizes his own likeness in the features of one of them: Peter recognizing himself in the image of Peter. This second contemporary story, told in the third person, begins on October 29, 1984, in Boston, where Peter Mays works for a computer magazine. There he sees, from the eighth floor of a high rise, a beautiful young lady, a redhead with an oboe in her hand, struggling against the crowd after a Veterans Day parade. Finding her becomes as much an obsession with him as it is for the I-narrator to discover the history of the Sander photo. She is an actress impersonating Sarah Bernhardt, once the friend of Henry Ford and of many other famous people whom we know from photographs of the early twentieth century. In one of these photographs used by the actress in her performance, Mays believes he recognizes his lost great-grandfather. It may be the Peter of the story that is

told/invented in the second narrative strand that deals with the life histories of the three farmers photographed by Sander.

These mutually reflective, intertwined, and interacting elements are parts of a complex narrative strategy designed to make the past speak to the present: a double, or more precisely, a triple perspective based, surely first, on the photographer's act but, second (and perhaps more importantly), on the narrator's and his alter-ego's reinvention of that frozen moment of a pictorially arrested past from different positions in the present. The narrator calls this a "stereo view" that gives three-dimensional depth to the photograph's flat surface: "One context did not replace the other but existed concurrently, like the two views needed to create the illusion of depth in a stereoscope… I saw the thin film of the image spreading out in two directions, back through the past, through catastrophe, to that idyllic day that had brought the taker and subjects together, and forward, far forward in time until the product of that day crossed the path of one who, like me, took on the obligation of seeing."[11] The ambivalent reference to an "I" that is not only "one like *me*" but also an other, one "*like* me," clearly is intentional. The history of the person(s) caught in the "arresting moment" of photography (Kroes) is brought to life not only by a future "reader" but by a process of interpretation that connects past and present in an act of self-recognition.

With Powers, time is therefore potentially simultaneous since, by its interpretative reconstruction, the past becomes present in the future (as much as the future is already present in the past): "When we come behind the photographer's shoulders into conjunction with that gaze, we have the macabre feeling of being its object, the sense that the sitters mean to communicate something to us, to all posterity."[12] The photograph needs the gaze of an observer/narrator who, by injecting himself into history in the effort of grasping it, inversely— dialogically—comes to understand himself, his own life, in the process.

In contrast, Theresa Hak Kyung Cha uses photography together with other visual material as part of a strategy of (non)representation that aims at breaking up narrative linearity and textual coherence in a "discontinuous weave,"[13] at the same time that it undermines what one might call "cultural linearity" by juxtaposing linguistic as well as pictorial materials from different cultures. Cha, who

came to the United States when she was eleven, thus engages in a subversive dialogue with a broad variety of linguistic and cultural forms of colonial dominance: of the Korean child's submission to Christian missionary teaching, the collective submission of Koreans to Japanese repression, the submission of the Korean immigrant to American dominant culture. Cha links this dialogue to a search for finding voice that is also staged as a search for the "lost" mother—for her culture and her history. The book's cover displays a photograph of Cha's mother that reappears in the text along with photographs of the Korean Joan of Arc, Yua Guan Soon, who, in 1920, was killed by the Japanese at the age of 17. As the title suggests, the text is, to some extent, modeled on the form of a dictation—as the linguistic exercise of a French-Catholic missionary school. Beyond this, "Dictée," "dictation," opens a wide range of associations: the mind's submission to the authority of the foreign language, or of the written word, or to the authority of language teachers, priests or missionaries, dictators and military oppressors, colonial autocrats, or bureaucratic dispensers of passports and visas. Accordingly, the book contains several examples of dictated submission to various forms of cultural domination; and yet, by its very fragmentariness, it also appears to run counter to dictation and the dictates of a quasi-colonial patriarchal order. Against the male and (mono)cultural written *dictée/dictum/ decree*, it sets the female voice, the wordless image, and the transgressive perception of difference.

Apart from several dictation and translation exercises, *Dictée* (1982) includes prayers, liturgical texts, mythological allusions, and documents of Korean history, which is a history of repression as much as of rebellion.[14] It tells the mother's history of exile in Manchuria, where she was forbidden to speak Korean, her mother tongue. It refers to the bloody uprising of 1919, in which Yu Guan Soon played a leading role. We learn this from a collage of personal letters, passages of history books, and a petition sent by Hawaii's Korean community to President Theodore Roosevelt about the brutality of the Japanese occupation (a petition he ignored). *Dictée* cuts across genre divisions by combining narrative prose and poetry (in several languages) and juxtaposes excerpts from the autobiography of Saint Thérèse of Lisieux and a variety of visual texts. One of its nine chapters seems to stage a film scene, and there are some seemingly misplaced pages that one might nevertheless read as two different video

films running next to each other. And there are empty pages as well as empty spaces between paragraphs marking rupture, collapse of voice, or meditative silence. There are also photographs; film stills; Korean, Chinese, and Japanese pictorial signs; the reproductions of handwritten letters; and of maps and illustrations.

The first chapter is preceded by an opening section titled "Diseuse." Although this refers to the narrator as female storyteller, it seems also to imply a passive function: as someone trained only to repeat, who slowly and painfully finds voice and articulation. "Allez à la ligne," to submit, to give in to dictation, is also to take in, to internalize, the Word. But the tongue that takes the Host of the Word is also the tongue that is to utter speech and stutter in a foreign tongue, as much as it is the place of the lost or forbidden mother tongue. The dictation: GOD WHO HAS MADE YOU IN HIS OWN LIKENESS is accepted and repeated but also turned around in stuttering and rebellious parody: "Acquiesce, to the correspondence… Acquiesce, to and for the complot in the Hieratic tongue. Theirs. Into Their tongue, the counterscript, my confession in Theirs. Into Theirs. To scribe to make hear words, to make sound the words, the words, the words made flesh." [15]

To inscribe itself subversively into the "Hieratic tongue" thus seems to be the hidden project of the text—the hieratic tongue being any language of dominance, be it Latin, Japanese, or French, or English, or the linguistic order of patriarchy. The section ends with an evocation of the nominal: "In Nomine—Le Nom—Nomine."[16] It associates the "Name of the Father" with the (forbidding) Law of the Father: the ambivalent "Nom(n) du Père" that Lacan talks about. Inscribed in the very dictation of the title is thus the rebellion of the one dictated to (dictée)—and the dissolution of dictation into the multicultural, multilingual, multimedial performance of the text as "counterscript."

Dictée is, in this sense, a radically dehierarchized text: de-centered, out of focus, semantically incoherent, and therefore beyond firm notions of identity: between genres, languages, and cultures. But if it is, on one hand, about loss, it seems, on the other, also about finding. The finding is almost excessively suggested by the recurrence of the number nine—a sacred number, since it is connected in mythology with pregnancy and gestation. *Dictée* consists of nine chapters named after the nine muses, the daughters of Mnemosyne, the

Greek goddess of memory. There are also frequent allusions to Demeter, who had wandered nine days and nights in search of her daughter Persephone. In the Catholic ritual cited in the book's opening section, the nine novitiates sing the "Novena of the Immaculate Conception, nine each [...] during a nine day period."[17]

Dictée, almost programmatically, displays on its cover the image of the exiled mother (whose fate seems to repeat itself in the exile of her daughter). On the book's first page we find the mysterious photograph of signs carved into a wall. According to secondary sources, it says in Korean script: "Mother, I miss you, I am hungry, I want to go home to my native place"[18] and was probably scratched into a wall by Korean prisoners during Korea's occupation by the Japanese. The chapter dealing with the divided Korea evokes the mythological mother Demeter and her tragic separation from her daughter.

Thus the book not only deconstructs the order of dictation, it also duplicates in its own disorderliness the havoc created by dictated order: the loss of voice and native place, the repression of mother tongue, the pain of division and separation. Yet its subtext, connected with the number nine, is reconstructive, stages a finding of voice, a homecoming and a reunion of daughter and mother. There are unmistakable allusions to mythic rites of regeneration: "Dead Gods [...] Turned stone. Let the one who is *diseuse* dust breathe away the distance of the well. Let the one who is *diseuse* again sit upon the stone nine days and nine nights. Thus. Making stand again, Eleusis."[19] The Eleusian Mysteries, which lasted for nine days, celebrated Persephone's return to her mother Demeter. Note that the "diseuse" is no longer *being* spoken but now has the magic power to evoke the lost and the forgotten, to overcome "the distance of the well."

This "well" is finally reached in the ninth chapter by the daughter-protagonist who, exhausted from her long trip from "a far," finds a woman there who gives her water and ten "pockets" of medicine: nine for her sick mother, the tenth for herself. The ten pockets correspond to the ten steps of the Confucian "Way," which *Dictée* lists first in Chinese script, then, several pages later, in English translation. The "Way" of Chinese wisdom runs parallel to chapters of the book named after the nine muses. The difference is that the "Way" offers yet a tenth step, corresponding to the final section,

where mother and daughter are reunited at last: "Lift me up mom to the window…. Lift me to the window to the picture image unleash the ropes tied to weights of stones first the ropes then its scraping on wood to break stillness as the bells fall peal follow the sound of ropes holding weight scraping on wood to break stillness bells fall a peal to sky."[20]

However, this final section, with its promise of "unleash[ing] the ropes," is preceded by six lines that appear to confine such homecoming to a realm of desire, memory, and evocation. The text, although seemingly finding rest in a final vision of return, is in fact unsettled in the memory of absent presence, since origin can only be grasped as already lost to "time" and "distance"—as a "trace" left and inscribed in the word.[21] Although on the one hand, *Dictée* stages separation as fragmentation and inarticulate stammering, it suggests, on the other, the magic of the refound voice, the ecstatic stammering of mystic vision. St. Thérèse of Lisieux's prayer to her beloved bridegroom Jesus is surely quoted in parodic and subversive mimicry, yet its visionary passion reverberates in the book's emotional intensity.[22] Cha's text might thus be understood as an attempt at creating a quasi-fluid verbal medium that would transport the immediacy of touch and dream image, a language *before, underneath,* or subversively *within* the symbolic order; a language, in short, beyond the dictate of the Father—a found again (if verbally/pictorially reconstructed) Mother tongue![23]

In a project statement of 1978, Cha herself points in this direction: "The main body of my work is with Language, 'looking for the roots of language before it is born on the tip of the tongue.'"[24] And: "My work […] has been a series of metaphors for the return, going back to a lost time and space, always in the imaginary. The content of my work has been the realization of the imprint, the inscription etched from the experience of leaving, the experience of America."[25] Her writing grows out of the painful experience of loss and exile. Yet it also opens up the "counterscript" of an imaginary space "in-between" in whose very gaps and silences it is yet possible to find voice and home.

Notes

1 On photography, narrative, and memory, see Rob Kroes, "Arresting Moments," *Photographic Memories: Private Pictures, Public Images, and American History*, 9–33 (esp. 14 and 15), and Roland Barthes, *Camera Lucida: Reflections on Photography* (New York: Hill and Wang, 1982).

2 "One Saturday, I went to see a show of a German photographer whom I thought I had never heard of before. It was the first American retrospective of his work. I remember very vividly walking into the exhibition room and bearing to my left and seeing this photograph on the wall that instantly seemed recognizable to me. Three young men in Sunday suits, looking out over their shoulders as if they had been waiting there for seventy years for me to return their gaze. I leaned forward to read the caption, and the picture was named, 'Young Westerwald Farmers on Their Way to a Dance, 1914.' The words went right up my spine. I knew instantly not only that they were on their way to a different dance than they thought they were, but that I was on the way to a dance that I hadn't anticipated until then. All of my previous year's random reading just consolidated and converged on this one moment, this image, which seemed to me to be the birth photograph of the twentieth century;" in Jeffrey Williams, 1999 ("The Last Generalist—Interview with Richard Powers," n.p.); see also "Richard Powers: On the Novel in the Digital Age," in Jefferson Hendricks, "Richard Powers: On the Novel in the Digital Age," *Poets and Writers* 28: 4 (July/August 2000): 1–16. The phrase "remembering forward" is taken from the Hendricks interview (28). It is interesting that Powers felt so provoked into participation by Sander's photograph, while such a sensitive reader of photography as Susan Sontag felt only detachment and distance in Sander's "comprehensive taxonomy": "His complicity with his subjects is not naïve… but nihilistic. Despite its class realism, it is one of the most truly abstract bodies of work in the history of photography." Susan Sontag, *On Photography* (New York: Picador, 1990), 61.

3 Powers, *Three Farmers on Their Way to a Dance* (New York: Beech Tree/Morrow, 1985. In the present text page numbers refer to the New York: Perennial, 2001 edition), 348.

4 Jefferson Hendricks, "Richard Powers: On the Novel in the Digital Age," 28.

5 Powers, *Three Farmers,* 39.

6 Jim Neilson, "Interview with Richard Powers". *Review of Contemporary Fiction,* 18:3 (Fall 98) "A lot of my books have been structured around this idea of an asynchronic messaging, that there are two or more stories going on in different moments in time that are somehow trying to signal each other, trying to open a conversation between time periods that ought to be sealed off one from the other as far as any ongoing message. But in the moment of being reconstituted in the reader's brain those messages between past, present, and future are, I hope, detonating all the time." Powers in Jefferson Hendricks, "Richard Powers: On the Novel in the Digital Age," 28.

7 Powers, *Three Farmers*, 203.

8 James Hurt, "Narrative Powers: Richard Powers as Storyteller." *The Review of Contemporary Fiction*, 18:3 (Fall 1998): 26.

9 Significantly, the narrator does not—like his author, Richard Powers—discover Sander's picture in the Fine Arts Museum in Boston, but in the Detroit Institute of Arts. There he first encounters Diego Rivera's gigantic mural dedicated to machinery and mass production before he "wheeled smack" into Sander's portrait of the three farmers—also a work of social realism with a story to tell. As the narrator is dimly aware, that story, like his own, is part of—and feeds into—the story of the century.

10 Powers, *Three Farmers*, 79.

11 Powers, *Three Farmers*, 334.

12 Powers, *Three Farmers*, 258.

13 Lisa Lowe, "Unfaithful to the Original: The Subject of Dictée," in *Writing Self/Writing Nation: Selected Essays on Theresa Hak Kyung Cha's Dictée*, eds. Elaine Kim and Noma Alarcón (Berkeley, CA: Third Woman Press, 1994), 37.

14 On the importance and function of Korean history in Cha's book, see Lisa Lowe's article. Lisa Lowe, "Unfaithful to the Original: The Subject of Dictée," in Elaine Kim and Noma Alarcon, *Writing Self/Writing Nation*, 35–69. At the same time, Lowe argues convincingly against any attempt to associate the book with the essentializing tendencies of ethnic nationalism: "Thus, in reading *Dictée*, the irony cannot be escaped that the very ways in which the text presents a critical problem for the emergent fields of Asian American Studies, Third World Studies, or Women's Studies, particularly in how it problematizes the uniformity of ethnic, gendered, or nationalist identity and genre, constitute, paradoxically, precisely the most powerfully suggestive critiques of dominant colonial and imperial interpellations" (38); and: "While its critiques of identity engage with feminist, psychoanalytic, and Marxist discussions of subjectivity and ideology, in the multiplication of perspectives, and the refusal of inference, deduction, and causality, *Dictée* unsettles the authority of any single theory to totalize or subsume it as its object" (37). Although this is clearly due to the aesthetic status of the text, Lowe discusses it almost exclusively in political terms. Without denying the political dimension of *Dictée*, Juliana Spahr and Kerstin Twelbeck emphasize its aesthetic function in their own reader-oriented analysis. Juliana Spahr, *Everybody's Autonomy: Connective Reading and Collective Identity* (Tuscaloosa: University of Alabama Press, 2001). Kirsten Twelbeck, "Entführung in eine andere Wirklichkeit: Theresa Hak Kyung Chas Dictée," *No Korean Is Whole—Wherever He or She May Be: Erfindungen von Korean America seit 1965* (Frankfurt: Peter Lang, 2002), 184–239.

15 Theresa Hak Kyung Cha, *Dictée* (Berkeley: University of California Press, 2001), 17–18.

16 Theresa Hak Kyung Cha, *Dictée*, 21.

17 Walter K. Lew, *Excerpts from: Dikte for Dictée* (Seoul: 1992), n. p.

18 In Elaine Kim and Noma Alarcón, *Writing Self/Writing Nation,* 10.

19 Theresa Hak Kyung Cha, *Dictée*, 130.

20 Theresa Hak Kyung Cha, *Dictée*, 179.

21 Derrida's concept of "trace" is brilliantly used in Twelbeck's analysis of the text as "weibliche Inszenierung."

22 The erotic mysticism of Irigaray's "La Mystérique" comes to mind, with its evocation of yet another sainted Theresa, Teresa de Avila. Luce Irigrary, *Speculum of the Other Woman* [1974]. (Ithaca: Cornell UP, 1985), 201.

23 This would give a specific feminist twist to the general attempt of her written as well as her visual work. (When studying in Paris, in the late 1970s, Cha, in all likelihood, absorbed the film theories of Jean-Louis Baudry, Monique Wittig, and Christian Metz, along with the writings of Hélène Cixous, Julia Kristeva, and Luce Irigaray.) She combined avant-garde and feminist with Chinese poetics, to reach beyond the verbal, rational, and individual toward deeper areas of consciousness. In a statement written in 1978 ("Paths"), Cha supported her aesthetic convictions with a quote from Ekbert Faas: "For most, the pursuit of literature and art is simply a vehicle of the Way, which, besides the notion that poetry expresses the intent of the heart (or mind), is the most widely quoted principle of Chinese poetics. And the Way is as long as the mind is deep, comprising, as Buddhist philosophers knew long before Jung, not only the personal 'mind-system,' but the huge memory storehouse of the 'Universal Mind' in which 'disseminations, desires, attachments, and deeds' have been collecting 'since beginningless time' and which 'like a magician… cause phantom things and people to appear and move about.'" Lawrence Rinder, "The Plurality of Entrances, the Opening of Networks, the Infinity of Languages," in *The Dream of an Audience: Theresa Hak Kyung Cha*, ed. Constance M., Lewallen (Berkeley: University of California Press, 2001); bilingual edition: *Der Traum des Publikums/The Dream of an Audience* (Vienna: Verlagsbuch-handlung König, 2004), 30.

24 Constance M. Lewallen, *The Dream of an Audience*, 19f.

25 Lawrence Rinder in Lewallen, *The Dream of an Audience*, 30f.

Memory and/or Construction

Family Pictures
in W.G. Sebald's *Austerlitz*

Zsófia Bán

Over the last decade German writer W. G. Sebalds's oeuvre has become a locus classicus for the interplay of photograph and text. When we take a closer look at the various visual media and genres he uses in his works—namely, photography, film, architecture, floor plans, and maps—they all turn out to be visualized metaphors of memory. This means that verbal images appear as real images around which Sebald constructs his narratives. Underlying the family histories presented in his writings, there is a collective event (the Holocaust) of incomprehensible and unthinkable dimensions, as well as the memory of this event. But how *should* we and how *can* we remember an event of incomprehensible and unthinkable dimensions that is *sublime* in the sense of being terrible? And how can we represent this act of remembering? This is the painful, burning central question in Sebald's work. Because remembering is clearly an imperative here. The only question is *how*. How is a question especially when we speak of texts like Sebald's novels, in which the photograph—in contrast to its traditional function of authenticating and giving evidence—only widens the gaps and cracks between document and fiction. Moreover, Sebald achieves this effect not by using the tools of manipulated digital photography, so fashion-

able in our day, or by reflecting on its problems, but without doing anything to the photographs, without any direct intervention in their being as objects. Instead, Sebald uses series; he places the photographs in various sequences; in other words, he uses the method of contextualization. The photograph as a means of the representation of remembering and memory, and of forgetting and death, in its turn, has already become a commonplace. And resulting precisely from these qualities, namely, from the fact that it reveals and conceals at the same time, the photograph, as Roland Barthes says, is never *what* we see. We look at a photograph with a kind of penetrating blindness: the photograph becomes invisible, and what we imagine behind it appears before our mind's eye. In Sebald's novels, it is usually the story itself. Or it is what these stories leave unsaid. And in these stories, the revealing and concealing natures of the photographs alternate (we can find examples for the former in *The Emigrants*, while for the latter more in *Austerlitz*[1]). However, as opposed to Barthes' theory, our dead return to us not only in the photographs, and it is not only that we bring them back to life with our gaze, and it is also not that, in their turn, they also bring us to life by looking back at us:[2] in Sebald's world the dead are *always* present, and sometimes they are even more alive than the living. The characters are not always aware of this, or if they are, if they become aware of it somehow, then they are not really able to live with this awareness (see the four suicides in *The Emigrants*).

Nevertheless, the fact that they are not always aware of this does not mean that they are not aware of it *at all*. Rather, they suppress this awareness into their subconscious. And in the case of Sebald's works, this problem has to be interpreted simultaneously on the levels of private and collective memory. Because if these dead are the victims of the greatest trauma of the twentieth century, then they are also the ones who represent this historical trauma—they are its ghostly embodiments. In his book, often quoted in the context of the Holocaust, photography, and trauma, Ulrich Baer argues that there is a structural similarity not only between the photograph and memory but also between the photograph and trauma, in that they represent the eternal recurrence of something that is no longer there, yet is frozen in time.[3] The broken, non-linear temporality of Sebald's novels, as has been pointed out, is a precise reconstruction of the similarly broken temporality of the trauma (or dream and memory)

with its rhythm of alternating suppression and surfacing. These works also represent precisely the process of becoming conscious of the trauma, which is often delayed, and of dealing with it, which sometimes takes place only several generations later. Research on the psychological effects of the Holocaust has already proven that the trauma can be hereditary (*see* transgenerational trauma): parents and even grandparents can transmit their conscious or suppressed trauma.[4] In my view, this transmission is represented by the acts of *handing over* (i.e. the entrusting of family photographs to others) in *The Emigrants* and *Austerlitz*, even if the people to whom the documents are handed over are not members of the family (in both novels it is the narrator). I propose that this gesture represents the *collective* transmission of knowledge, the working and maintaining of cultural memory.

In *Austerlitz*, the main character, Jacques Austerlitz, was saved from World War II when he was four—his parents sent him from Prague to the United Kingdom in a *Kindertransport*, never to see him again.[5] Austerlitz tries to use not only photography, but also film, as a medium in his attempt to restore the family history he lost, and by doing so, to restore his lost identity and lost memories. As Austerlitz has no photographs, nor even visual memories, of his mother, he tries to find a photo of her, or identify her in a photo, with the help of Vera, his nanny whom he miraculously finds in Prague. The missing photo or memory is more emphatically present in the story than any picture or memory that is not lost, that is still there. Jacques's quest, and the entire book, is built around an absence. The text circumnavigates this absence, and eventually only the contours of a ghost image are drawn. In my reading of the story, in contrast to the impression left from a first reading, this novel does not offer a reassuring solution or resolution for this question either, as its entire texture and strategy make it uncertain for the reader whether the woman Vera identifies in one of the photos as Agata, Austerlitz's mother, is really his mother. When he finds out from Vera that his mother was deported to Theresienstadt, Austerlitz first obtains a copy of a manipulated pseudo-documentary film (*Der Führer Schenkt den Juden einen Stadt*[6]) made by the Nazis, in which Theresienstadt is presented to the world as a model camp. It is highly problematic in itself that Austerlitz uses manipulated, totally untruthful material to prove that his mother was there and to revive her memory. Whatever evidence he may

find will appear in the context of a blatant lie and an intent to deceive, which makes its reliability as evidence rather doubtful. What he can see in this film is the same kind of costume-play performance (or masquerade) as all the other photographs he finds during his quest, including a childhood photo of himself in costume. Everything and everyone is wearing a mask, a costume: nobody is what or who they seem to be. In essence, the photos do not let him get back to the "original state" *before* his trauma, the trauma of losing his parents and his original identity.

Watching the film in slow motion, Austerlitz spots a woman whom he believes to be his mother. He makes a large photograph of the frame (that is, he manipulates the manipulated footage[7]) and shows it to Vera. She tells him immediately that it is not Agata, and by doing so, she deprives Austerlitz of a potential mother image. Later, when in an old theatrical magazine Austerlitz finds the photo of an actress who, he believes, may perhaps be his mother, at long last, Vera finally utters the "yes" Austerlitz has desired so long: she *recognizes* Agata in the picture. However, we do not know whether she really recognizes Agata or it is just a merciful "gift." We do not know whether Vera's view of Jacques has changed by then, whether she took pity on him and decided to help her beloved Jacquot by presenting him a mother image, instead of holding fast to the "truth," which had no value in that context, and was even detrimental. If this is the case, instead of an image reviving a memory, we have one that replaces or constructs a memory that has a power to redeem. As I have said, there is no way we can find out what the truth is. Sebald gives us no evidence. By the time we reach this point in the novel, text and image have conflicted so many times (only seemingly complementing and supporting each other), and their authenticity and meaning have been questioned so many times, that the only sure thing is that everything is uncertain.

Obviously, the reader would like to know whether the woman in the photograph is Jacques's mother. Most readers are inclined to believe it with relief, and they rejoice. We cannot know for sure, but in Jacques's world the woman in the photo has already *become* his mother (she fulfills that role), so she *is* her mother. And who would reproach Vera for all this in such a situation? Who would call upon her for the "truth," once it looks very much as if truth can be constructed of matters other than mere facts? At a certain point, Vera

says to Jacques that it seems as if photographs have a memory. But this memory is not always accessible to those looking at the photos. They sometimes show (know) things that we have no knowledge of, and therefore they do not revive anything for us: they only suggest something that we cannot grasp, something that we cannot touch. It is like when we reach out towards the mirror, but we can only bump into ourselves, unable to get behind the mirror. In such cases the meaning of images is what we read into them, or what we use them for (meaning is in use, according to Wittgenstein, whose figure Sebald evokes by allusions in the figure of Austerlitz in this novel, and reference is also made to Wittgenstein earlier in the chapter on Max Ferber in *The Emigrants*). This lack of knowledge can be distressing, or sometimes even humiliating, but in other cases it may generate a kind of freedom and values that nothing else could. For example, this is how someone can get a mother. This is how an image received externally and artificially is internalized. I think this is why Austerlitz can part with the photo of his mother that he came by with so much difficulty, when he gives it to the narrator to keep it safe. He no longer needs the object, the image in its physical existence permanently, as it has been internalized. And now, his hands are free, both literally and figuratively, to start a quest for his father.

Walter Benjamin identified what he called the optical unconscious as the specific knowledge of the photograph—that is, its faculty to show things we do not always notice in reality, looking at things with our "bare eyes." In other words, the photograph may reveal things beyond the intentions of its maker.[8] Things that in other circumstances are invisible or hard to see become visible. In contrast to this, in Sebald's novels the photographs are often blurred, they are of poor quality or small, and are often unsuitable to show adequately what would be their apparent subject, let alone their optical unconscious. According to this strategy, that which I (apparently) present in an image cannot be seen, but that which I do not show (visually or textually) becomes "visible" or can be inferred. As a result of this strategy, an alternative vision and an alternative visuality unfold in Sebald's works. It is an inverse mode of presentation—Oriental, if you like—where the place of absence is drawn or hatched around, and the contours of what lies underneath become distinct in the space left blank. In Sebald's work the authenticity supported by photographs and other visual "documents" (maps, blueprints, floor plans) draws on the faith of the reader—

albeit weakened by today—or rather on the primary *desire* of the reader to see as proven what is written.

In contrast to this, evidence is given not by the narrator's voice but by the act of hearing, the fact of *being heard*. In both *The Emigrants* and *Austerlitz*, the narrator becomes a *witness* to the narrated life stories. In each case the narrator is the *addressee* in the sense that Levinas uses this term: in the context of the ethical encounter with the Other who is "you," the encounter that becomes an event of the "Saying." The narrator becomes witness to the narrative and to the narrated life stories that give those lives their ultimate meaning. Of course, along with the narrator, the reader also becomes an addressee and thereby, a witness. This undoubtedly creates a difficult situation for those who believed they were no more than simple readers. While reading Sebald's work, they have to learn to live up to what it requires of them: to assume the role of the addressee, the role of "you." For it is no easier to listen to such stories than to tell them. Thus, whenever the addresser and the addressee meet in Sebald's works, whenever an event of the "Saying" is performed, not only an aesthetic but also an ethical victory is won. And what more can you expect of a work of literature?

English translation by Zsolt Kozma

Notes

1 W.G. Sebald, *Ausgewanderten* (1992); W.G. Sebald, *Austerlitz* (2001).

2 Roland Barthes, *Camera Lucida*: *Reflections on Photography, Narrative and Postmemory* (Cambridge, MA: Harvard University Press, 1997).

3 Ulrich Baer, *Spectral Evidence: The Photography of Trauma* (Cambridge, MA: MIT Press, 2002).

4 See, e.g., the concept of *postmemory* in Marianne Hirsch, *Family Frames: Photography, Narrative and Postmemory* (Cambridge, MA: Harvard University Press, 1997). See also Ernst van Alphen "Second-Generation Testimony, Transmission of Trauma, and Postmemory" in *Poetics Today* 2006 27(2): 473–488.

5 Cf. the strongly implied inverse of the *Kindertransport* (transports of Jewish children sent to safer countries during WWII) in Péter Nádas's novel *Párhuzamos történetek* [Parallel Stories, 2005], where Hungarian children are sent in large numbers to summer camps in the German Democratic Republic, that is, to (East) Germany, for holiday in 1957. A shocking account of

the experience of Kindertransports in World War II is the documentary *Into the Arms of Strangers* (2000, directed by Mark Jonathan Harris).

6 The pseudo-documentary was shot in the summer of 1944, directed by Kurt Gerron, a famous German actor and cabaret star deported to Theresienstadt. Gerron was promised that, in return for his cooperation, he would not be sent on to Auschwitz. The promise was not kept; Gerron died in Auschwitz. A documentary of his story, entitled *Prisoner of Paradise,* was made in 2002 (directed by Malcolm Clarke and Stuart Sender).

7 Among other things, he takes the image out of time and "freezes" it, like a person freezes a trauma he or she has undergone.

8 Walter Benjamin, "Short History of Photography," trans. by Phil Patton, in *Artforum* 15, 6 (February, 1977): 46–51.

PRIVATE AND PUBLIC ARCHIVES

Virtual Communities of Intimacy

Photography and Immigration

Rob Kroes

In this essay I propose to look at the ways in which immigrants in their new American setting connected to relatives, friends, and neighbors in their areas of origin. They expressed these continuing bonds through letters sent home, trying to preserve a sense of intimacy with those who had stayed behind. They also added a touch of closeness through the use of photography as a visual aid providing vicarious eye contact. There is an enticing directness to these photographs, suggestive as they are of a density of information, even though their rich and manifold meanings to those receiving them may have faded after a century or more. All that later observers can do is to try to recreate the role of photographs in preserving virtual communities of intimacy spanning half the globe.

Those interested in American photography all know the great photographic icons of American immigration. They can, at the flick of a mental switch, call forth the images of immigrants setting foot on Ellis Island, carrying their meager belongings in a bundle. The images show, in a strange intimacy, the faces of immigrants, in repose, yet in anticipation of the imminent encounter with their new country. We may mention, among many examples, Lewis Hines's "Madonna of Ellis Island" or Alfred Stieglitz's "The Steerage."[1]

But, as I said, most photographic representations of the immigrants functioned on a different level of communication. They were part of highly private exchanges, meant to convey their messages within private networks of relatives and friends. They added a visual element to ongoing written exchanges and could only derive their precise reading from that context. The iconic photographs that we all know how to read are like the photographs in the window display of an archive storing millions of pictures whose reading has become uncertain. It is an archive of almost Borges-like dimensions, a maze of many nooks and niches, stacked with uncataloged boxes of words and images, fragments of stories that we may no longer be able to piece together. Occasionally there are guides, ghostlike figures, who have only their memories to live by and who can bring words and pictures together again. One such guide emerges from the pages of Louis Adamic's *Laughing in the Jungle*, an old and frail return migrant from the United States to the old mother country which, until recently, we knew as Yugoslavia. At one point Adamic remembers the day when, as a young boy, he sat beside this old man, listening to him, to his stories about work in the mines and the steel industry, looking at photographs that the old man brought home with him. Photographs of New York:

> The day before I sailed home I walked in the streets"—he pointed at the picture—"where the buildings are tallest—and I looked up, and I can hardly describe my feelings. I realized that there was much of our work and strength, frozen in the greatness of America. I felt that, although I was going home ... I was actually leaving myself in America.[2]

But more often than not, such explanatory voices have gone silent. We are left facing photographs that no longer tell their own story. We are no longer able to recreate the recognition they evoked at both ends of lines of communication maintained between immigrants and those who stayed behind. Such photographs have become the silent documents of an anonymous past.

Thus, in the archives of the Historical Collection in Heritage Hall at Calvin College in Grand Rapids, Michigan, the center of learning of the Christian-Reformed Dutch-American community in the United States, the

visitor comes upon many photographs whose sitters are referred to as "unidentified persons." Many of the older pictures are studio photographs, giving us the name of the studio in ornate lettering. The sitters have dressed for the occasion and are photographed against backdrops redolent of luxurious mansions. Whom did these early immigrants want to impress? Were these photographs ever sent to relatives in the home country? Did they simply serve the purpose of an embellished family memoir, in their vicarious display of a life of ease and luxury?

We will never know. What we do know is that these photographs belong to an era and a genre of studio portraiture in which photography was subordinated to the creation of an illusion. The new mechanical medium reproduced for the many the pictorial aura of ease, refinement, and culture that only the wealthy could afford in the heyday of painting. If this was democracy, it was the democracy of illusion. Costumes, stage props, and backdrops were all provided by the studio. Willingly the sitters subjected themselves to the choreographic rules and the stage directions that had modeled family paintings since the seventeenth century. The mold of self-presentation was definitely patriarchal, although it came in two varieties. Mostly, in the cases where husband and wife had their photographs taken, the husband is seated with his wife standing beside him. An extreme version of this choreography is a photograph of an old woman standing beside an empty chair. She was a widow. But in a sense the dead husband was still there, defining her role and position. Occasionally, though, the woman is seated, with the husband standing by her side, the good provider and protector. In studio portraits of parents and their children, the parents are usually seated, with the children standing.

If these photographs show us reality as a fiction, it was not necessarily one consciously fabricated to mislead the homefront in the mother country. The representational code underlying this particular genre of studio photography was widely known: this was what people, in Europe and America, expected portraits to look like. Yet the fact that people could have their pictures taken in the first place was proof not only that they could afford this relative luxury, but also that even in their pioneer existence in America they enjoyed the amenities of a modern technical civilization. Studio photography was never far behind the frontier of settlement. Studio photographs were not solely a big-city phe-

nomenon; many photographs were taken in small towns all across the United States. For some it may have required a day trip to the nearest town and back, yet the message was clear: civilization was never far. Theirs was not a life in the wilderness.

Of course there were cases where the use of studio props did in fact serve the purpose of willful fabulation, where indeed the fictitious overstatement did go beyond the representational conventions that sitters and beholders shared in common. In his study of immigrants from the Italian *mezzogiorno, Il pane dalle sette croste,*[3] P. Cresci mentions a genre of studio photographs that showed the immigrants holding a bicycle or casually leaning on a motorcar. More often than not, these were the studio's property, used to convey an image of material well-being that may have been a distant dream to the immigrants as much as to their Italian relatives. Such photographs are a clear case of theatrical impression management. They were the visual accompaniment to the glowing overstatement in many of the immigrants' letters.

In general, whether or not the intended message was an overstatement, photographs were accompanied by words, either scribbled on their backs or in enclosed letters. Language added to the photographic information, contextualizing it by giving names, ages, color of eyes or hair, or by referring to the occasion, such as a baptism or a wedding anniversary. They were all matters of private relevance, providing the recipients with—literally—a closer look at their distant relatives and friends. Words were meant to add focus and detail to the photographic image, yet they could only function within the wider unspoken context of established relations of kinship or friendship. Outsiders, strangers to such intimate relationships, could never hope to get the full message. How much more strongly is this the case with later observers, such as students of immigration history: the passing of time and of generations has filtered, if not erased, family recollections; has caused the loss of letters and photographs; and has severed the links that connected both meaningfully to one another. There has been a massive loss of vital context. We are left with the mere fragments of what once was a meaningful and ongoing communication across the Atlantic.

Yet the fragments are all over the place. The "archive" of immigration history is tentacular, reaching as far as the catchment area of American immigration. Letters and photographs, half-forgotten, half-remembered, are still be-

ing kept by individual families all across that area. Occasional conversations as much as concentrated research efforts can result in lucky strikes. Thus one day, a Polish colleague, Jerzy Topolski, who spent a year with me at the Netherlands Institute for Advanced Research and who knew of my research interest, told me that he knew of photographs of distant relatives in late nineteenth-century America that were still being kept by family members in Poland. A little later in the year, he brought them with him from Poland. They were all studio photographs, from Chicago and New York, all with the sepia hue that tied them to the era of the "Brown Decade." There were more markers of time, place, and country of origin. In addition to the name and address of the studio, prominently featured below the actual picture, handwritten notes on the back added information of a more private nature.

Such brief notes at the time must have sufficed to put the various persons shown in the photographs unfailingly within a network of relatives living on both sides of the Atlantic. Such immediate genealogical mapping is no longer possible among their present-day offspring. The photographs are the faded effigies of relatives who themselves have faded from memory. No longer able to call forth a repertoire of anecdotes and stories and set in a context of silence, these photographs are not unlike weathered tombstones, the mute markers of family history. This comes out most tellingly in one of the Polish photographs. It is the portrait of a young woman, showing just her head and shoulders, in the style of a sculptor's bust, the shape reduced to an oval, the rest retouched to nothingness. The impression is one of an image emerging in clear focus from an enveloping mist. (Fig. 1) The little photograph was taken by Hartley's Studio in Chicago. The name is partly hidden from view by some of the flowers and leaves of an ornate wreath that encircles the little picture. For in fact, what we are looking at is a photograph of a photograph, once again taken by the Hartley Studio. Below the wreath there is a rectangular shape, suggesting the heavy stone lid of a grave. The image as a whole is definitely a studio arrangement. More than any other photograph, it conveys the sense of the past as lying irretrievably across the river Styx, in the domain of the dead. The handwriting on the back dryly informs us that the woman is Elisabeth. "When died she was 24 years, 3 months, and thirteen days old."

1. Elisabeth. Photograph from the US, late 19th century

Only the living memory of those beholding a photograph can bring the sitters back to life. I was reminded of this when reading a story by James Schaap, a Dutch-American author.[4] The story tells us of a young man who had come to see his grandmother on her deathbed. He enters the bedroom. "Nameless faces lined the walls, and an old Dutch couple peered at me from an ornate oval frame hung above the headboard. I always loved that room, for there was excitement here, the fascination of experiences long past. I loved to sneak in as a boy, to sit alone on the bed and look around." Now, for the first time, he is not alone. In her final days, his grandmother tells him about the past before it is too late, about "the nameless faces" on the wall, her father and mother. "What was your mother like, Grandma? Like you?" Slowly, in answer to his queries, she brings the past back to life, telling a story that she had kept to herself for years, about a disastrous fire on board an immigrant ship crossing Lake Michigan en route to Sheboygan. The father died fighting the fire; the mother died looking for one of her daughters. The portrait of his grandmother's parents comes to life: "I glanced at the portrait. I had seen it often before. It had come from Grandma's uncle in Holland. He was seated on a chair as big as a throne, his wife's hand rested on his shoulder as she stood soberly at his side." And as the drama unfolds, of his grandmother's parents dying, but also of his grandmother going back in time, reviving the story, the grandson keeps looking up at the picture. "I tried to imagine [them] as Grandma spoke." They were no longer nameless faces.

When I was reading the story, there was a strange sense of *déjà vu*, of something half-forgotten pushing to resurface. Suddenly, there it was. In a book by a Dutch amateur historian, in which he pieces together the emigration histories of his forebears, reference is made to the same tragic event on Lake Michigan. I had heard the story before and had gone through the same emotions as the young man in Schaap's story listening to his grandma. I had also been looking at photographs of people who were in the fire. They were reproduced in the book, relatives and friends of relatives of the author. In his act of filio-piety, he manages to draw outsiders like me into a quasi-familial circle, where "nameless faces" are being restored to their place in history through stories told by their distant offspring.[5]

If, in the exchanges between immigrants and their relatives and friends in the home country, photographs acquired their full meaning and sense only in a

context of written words, one of two things usually happens with the passing of time. Either we find separate photographs that time has cut loose from their accompanying annotation, or we are left only with the annotation, with cryptic references in letters to pictures that must have been originally enclosed. Many people, in acts of filio-piety, have sat down to collect and organize what is left of the communications of their relatives across the Atlantic. They have sorted out whatever letters have remained; they have made copies available to official immigration archives in their home countries or in the United States. But more often than not, these are mere fragments of exchanges that went on for years, if not decades.

One of the tasks that immigration research has set for itself is archival. It is precisely the task of bringing together as many of these fragments as one possibly can. And the results have been impressive. Massive numbers of immigrant letters have been collected, ordered, and made available for immigration research. Large selections have been published, in the United States and in the main countries of emigration in Europe.[6] Larger collections are available in immigration archives in all those countries. Yet much of the archive is still as labyrinthine as before. Serendipity still reigns supreme; researchers in the field keep stumbling upon unmined treasures. No single researcher can pretend to have seen it all, or can confidently claim to have gone over a representative sample. Yet there is always the temptation to come up with some tentative general statements. So, with all due provisos, let me give some general impressions before I go into greater detail.

My own work in immigration history has been concerned mostly with Dutch immigrants in the United States and Canada.[7] In the course of my research, I have come upon hundreds, if not thousands, of letters, and there are new finds all the time. On that basis, and also on the basis of the collections of letters that have been published in other countries, it seems safe to say that photographic information played only a marginal role. Entire exchanges between family members, even many that went on for decades, have no reference at all to photographs. A collection of Dutch-immigrant letters, published by Herbert J. Brinks,[8] never once mentions photographs in its selected fragments. And only a few of the many photographic illustrations in the book are clear cases of pictures sent home to the mother country. Thus there is one example of those stilted studio photographs that we have already described as a genre. We

see husband and wife, the man sitting, the woman standing by his side, both looking as if they have just swallowed a broomstick. The caption, in quotation marks, reads: "In this letter I send you my portrait and that of my husband. I can also send you the children, but then it may be a little too heavy."

One explanation for the relative scarcity of visual images in the letters that Herbert Brinks used, or that I myself have mostly worked with, may have to do with religion. After all, these are letters from a staunchly Calvinist immigrant population that tends to conceive of itself as the people of the Word, averse to any form of visual representation. As descendants of the iconoclasts, as worshippers in whitewashed churches, devoid of imagery, the mechanical muse of photography may have been just another idol to them. Yet irrespective of religion, the relative scarcity of written references to enclosed pictures is too widespread for this explanation to hold.

To the extent that we find photographs mentioned at all in immigrant letters, what does this tell us about their communicative value and function? Let us consider a few examples. For the earliest period in the history of photography, I have one set of letters, exchanged between members of the Te Selle family from 1865 to 1911. The earliest mention of a photograph is in a letter from 1869, scribbled in the margin and added as almost an afterthought: "Here is a protrait [sic] of our little Dela. She is now eleven months old. She sits on a chair but it was difficult to keep her still for so long." Another note in the margin adds this: "I took the letter to the post office but then it was too heavy. I will send the protrait with G. Lammers." In a letter sent from Winterswijk in the Netherlands in 1873 to relatives who also lived in the Netherlands, there were originally two enclosures: a letter from an elderly uncle in America and his photograph. In the little accompanying note we read: "So I send you this letter, and also the portrait, so you can see him on it, and also read in this letter how he is doing. Also you can perhaps send it to your other sister who would also like to have it and see it."

This one collection of thirty-five letters, spanning a total of forty-seven years, is fairly representative of other such correspondences. The references to photographs are few, and of those most related to portraits. Apparently, the main informative function of photographic enclosures was to maintain a sense of visual proximity among family members in spite of geographic distance.

Clearly, in the early years both of photography and of large-scale Dutch migration, economic considerations affected the selective nature of photographic information as well. Having portraits made and sending them across the ocean was relatively costly. A letter from Michigan City, Indiana, dated June 5, 1894, is quite explicit on this point: "Had we not had such a bad time, we would have had our pictures taken this summer: but now this will have to wait a while." Yet, economic means permitting, the first priority in the exchange of pictures was family portraits rather than any other topic of visual information. Our same correspondent, in a later letter sent from Holland, Michigan, in 1900, is exultant: "Dear Brother and Sister, With joy and gratitude we received your letter with portrait. We were overjoyed for now we could behold your family from afar."

Further evidence that this was the favorite subject of photographic information comes from the later period, when price was no longer a limitation. When immigrants were better off, after years of hardship, and when photography itself had come within reach of the general public, family pictures were still by far the leading genre. Rather than economics it was now the technology of the early amateur cameras that set the constraints. Exposure time practically prevented indoor photography. But even outdoors the light was not always sufficient. "Last Sunday we have taken pictures of the children. We would take a few more the next Sunday but it was a dark day so we have to wait until the following Sunday. As soon as they are ready, we will send them to you. Monica is quite a girl already and Anna comes along nicely."

Photography had moved outside the confines of the studio and into the private realm of the family garden. If the focus was still on family members, explanatory notes now increasingly referred to details of the setting as well, such as "our house," "our front porch," "our garden patch." One caption reads: "This is our house, we built it." But still the eyes of the recipients of such pictures set most eagerly on the human presence. Tiny details of physical appearance were added in writing, or commented on in letters from the home front. Color of hair and eyes, signs of aging, and family resemblances were standard topics in the exchanges accompanying this photographic communication. Photographs were passed from hand to hand among family members at the receiving end.

In this later age of the amateur snapshot, there is a greater informality in the way people have themselves represented. People in their everyday clothes doing little chores around the house are a common theme: "Father feeding the chickens." Yet there are clear echoes of earlier strategies of self-representation. Often people still dress up for the occasion and stiffly pose for the photograph. The choreographies may be vaguely remembered and awkwardly executed, yet in the family groupings on the front porch, we recognize the prescriptions and styles of self-representation that reigned supreme in the era of the studio photograph.

Notes

1 Stieglitz's "The Steerage" has acquired its iconic status as a picture of immigrants in spite of the fact that the steerage passengers he photographed were most likely return migrants. Stieglitz was on his way to Europe when he took the photograph.

2 Louis Adamic, *Laughing in the Jungle* (New York: Harper and Row, 1932), as quoted in *A Nation of Nations: Ethnic Literature in America,* ed. Th.L. Gross (New York: The Free Press, 1971), 81.

3 P. Cresci, *Il pane dalle sette croste* (Lucca, 1986), 239.

4 James C. Schaap, "The Heritage of These Many Years," in *Sign of Promise and Other Stories* (Sioux Center, IA: Dordt College Press, 1979), 248 ff.

5 Willem Wilterdink, *Winterswijkse pioniers in Amerika* (Winterswijk: Vereniging "Het Museum," 1990), 32 ff.

6 The largest collection of letters to be published is W. Helbich, W.D. Kamphoefner, and U. Sommer, eds., *Briefe aus Amerika: Deutsche Auswanderer schreiben aus der neuen Welt, 1830–1930* (Munich: Verlag C.H. Beck, 1988).

7 See, e.g., my *The Persistence of Ethnicity: Dutch Calvinist Pioneers in Amsterdam, Montana* (Urbana-Champaign and Chicago: University of Illinois Press, 1992).

8 Herbert J. Brinks, *Schrijf spoedig terug: Brieven van immigranten in Amerika, 1847–1920* (The Hague: Uitgeverij Boekencentrum, 1978); also available in an English translation: *Write Back Soon: Letters from Immigrants in America* (Grand Rapids, MI: CRC Publications, 1986).

Buried Images

Photography in the Cult of Memory of the 1956 Revolution

Géza Boros

The fiftieth anniversary of the 1956 Hungarian uprising and revolution directed the attention of scholars and the public to many of its aspects related to photography. Photo albums were published; photos that were well-known, as well as some that were previously unknown, were exhibited;[1] the story of people in photographs whose identity had been unknown came to be revealed;[2] and archives discussed questions related to photos of 1956 in their collection at conferences.[3] The subject of my essay is a topic thus far unexamined: the use of photography in the martyr cult of the 1956 revolution in public spaces. During my research of this topic, where private and community memory meet, I studied sepulchral monuments with photographs and installations that included photographs, made for the fiftieth anniversary of the revolution, and exhibited in public spaces.

All sepulchral monuments address the present, they speak to those who are alive, but at the same time, they are also self-representations of the family, of the people who erect them. The aim of the study of sepulchers can be to reveal what and how they preserve and communicate to outsiders and posterity.[4]

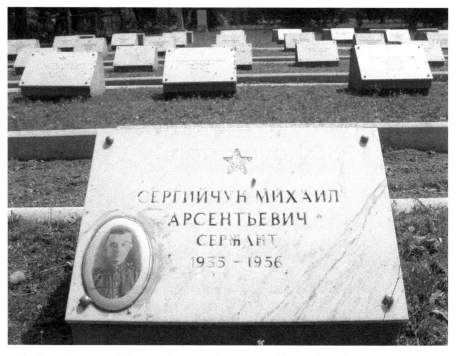

1. Tombs in the section of Kerepesi Cemetery where Soviet soldiers are buried, 2006

The first field where I studied sepulchers was the section of Budapest's Kerepesi Cemetery where Soviet soldiers are buried. This is the resting place of most of the Soviet troops who died in the siege of Budapest in 1945 or during the 1956 revolution. Looking around in the section, which has seen better days but is still not abandoned, one can see typical examples of the use of photography in cemeteries. Mounting photographs on the monuments of individual people or groups after the monuments are erected is part of the act of preserving family memories. The purpose of placing portraits on monuments is to distinguish one's relative from the many others who remain faceless and are doomed to be forgotten. (Fig. 1)

In photographs on sepulchral monuments, the deceased person usually appears in a posture that is significant to family memory. Most of the Soviet soldiers are in uniform, but in some photos they wear civilian clothes. Some of the photos are oval enamel pictures; others are on porcelain; and some of the more recent ones are etched. For the latter, the image of the deceased person is etched

90

on the monument or on a separate plaque. The disadvantage of this method is that it can be used only on dark stone; however, when it is used for people who died of unnatural causes, the somberness of the black color befits the tragedy. Most photographs on the monuments are black and white, but some of the enamels are color. (Fig. 2) Some pictures have the name of the deceased person written on them, while in many cases the portraits are anonymous, making it clear to outsiders that these photos represent individual memory.

The porcelain picture fell off one of the 1956 monuments, and as a sign of the living cult of family memory, it is replaced with two black-and-white paper photos glued onto the obelisk. (Fig. 3) The photo is made waterproof with a foil. There is no doubt about the potential of this gesture to attract attention, but the fact that the photo is duplicated suggests that the person who glued the pictures onto the obelisk was aware of the transitory nature and imperfection of this solution.

Military cemeteries have a strictly hierarchical order of iconography. However, civilian cults soften this rigid military discipline. It is interesting to see that while official political representation has been reduced to a minimum in the Soviet military section of Kerepesi Cemetery, the manifestations of family memory try to overcome time and geographical distance. For the Hungarian visitor the most obvious change is that the inscriptions are no longer relevant. In the Orwellian sense, they mean just the opposite of what they were originally intended to mean. In 1956 these soldiers did not die a hero's death "for the freedom of the people of Hungary," as the inscription on the monument says. In fact, the truth is just the opposite: they died in the fight *against* the people of Hungary. As a result of the change of their meaning, the inscriptions have now come to function as fragments of an unveiled lie in the public space. Their meaning is made even more complex by the fact that many of them are grotesque by definition. For example, one of the obelisks built in 1957 "was erected and is maintained by the workers of the Underwear Factory in honor of the memory of the Soviet soldiers who died a hero's death."

Due to the change of the historical-political context, the change of meaning is even more striking on the other side, in the case of the Hungarian martyrs of the revolution, who turned from revolutionaries to counter-revolutionaries, from concealed victims to heroes all at once with the country's transition to democracy.

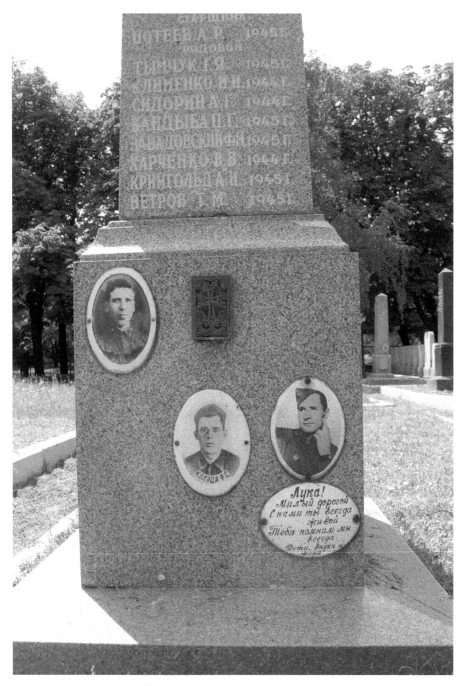

2. Monument in the section of Kerepesi Cemetery where Soviet soldiers are buried, 2006

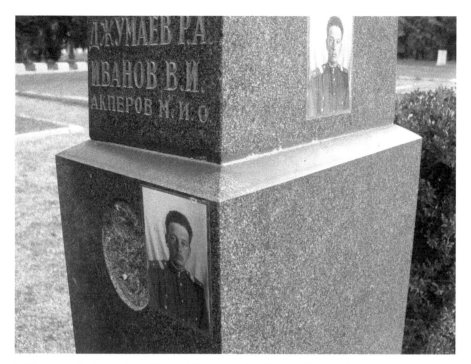

3. Monument in the section of Kerepesi Cemetery where Soviet soldiers are buried, with paper photo, 2006

By definition, soldiers who fall are considered "professional dead heroes," while civilians who die are "innocent victims." However, quite often, they are also heroes in the eyes of posterity and their families. Their sacrifice could not be in vain; their death cannot remain just a fatal accident. In their case we witness a kind of heroization, for which portrait photos are sometimes used.

Already in 1956, wooden grave posts with photos appeared on graves in the parks and squares of Budapest. The function of this form of representation and identification was not so much to pay respects but rather to demonstrate in a visual form the loss of civilian lives in public space. Most people whose resting place is known from among those who died in combat in Budapest between October 23 and November 10, 1956, are buried in Kerepesi Cemetery. Those who died on the streets, revolutionaries and those fighting to protect the ruling regime, and civilian victims who died in the combat areas rest in Plot 21 of the cemetery. However, communist victims were exhumed in 1958 and were rebur-

93

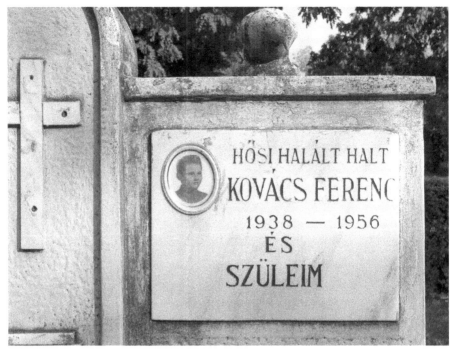

4. Tomb of Ferenc Kovács in Plot 21 of the Kerepesi Cemetery, 2006

ied in honorary graves at the entrance of the cemetery, adjacent to the Soviet plot.[5] In the early 1980s the authorities wanted to eliminate Plot 21, claiming that the moldering period was over, but eventually, as a result of international protest and the resistance of the victims' families, the graves were allowed to remain there for private visits. These conventional tombs were the only mementos of 1956 tolerated by the authorities in public space before Hungary's transition to democracy.

Here too, the portraits on the tombs can be interpreted together with the inscriptions. In most cases, we can deduce only from the date of death that these are graves of people who did not die a natural death. An interesting feature of the inscriptions is that their stylistic turns reach beyond the time-frame of the images. The use of first-person singular or first-person plural possessive constructions is worth closer attention. *Hősi halált halt Kovács Ferenc és Szüleim* (Ferenc Kovács, who died a hero's death, and my Parents, Fig. 4) or, on another

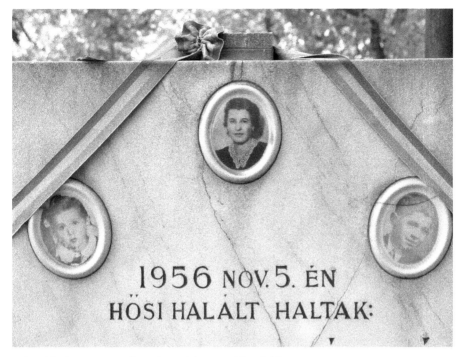

5. Sepulchral monument of Mrs. István Thoma and her children
in Plot 21 of the Kerepesi Cemetery, 2006

grave: *Szeretettel állíttatta Nagymamám* (Erected with love by my grandmother). It is as if, through the text, the deceased person is communicating with the living: the inscriptions suggest that they are with us in another dimension of existence.

A 1956 memorial plaque in Szombathely is a good example of how strong an inscription can be by itself. The plaque in Szombathely says only this: "We were executed." And the names of the victims appear below that short sentence.

The sepulchral monument of István Harmincz, made of artificial stone, with a photograph on it, stands in the resting place of those executed in 1956, in Plot 301 of Rákoskeresztúri Cemetery. Its inscription is also very short: *Találkozunk.* (We will meet again.) That laconic phrase is the same one that usually appears on tableaus of photos of graduating high-schoolers in store windows in the cities, and then on the walls of high-school corridors. Its strength is in its

95

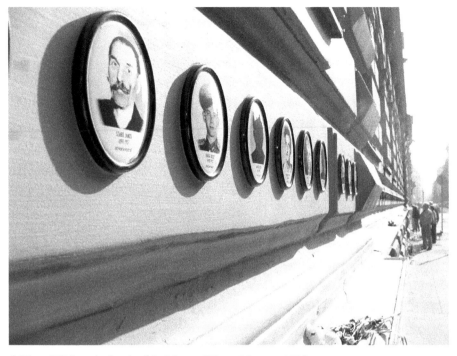

6. Heroes' Wall on the façade of the House of Terror Museum, 2006

ambiguity: obviously, it means something else for someone who fought on the other side, who defended the communist regime and survived the revolution, than, for example, for the widow who erected the monument.

Besides professional soldiers and innocent civilians, the other most important group of martyrs are the victims of retaliation, those executed in the Kádár era. Their sepulchral monuments with photographs appeared only after 1989. Until then, they did not even have graves in the everyday sense of the word. The most important myth-making element of the cult of the martyrs of 1956 is rooted in this absence, the fact that the rulers of the country kept the resting place of those executed in secret; it was a taboo subject. This is also referred to in the cemetery monument entitled *Nyitott sír* (Open Grave), erected by György Jovánovics, featuring a 1,956-millimeter-high black granite pillar.

The purpose of using photographs in a cemetery is to provide a face for the body. In the case of symbolic graves of people whose real resting place is

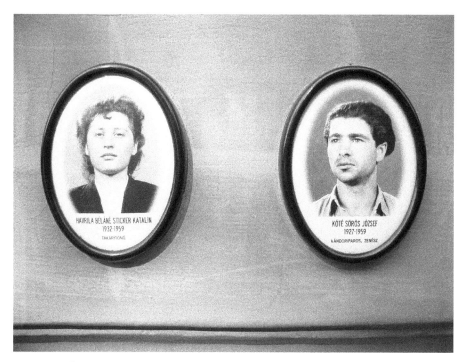

7. Portraits of Mrs Béla Havrila, née Katalin Sticker cleaning woman
and József Kóté Sörös craftsman on the Heroes' Wall, House of Terror Museum, 2006

unknown, the photo is supposed to substitute for the body. In these cases, the photograph not only reveals but also hides the truth. For example, the family of Dezső Kálmán placed his portrait on the sepulchral monument in the cemetery of Szava village in Baranya County. Kálmán was executed and buried at an unknown place after the revolution; his portrait appeared on the monument in the 1970s with the inscription *Itt nyugszik* (Here lies)—which does not refer to his actual resting place but has a symbolic meaning.

During the decades of repression, the acts of preserving the memories of 1956 were confined to families. From research on the lives of the children of people who were imprisoned or executed after the revolution, we know that there were cases when the family did not reveal to the children the reason for the father's absence.[6] Meanwhile, in many families, family photographs were the most important and carefully preserved requisites of honoring memories during the decades of suppression and denunciation.

97

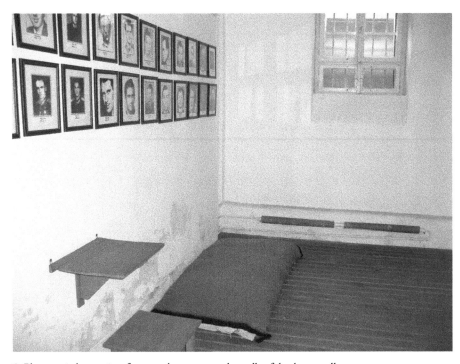

8. Photocopied portraits of executed martyrs on the walls of death row cells
at the Kisfogház-emlékhely, House of Terror Museum, 2006

We also know of cases when relatives even tried to get rid of family pho-
tos. In 1989, when not only the names but also the portraits of martyrs were
published for the first time, in a volume entitled *Halottaink* (Our Dead), in
many cases the place of the photo was left blank. Imre Mécs, the editor of the
volume, writes this at the end of the biography of József Nagy, who was execut-
ed: "His mother, Mrs. István Nagy, watched their funeral from a hiding place,
bribed the grave diggers, mounded the graves of all four of them, and took care
of the graves until she became physically disabled in 1985. She died at the age
of 89, in January 1988. Her relatives, who inherited her flat, threw away all
her documents, all the photos of József Nagy, and all the relics she had of him.
They considered these things to be mere junk. This is why we have no portrait
of József Nagy in this volume. Instead, his mother's photo appears here."[7]

Thomas W. Laqueur speaks of the hyper-nominalism of monuments, in
which those erecting the monument want the names of each victim to appear

98

on it.[8] In a kindred attempt, some museums strive to archive and make accessible to the public the portrait of every victim. Obviously, it is impossible in the case of world wars or the Holocaust, and it is also very difficult even in the case of events that had far fewer victims, such as the martyrs of the 1956 Hungarian Revolution. Two attempts were made in Budapest during the fiftieth anniversary of the revolution. One was the Hősök fala (Heroes' Wall) on the façade of the House of Terror Museum (Fig. 6),[9] while the other was the temporary photo installation near Heroes' Square.

In his essay on the relationship of photographs and death, Jean A. Keim writes that only the photo of a dying person is more disturbing than a dead person. However, Keim notes, the portraits of people sentenced to death are even more shocking. "We knew that he would die, and this knowledge made what we saw even more disturbing."[10] Looking at the portraits of people executed in and after 1956, the shocking awareness of the fact that all these people were hanged is constantly there in us. This is so despite the fact that most of the 228 portraits on the Heroes' Wall on the façade of the House of Terror Museum are very peaceful—they were taken before 1956—and even most of those who look at us from pictures taken after they were arrested could hardly be aware of what would happen to them. Nevertheless, the eyes speak to us. We imagine that the elevating drama of martyrdom is somehow there in their look, and this posterior cathartic awareness—the gaze beyond time—ennobles even the roughest face in retrospect.

The real strength of these images comes from the distance between the time of the picture and real time. This distance can be measured not only physically: the path from a being a culprit to being a victim and then a hero, the path of justification, is also a metaphysical distance. In the case of these photos too, we can see how greatly the meaning of an image is determined by its context. Yesterday the very same portraits could figure in a *White Book* as the photos of "wicked counter-revolutionaries," and today we honor these people as heroes. This use of the photos seems to justify the tenet of art historian György Sümeghy about the use of photographs from 1956 for political purposes. Sümeghy observed that in the history of photography in Hungary, no other photos have been used "for such contrasting purposes."[11]

The Heroes' Wall, designed by Attila F. Kovács, the architect of the House of Terror, is made up of a series of small porcelain pictures. The material of the

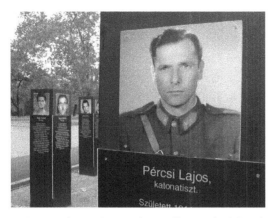

9. Portrait of Lajos Pércsi military officer in the Liberty's Heroes' Square, 2006

10. Projected photo of Ilonka Tóth at the inauguration of the 1956 memorial, 23 October, 2006

pictures as well as their shape clearly evoke associations of the cemetery. Moreover, the delicate graphic lines around the heads of the people in the portraits (glorification) even refer to pictures of saints. (Fig. 7)[12] This is in full accordance with one of the often-used slogans of the cult of the memory of 1956: *Gloria Victis*—Glory to the Defeated! The name of the memorial wall also calls forth associations of a sacral cult: heroes' walls are usually erected in churches.

Many of the portraits on the Heroes' Wall are there out of necessity. In the absence of high-quality photos, the compilers of the portrait gallery had to use whatever they found (portraits from IDs, monthly bus passes, tableaus from high-school graduation, etc.). The fact that such photos are used also demonstrates formally that these pictures represent extraordinary life stories. There are situations where the use of photos of a low aesthetic quality is adequate. A good example of this is the Kisfogház-emlékhely (Small Penitentiary Memorial Place) inside the prison in Budapest's Kozma Street, where portraits of the executed martyrs, enlarged on a photocopier, blurred and framed, hang on the walls of death row cells. (Fig. 8)

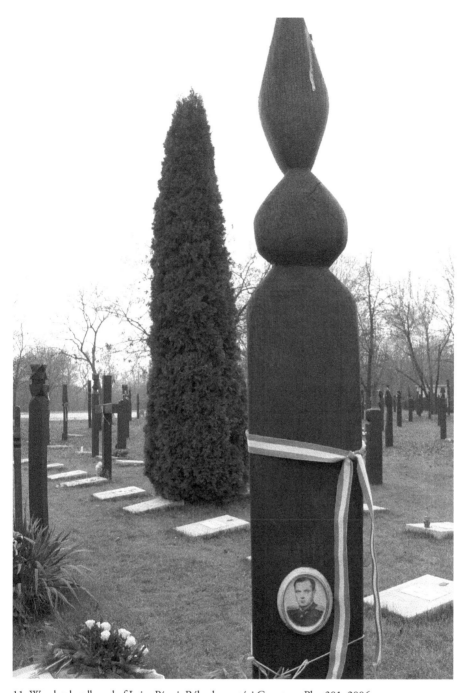

11. Wooden headboard of Lajos Pércsi, Rákoskeresztúri Cemetery, Plot 301, 2006

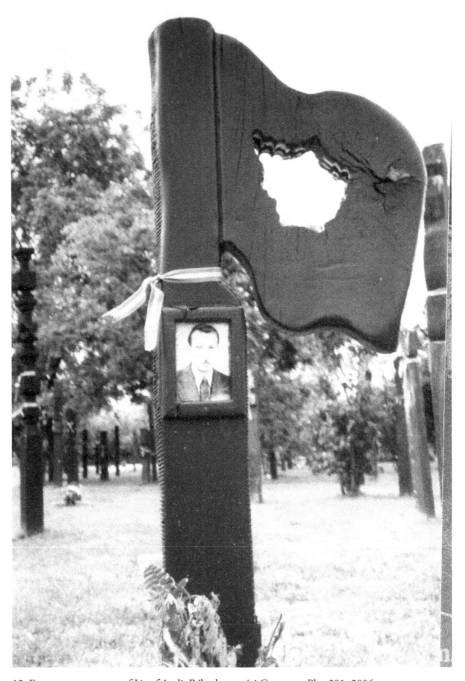

12. Funerary monument of József Andi, Rákoskeresztúri Cemetery, Plot 301, 2006

Surprisingly, for many executed revolutionaries no photos were found during the sixteen years between the start of the transition to democracy and the fiftieth anniversary of the revolution. To compensate for the absence of photos, only a black silhouette appears above the name of 23 victims out of the 228, and a similar (but not identical) solution was used in the photo installation at the Heroes' Square. These martyrs are present only virtually, as if their bodies were still lying in unmarked graves. It is as though they were victims of even more merciless retaliation: not only their life but even their memory was destroyed. The absence of the photo, the lack of the face, convinces the spectator that the fate of these people was especially tragic. At the same time, this type of visual representation contributes to the fact that the trauma of 1956 is still to be overcome; it sustains the forms of traumatic memory.

Only the dates of birth and death and the job of the martyr appear in the captions under the portraits. Exceptions were made for only three victims, where attributes also figure in the caption: relativizing their martyrdom, the curators of the House of Terror found it important to indicate that Imre Nagy, Miklós Gimes, and Géza Losonczy were communists, that is, comrades of those whose victims they became. Another problem is that it is not Losonczy who appears in the portrait above the caption that has his name! Like the man in the portrait, he also wore glasses; however, it is not his portrait, but that of Szilárd Ujhelyi (who married Losonczy's widow and died in 1996).[13]

A similar exhibition, titled *A Szabadság Hőseinek tere* (Liberty's Heroes' Square), was displayed in October and November as part of the government memorial event series near the newly inaugurated monument. Here the curators used photos that were square-shaped and larger, inviting visitors to walk inside the installation. (Fig. 9)

The photos of martyrs were also used in the communication of the new monument. Its critics claim that the new monument, erected on the site of the destroyed Stalin statue and intended to represent the dynamism of the revolutionary multitude, is too rigid and abstract, that it cannot be understood by the man in the street and has nothing to do with 1956. Moreover, the new monument is one of the rare mementos of 1956 where the churches did not take part in the inauguration (it is not consecrated); therefore, this act had to be replaced by a secular ritual. In my view, the projection of the martyrs' portraits

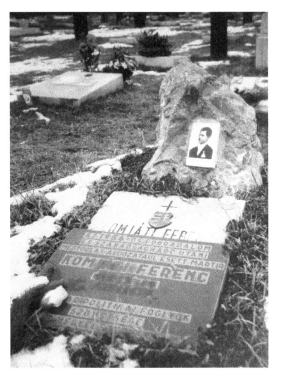

13. Grave of Ferenc Komjáti, Rákoskeresztúri Cemetery, Plot 301, 2006

onto the monument during the inauguration ceremony, televised live, was intended to substitute for this sacralizing function (Fig. 10).[14] Nor is the exhibition at the House of Terror merely an open-air show. Placing the portraits of the martyrs on the museum's façade is intended to assert the function of the institution as a "political sacral place." And it is part of the role of the consciously composed view to support the main purpose of the museum, namely, to become the central locus for making people remember the crimes of communism constantly, to become an everyday memento of a new, worldly manner of facing and living with the memories of 1956.[15]

Special cases of family cults can be observed in Plot 301 of Rákoskeresztúri Cemetery, the resting place of those who were executed. József Andi's son erected a carved wooden grave-post in the shape of a flag with a hole in it[16] on Andi's grave around 1990, and put a framed portrait on it, enlarged from an ID photo. (Fig. 12) Unfortunately, this unique sepulchral monument is no longer there; the family removed it because it deteriorated very quickly. Currently there is a simple wooden cross on the grave.

Using the civilian portrait, Andi's family wanted to present the executed martyr to the world as a private person. At the same time, on the Heroes' Wall, Andi appears in military uniform, while for another executed military officer, Lajos Pércsi, the visual representation by the family is in full accordance with the form of representation by the community: the same photo appears every-

104

where. A special feature of the cemetery display is that the porcelain image appears on the wooden headboard standing closest to the grave of the portrayed person, and as a result, one of the 301 common wooden headboards has been transformed into a personal, individual grave marker. (Fig. 11)

The grave of Ferenc Komjáti, executed in 1957, forms a special composition, where requisites of the official, political, and family cult of remembering are piled on top of one another.[17] (Fig. 13) The basis is the uniform stone grave slab used on every grave in Plot 301, bearing

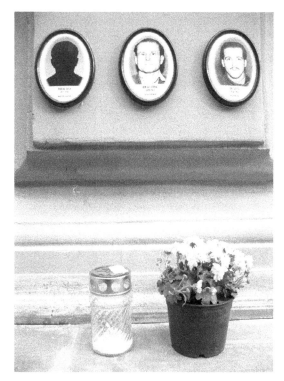

14. Portrait of Ferenc Komjáti on the Heroes' Wall (in the middle), 2006

only the name, the date, and the Kossuth coat of arms. This stone cover also has a cross engraved on it. A black memorial plaque was placed on it by the National Association of Political Prisoners (POFOSZ), which was probably originally designed to be displayed on the wall, and so looks somewhat strange on the ground. A small rustic stone is installed in place of the headstone, with a porcelain photo placed on it by the family. The portrait was probably made at Komjáti's wedding. The portrait displayed on the Heroes' Wall was made later; in that photograph he is in worse shape. (Fig.14)

It is a common feature of sepulchral monuments with photographs that in the pictures, the deceased is at a much younger age than he was when he died. This may have practical reasons; for example, the family might have only photos from a younger age of the deceased. But more likely, a portrait taken at a younger age better fits the image that the relatives consider as

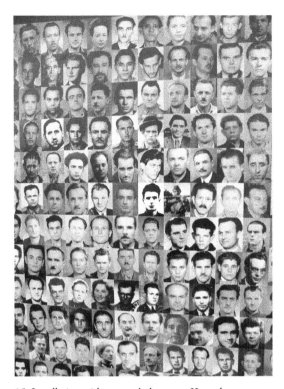

15. Installation with martyrs' photos on Kossuth square, 16 July, 2007

the ideal to present, the one that is most suitable for idealization.

Of all people who die in tragic circumstances, it is young people whose death is the most shocking for the family and the bigger community. In the cult of the 1956 martyrs too, children have a distinguished role. The younger the victim, the greater the moral weight of the sacrifice.

Just 16 in 1956, Katalin Magyar was a voluntary nurse during the revolution. She was killed by machine-gun fire from a Soviet tank. In 1990 her former classmates placed a memorial plaque at the Budapest High School for Art and Design to honor her memory. In addition to the inscription, the plaque bears a portrait enlarged from the photo on her monthly public-transport pass. A paper print is usually used in absence of a better solution, and it is generally replaced with a more durable and valuable (more elegant) version later. That is also what happened here: in 2004, the portrait glued on cardboard paper was replaced with a blue ceramic photo, made by Ildikó Polgár, who often uses family photographs and documentary photos from 1956 in her ceramic pictures. She developed a special technology, photo-porcelain, which can preserve an image for thousands of years, as opposed to short-lived porcelain photos generally used on sepulchral monuments.[18] Another copy of Katalin Magyar's portrait is displayed in her primary school in Mosonmagyaróvár.

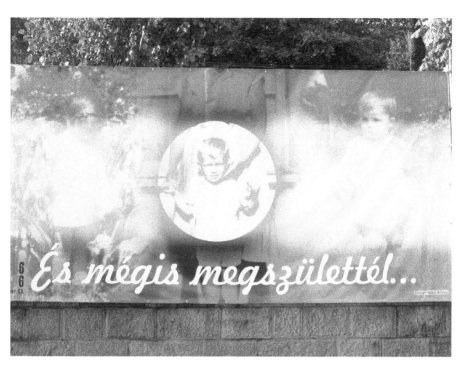

16. Kincső Noémi Sólyom: And you were born after all… Billboard, 2006

To honor the memory of László Tihanyi, a teacher who became a martyr in 1956, a ceramic portrait was added to his memorial plaque in 2002 in the school where he taught in Győr, at the initiative of one of his former students. In 2004, a similar, photo-based, mosaic-type color ceramic portrait was added to the plaque of another martyr of Győr, stage director Gábor Földes, on the wall of the city's old theater. These additions made more personal and intimate the memorial plaque, this simple and impersonal medium of cultivating memory, which only had a bare inscription before. (Made by József Sándor Nagy)

The best known of all the young victims of 1956 is Péter Mansfeld, whose martyrdom is made even more shocking by the extreme brutality and obvious retaliatory nature of his execution. He could not be sentenced to death, as he was only 15 at the time of the revolution. Therefore, the authorities waited until Mansfeld turned 18, then changed the original sentence to death and executed him.[19] His relatives often put ribbons with the national colors and photographs

107

on his cross in Plot 301.[20] The portrait of Mansfeld that is published most often is based on an ID photo. His mother keeps an enlarged and framed version of this picture. This portrait appears on the Heroes' Wall, on the cover of the book about his life,[21] and on the poster of the movie titled *Mansfeld*, made for the fiftieth anniversary of the revolution. The volume entitled *Halottaink* (Our Dead) includes an invitation to a funeral, from which we can find out that in August 1988, the family symbolically buried the martyr child, whose original burial place was still unknown then. His family placed his photo in an unmarked urn for the burial.[22]

One notable sepulchral monument is in Plot 21 of Kerepesi Cemetery. It also bears a photo of the people buried there: Mrs. István Thoma and her children—Pityuka, who was 12, and Marika, who was 7, when they died heroes' deaths. A permanent ornament of the grave, a ribbon with the national colors around the headstone, demonstrates that this is not simply an ordinary family grave. (Fig. 5)

My last example is a billboard designed for the billboard contest—held to commemorate the fiftieth anniversary of the revolution—whose theme was the flag with a hole in it.[23] (Fig. 16) One of the young contestants, Kincső Noémi Sólyom, used an unknown family photo for her interpretation of the flag with the hole. A little boy (who must be about fifty years old today) looks at us from the center of the photo. The poster says: *És mégis megszülettél...* (And you were born after all...). A possible political-symbolic interpretation of the work is that despite the fact that the revolution was quelled, and decades of oppression followed, an independent and free Hungary has been born and has inherited the legacy of 1956. This poster also has another meaning: it refers to the importance of the family in securing the future of the nation. The family is a bond among people that helps them survive historic traumas.

English translation by Zsolt Kozma

Notes

1 A few of the most important publications: Rolf Müller and György Sümegi, *Fényképek 1956* [Photos, 1956] (Budapest: Történeti Hivatal, Állambiztonsági Szolgálatok Történeti Levéltára [Historical Archives of the Hungarian State Security], 2006); László Á. Varga, ed., *'56 izzó ősze volt… Pillanatképek a forradalom napjairól* [It was the glowing autumn of 1956… Snapshots of the days of the revolution] (Budapest: Budapest Főváros Levéltára [Budapest City Archives], 2006); Tamás Féner, ed., *Kor-képek 1956* [Photos of the times] Budapest, Magyar Távirati Iroda [Hungarian News Agency]; *Budapest—1956—A forradalom. Erich Lessing fotográfiái* [Budapest—1956—The revolution. Photographs by Erich Lessing] (Budapest: 1956-os Intézet, 2006); László Eörsi, *1956 mártírjai—Budapest a forradalom napjaiban* [The martyrs of 1956—Budapest in the days of the revolution] (Budapest: Rubicon-Ház Bt., 2006); Jean-Pierre Pedrazzini, *Budapest 1956* (Geneva: Association Jean-Pierre Pedrazzini, 2006); Violette Cornelius and Ata Kando, *Hungarian Refugees 1956* (Rotterdam: Veenman Publishers). Exhibition catalogs: Károly Chochol, *1956—56 kép—2006.* [1956—56 photos—2006] Privately printed, 2006); Róbert Jajesnica, *A meggyalázott város* [Dishonored city] (Budapest: Napkút Kiadó, 2006); *1956—Magyar forradalom* [1956—Hungarian revolution] (Kecskemét: Magyar Fotográfiai Múzeum [Hungarian Museum of Photography], 2006); *Budapest szétlövetése. Pauer Gyula '56-os sztéléi* [Budapest shot to ruins. Steles of 1956 by Gyula Pauer] (Budapest: Magyar Nemzeti Galéria [Hungarian National Gallery], 2006).

2 The story of the people in the emblematic photo published in the November 10, 1956, issue of *Paris Match*: Eszter Balázs and Phil Casoar, *Les Héros de Budapest* (Paris: Les Arenes, 2006). A documentary film was made about the research for the book: *A forradalom arca. Egy pesti lány nyomában* [The face of the revolution. On the trail of a girl from Budapest] (directed by Attila Kékesi).

3 Materials from the conference organized by the Miskolci Galéria (Miskolc Gallery), entitled *56-os fotók magán- és közgyűjteményekben* [Photos from 1956 in private and public collections], were published in 2007 on CD-ROM and in a printed volume.

4 About the use of photography in cemeteries, see Vilmos Tóth, "Fényképek és temetkezés" [Photos and burials], in *Körülírt képek. Fényképezés és kultúrakutatás* [Photos circumscribed. Photography and cultural research] András Bán, ed. (Miskolc and Budapest: Miskolci Galéria–Magyar Művelődési Intézet [Miskolc Gallery—Hungarian Institute for Culture and Art], 1999), 95–102; Ilona L. Juhász, "Fényképek a dél-szlovákiai temetők síremlékein és az út menti haláljeleken" [Photographs on burial monuments in cemeteries and on roadside memorial signs in Southern Slovakia], in *Acta Ethnologica Danubiana* 5–6 (2003–2004): 107–132.

5 A sarcophagus (designed by József Schall, 1959) stands in the center of the memorial place of the "victims who fell in the battles against the counter-revolution." It was not removed after the political transition, only hidden behind a screen of thujas. However, on the fiftieth anniversary of the revolution, the Nemzeti Kegyeleti Bizottság [National Memorial Site and Funerary Committee] decided it would no longer be so generous. The monument was mutilated: the words and the red star were removed.

6 Zsuzsanna Kőrösi and Adrienne Molnár, *Carrying a Secret in My Heart. Children of the Victims of the Reprisals after the Hungarian Revolution in 1956. An Oral History* (Budapest–New York: Central European Univesity Press, 2003).

7 János Balassa et al., eds., *Halottaink 1956* [Our dead, 1956], vol. 1 (Budapest: Katalizátor Iroda, 1989), 184.

8 Thomas W. Laqueur, "Memory and Naming in the Great War" [Hungarian translation], *Café Bábel* 4, no. 3 (1994): 101.

9 The database of the Wall of the Heroes can be found at www.forradalom1956.hu.

10 Jean A. Keim, "Photography and Death," in *Fotóelméleti szöveggyűjtemény* [Theory of photography reader], eds. András Bán and László Beke (Budapest: Enciklopédia Kiadó, 1997), 155.

11 György Sümegi, "Fotók a Történeti Levéltárban" [Photos in the Historical Archives of the Hungarian State Security], in *Trezor 3. Az átmenet évkönyve* [Vault No. 3. The yearbook of transition] Az Állambiztonsági Szolgálatok Történeti Levéltára évkönyve 2003 [The 2003 yearbook of the Historical Archives of the Hungarian State Security], ed. György Gyarmati (Budapest: 2004), 312. See also György Sümegi, "Az 1956-os fotók használatáról" [On the use of photos from 1956], *Fotóművészet* 59: 1–2 (2003): 137–141.

12 This is also the solution Attila F. Kovács uses in the permanent exhibition of the Hódmező-vásárhelyi emlékpont [Hódmezővásárhely Point of Remembrance], a partner institution of the Terror Háza [House of Terror]. The portraits of the local victims appear on large oval badges, which is a formal reference to the enameled signs of institutions of state power in the 1950s, bearing the Hungarian coat of arms.

13 I called attention to this mistake in an article, and, as a result, the museum replaced the photo with the right one in February 2007 on the Wall of Heroes, but the wrong photo remained on the website. See "228 pairs of eyes," *Élet és Irodalom* [Life and Literature] 46: 50 (2006): 30.

14 Even this was not enough to protect the dignity of the inauguration of the memorial from extreme rightist demonstrators disturbing the event. Then, in December, the monument was desecrated: a swastika and a Star of David were painted on it. About the radical rejection of the monument by the right, see my article: Géza Boros, "Ki fogjuk tépni mind egy szálig! A készülő

56-os emlékmű negatív visszhangja" [We will tear all of them out! The negative reception of the 1956 memorial monument under construction], *Mozgó Világ* 34: 3 (2006): 30–34.

15 Zsófia Frazon and Zsolt K. Horváth, "A megsértett Magyarország. A Terror Háza mint tárgybemutatás, emlékmű és politikai rítus" [Hungary offended. The House of Terror as a location for presenting objects, a memorial venue and a political ritual], *Regio* 12: 4 (2002): 39. This institution is an emblematic locus for manifestations of rightist politics: for example, the opposition demonstration started from here on October 23, 2006.

16 In 1956 some demonstrators cut the Stalinist coat of arms out of the Hungarian flag, making the flag with a hole in it a symbol of the revolution.

17 Komjáti was sentenced to death on charges of participating in the lynching after the fusillade in Miskolc. From our point of view, his role is especially interesting, because he took photos during the mob rule, and when the authorities found the photos later on, they were used for identifying people and as evidence against them. His family considers him innocent. About the hard life of Komjáti, see the interview with his brother, János Komjáti, by Adrienne Molnár in 1990. 1956 Institute, Oral History Archive, No. 271.

18 About her works see Ildikó Polgár, *Porcelánvallomások* [Confessions in porcelain] (Budapest: Hegyvidéki Helytörténeti Gyűjtemény és Kortárs Galéria [Hegyvidék Collection of Local History and Contemporary Art Gallery], 2002. An interpretation of the very same portrait in sculpture appears on a 1956 memorial monument inaugurated in Süttő in 2006, sculpted by Károly Ócsai.

19 Despite being falsified by historians, this legend survives in public memory. In fact, a contemporary law allowed the execution of people from the age of 16. See László Eörsi, "Péter Mansfeld and His Cult," *Népszabadság* (October 22, 2002), 8.

20 A photo of an ornamented cross is published, for example, in Ákos Kovács, ed., *Haláljelek* [Memorial signs] (Budapest: Liget Könyvek, 1990); *"Egészség" Alkoholmentes Rehabilitációs Egyesület* ["Health" Association for Alcohol-free Rehabilitation] (Budapest: Liget Könyvek, 1990).

21 Csaba Kósa, *Alhattál-e, kisfiam?* (Budapest: Kósa és Társai Bt., 1996).

22 Balassa et al., eds., *Halottaink 1956*, 169.

23 The Prime Minister's Office held a competition in which artistic high-school students and university students were invited to submit creative interpretations of the flag with the hole in it. To mark a national holiday, each winning work, representing the national colors, was placed on a billboard. The billboards, numbering several hundred, were displayed end-to-end in a two-kilometer-long "Freedom Banner," on the lower Buda embankment facing Parliament, stretching from the Szabadság (Freedom) Bridge to the Chain Bridge.

A Farewell
to Private Photography

András Bán

I began researching private photography in 1982. Let me list a few features of the intellectual and spiritual climate in Hungary during the late Kádár era that shaped this research. The concepts of forced modernization—that is, the centrally dictated pace of modernization for the underdeveloped economy— were becoming deflated by the 1980s: the fellow-feeling of West European communist parties had faded away, local strategies of consumption as a form of opposition were emerging. In the economy of shortage, consumption was ideologically connected to capitalism, that is, to the enemy, thus the desire or even modest practice of consumption was interpreted as a form of political resistance to the socialist regime. Art no longer authenticated the power of the state sufficiently, as a result of the Helsinki process. While in the 1960s some elements of communist idealism could be clearly felt behind the state's efforts in arts and education, by the 1970s, a shadow of suspicion came to linger on all autonomous initiatives and endeavors, be they amateur theater, university

The pictures illustrating the present essay are photos taken between 1930 and 1970, collected in the course of conducting different family interviews and preserved in the Archive of Private Photos and Films.

gallery, or folk dance house. In this spiritual and intellectual climate, sophisticated techniques of "reading between the lines" and the networks of alternative initiatives appeared. The Central European practices of making contacts in the field of arts froze due to the political events in Czechoslovakia and Poland. But due primarily to the activity of the Soros Foundation, as well as to new international connections initiated by art institutions, orientation towards the West became more intensive.[1]

I was motivated by two factors at the start of my research. One was that I followed the changes of the late modernist changes of art in that period with a kind of skepticism; and the other was that during a long journey to America, I had discovered the discipline of visual anthropology. This mixture of skepticism and revelation flared up in the form of the highly intense research that took place in the Művelődéskutató Intézet (Research Institute of Culture). During the research process, nearly 100,000 photographs and about 100 life interviews were archived; dialogue began with experts of related sciences who were very important for us; publications appeared; and intense international correspondence began. In the beginning, my research partner, filmmaker and visual artist Péter Forgács, was more interested in the visual characteristics of the private image, while my aim was to explore the modes of using images.[2]

The Horus Archives and its founder, Sándor Kardos, followed by film directors András Jeles and Gábor Bódy, certainly played a significant part in that. So too did the change of the conceptualist approach to art, as well as the emergence of the new world of photography in the 1980s—primarily in the photos of Lenke Szilágyi.[3] But in addition to all these, our research had a part (a part that we did not yet understand then but practiced anyway) that was closely related to the forced modernization described above, that took place during the Kádár era. Being the heir of the Stalinist regime, the governing regime had feelings of guilt. The past meant danger, because it was uncontrollable. The family legendry, the telling of personal stories, was also surrounded by suspicion. The discursive space of public history could be changed somewhat by narratives of the "workers' movement," but private history resisted such changes. By collecting family stories of nameless people and archiving their personal photos, we unknowingly attempted alternative historiography and social research. At the same time, in our research we strove to define new frames of thinking rather than attempting meticulous classification and archiving. Later, when the archive was lost without a trace, this methodological mistake turned out to be a benefit.

Our research of private photography became less intense in the second half of the 1980s, as Forgács's attention focused on making the *Privát Magyarország* (Private Hungary) film series,[4] while I made considerable efforts

to publish the photos we had collected—unfortunately with little result. In 1989 I exhibited the collection at the Tölgyfa Gallery in Budapest.[5] This exhibition seemed to mark the beginning of a new and methodologically better grounded phase in our research. However, it was just then that, with the collapse of the Education Research Institute headed by Iván Vitányi, the entire archive got lost.

Despite the loss of 100,000 photographs and several linear meters of written documents, the benefits and legacy of the research are significant. One of the benefits was that it opened new horizons regarding the concept of the image as such for many colleagues we cooperated with, including László Beke, Lajos Boglár, Elemér Hankiss, Özséb Horányi, Ernő Kunt, Géza Perneczky, Lajos Pressing, György Szegő, Rudolf Ungváry, and Anna Wessely. Another benefit was that, even though most of the publications we had planned remained unpublished, the five collections that came out[6] can still serve as resources for social theory, as well as for art theory. The works that were prepared but never published were a reader edited by László Beke titled *Privát fotó kutatás Európában* (The Research of Private Photography in Europe); a major collection of essays and studies compiled partly of manuscripts that I had edited by the authors mentioned above; a sizeable selection of resources; translations; and a very important volume of essays by Richard Chalfen, which got to the stage of printer's proof at the Múzsák Publishing House.[7] Ultimately, it is also certainly a benefit that just when the concepts of the teaching of cultural anthropology were being shaped at the universities of Budapest and Miskolc, the methodological arsenal evidently came to include the use of the camera, and the analysis of film and photography.

In retrospect, it is clear that our research was motivated by the political and social-historical context, and was also swept away by the major change of that context around 1989 and 1990. The transformation of Central Europe, the search for its own history on many levels, in many forms and with much controversy, was only one element of this change. In fact, this type of publication and research became scarce in other countries of Europe and in America as well. A long list can be compiled of the *Formato famiglia—una ricerca sull'imagine* type of publications in many languages, and also of small monographs presenting small-town photo studios as well as of personal accounts using photographs

as a surface of projection, like Catherine Hanf Noren's magnificent volume entitled *The Camera of My Family*. Nevertheless, only a few of these social history projects became resources of data for research (*Turning Leaves* by Richard Chalfen, analyzing the story of two Japanese-American families, is one of the rare examples).[8] The research of private photography does not seem to have found its place and justification in the attention of the ever-changing disciplines engaged in the study of the image, primarily in that of "visual culture."[9] Meanwhile, the use of the Internet, building databases, and digital photography became widespread in the past decade—and this is no coincidence.

By the end of the 1980s, I reached the same point as Michael Lesy, the famous vagabond of Atlanta, who wrote: "I've looked at hundreds of thousands of snapshots and listened to a lot of stories over the past ten years. I can read a picture the way some people can read the palm of a hand."[10] I never saw any of the photos that Lesy stole by the kilo from Technicolor Photo. However, I find it noteworthy that all the photos he saw led him to the same conclusion as the ones that I had seen, collected, or taken away from the photo company Főfotó Vállalat (the state owned photography company) led me to. Wherever I opened a publication that contained family photos, I always found additional evidence that there was a kind of global "Kodak culture."[11] The Polaroid people—who regard photography as an integral part of their family life, family memory, and legend—record their family relations and emotional ties in quite a uniform manner; they take photos of events that are significant to them (or have such photos taken) according to quite similar scenarios. This is why many of our colleagues have used the methods of folklore research to study photographs.

Lesy continues his argument: "By itself, an ordinary snapshot is no less banal than the *petite madeleine* described in Proust's *Remembrance of Things Past*. By itself, it is as bland and common as a tea biscuit; but as a goad to memory, it is often the first integer in a sequence of recollections that has the power to deny time for the sake of love. In Proust's novel, the discovery of the magical properties of the *madeleine* was fortuitous, but such denials and affirmations through the use of things seen or eaten, built or burnt, buried or unearthed, also characterize religious rituals of renewal and recapitulation. Snapshots may not have the numinous power of Communion wafers, Sabbath candles, nor Eleusinian sheaves—but they are often used as relics in private ceremonies to

reveal to children the mysteries of the incomprehensible world that existed be-
fore love and fate conjoined to breathe them into life."[12]

We have witnessed fundamental changes since those days. A longing for
the lost naivety and directness prevailed in the 1970s and 1980s, and figures,
who represented naive art, outsider art and self-taught art such as Utrillo, Rous-
seau, the customs officer, Lartigue, Atget, or Cheval the postman were held in
high esteem. However, in our times, permeated with the media, "vernacular doc-
uments," whether close or distant, cannot find their place. Saying farewell to the
innocent eye, we witness in an elegiac mood that the type of the image described
above becomes ennobled and more and more distant from us. We feel less and
less the disgust that the snapshot—the photos of the *other*—once evoked. It was
probably Medusa who was most responsible for this disgust—Medusa, that is,
the petrification that comes with the fulfillment of "destiny" and with growing
up. The snapshot could not create a distance, it could not speak in images about
petrification, it did not know dreams. We might as well say that, by its intention,
the snapshot was incapable of making an image. Nor was it capable of accuracy
because it had no draft, and it used the "visual language" indolently. At the same

time, it was unintentionally dense and complex, and, by its existence, it served as a counterpoint to public history. And this is what made it, again and again, a hinterland of fine art, which had been deprived of all of its other hinterlands.

The rhetoric of the snapshot belongs to a period that is already fading away. Earlier, when the limits of symbolism in images were set by norms, or at least by strong patterns, meanings that could be handled in collective memory emerged. With the mediatization of the everyday—in which private photography had a significant role—networks of the individual, local, spectacular, and virtual meanings emerged in which the researcher attempting systematization will unavoidably become tangled up. New images—the terms "private photo" or "snapshot" are no longer adequate—the Megapixel cameras, the images from Web cameras and mobile phones have crossed a whole range of the limits of objectivity, locality, finite cardinality, and ritualized use. Due to the immediate feedback inherent in the use of these devices, the miraculous accidents that the Horus Archives could count on were no longer there. Increasingly, new images are produced because the possibility is there, and not because they are needed. The new images have redrawn the limits of the personal, and contemporary art is still only in the process of assessing the consequences. As Tibor Szűcs commented: "Art is said to be one of the forms of living that are very close to the freedom of the soul. And indeed, I studied art in order to achieve a certain level of freedom. …I gave up practicing art because the circumstances created by this practice [turned out to] limit[ed] my freedom."[13]

The shocking number of photographs and the complexity of the relations among images and memories created a difficult situation for researchers of the private sphere and of private photo archives. Instead of systematic analy-

sis and publications, they predominantly chose to limit their research to case studies that demonstrated certain rules. However, the new image has created a hopeless situation for researchers. As they hold the new photos in their hands, their first thought is to give up on scholarly terminology and discourse, for the best option is to indulge in hermeneutical-poetic adventures, and for that, they find and analyze "heavy images."[14]

But perhaps this is not the only possible method. When gaining first-hand experience of the world of optical-chemical photography, we thought it was infinite. We cared only about a very few photos, because tens of thousands of new photographs were generated every second, in an unstoppable flood. The old story has ended before our eyes: the images enlarged in dark rooms on photographic paper have become antiques, or will be by tomorrow. In this sense, photo-museology is beginning today; we are coming to evaluate photography from our own point of view, as a poetic object, a historical resource, as a fading memory of lives, emotions, desires and personality, further and further behind us in time.

If we were to establish the archives of the private sphere today, obviously, we would try to include in the collection as many of these images and memories as possible, to save them from being lost forever. However, such an immense archive of important, one-time, unique, and personal memories would probably not let us see the history that we share, the characteristic great narratives of our age.

The new, immaterialized images live their lives in their immediate communicative space, and if that is so, maybe the researcher should also enter that space. If I had to think about the research of new private images today, I would never consider filing cabinets, cardboard boxes, or folders for storage, and would not invent interview guidelines. Mostly, I would not need to leave my desk for participatory observation. I believe that the researcher of private photography, sitting in front of a computer monitor studying old and new photographs, may have the role of the initiator who catalyzes the process where images and commentaries come to match spontaneously and self-sufficiently, finding their contexts, their interpersonal and interdisciplinary relationships on their own.

And this method would do more than just keep old images alive: it would make traceable numerous lines of their complex relations and include them in new contexts of interpretation. Developing this type of research attitude and strategy is our imminent task.

English translation by Zsolt Kozma

Notes

1 Literature on the period has grown fast recently. Works that are closely related to my subject are: Sándor Révész, *Aczél és korunk* [Aczél and our age] (Budapest: Sík, 1997); Gábor Andrási, Gábor Pataki, György Szűcs, and András Zwikl, *Magyar képzőművészet a 20. században* [Hungarian art in the 20th century] (Budapest: Corvina, 1999); Hans Knoll, ed., *A második nyilvánosság. XX. századi magyar művészet* [Secondary publicity. 20th-century Hungarian art] (Budapest: Enciklopédia Kiadó, 2002); Tamás Szőnyei, *Nyilván tartottak. Titkos szolgák a magyar rock körül 1960–1990* [You were in their files. Secret agents in the Hungarian rock music scene, 1960–1990] (Budapest: Magyar Narancs–Tihany-Rév, 2005).

2 See András Bán and Péter Forgács, "Privát kép és érték" [Private image and value], in *Értékek és változások* [Values and changes], eds. Mihály Hoppál and Tamás Szecskő (Budapest: Tömegkommunikációs Kutatóközpont [Center for Mass Media Research], 1987), vol. 2, 79–88.

3 About Sándor Kardos's filmmaking career, see www.filmunio.hu/object.7594e576-f680-4101-8be1-08c7de8c5698.ivy. About the Horus (also known as Hórusz) Archives, see László Haris, ed., *Hórusz Archívum* (Budapest: Magyar Fotóművészek Szövetsége [Association of Hungarian Photographers], 2004). Of Jeles's films I refer here primarily to *A kis Valentinó* [Little Valentino] (1979), whose director of photography was Sándor Kardos. About Gábor Bódy, see www.bodygabor.hu, www.c3.hu/collection/videomuveszet/muveszek/Body/cv.html. Of his films, the one related directly to the subject is *Privát történelem* [Private history] (1978), directed jointly with Péter Tímár. Sándor Kardos was also the director of photography of *Egészséges erotika* [Healthy erotica] (1985), directed by Péter Tímár. This film drew significantly on forms of the private image. The significance of Lenke Szilágyi can hardly be demonstrated clearly by the books compiled of her photographs. An authentic monograph of her career has yet to be written. Her most important collections of photographs are *Fotóbrancs* [Photo gang] (Budapest: Budapest Galéria, 1994) (exhibition catalog); *Látókép megállóhely* [Vision halt] (Budapest: Magvető, 1998); and *Fényképmoly* [Photoworm] (Budapest: Ernst Múzeum, 2004) (exhibition catalog).

4 About Péter Forgács, see www.filmunio.hu/object.e44d3b11-7793-4497-bad2-48eed-da0c9f7.ivy; a few important studies representing the Hungarian reception of the film series *Privát Magyarország* [Private Hungary] in Hungarian: Miklós Peternák, "Privát Magyarország," in *Belvedere* 3: 1 (1991): 40–42; Ágnes Gyetvai, "Privát Forgács. Beszélgetés Forgács Péterrel" [Private Forgács. In conversation with Péter Forgács], *Új Művészet* 2: 9 (1991): 63–66; Péter Balassa, "Forgács Péter: Privát Magyarország," *Kritika* 21: 2 (1992): 36–37; J.A. Tillman, "'Az én munkám a szemlélődés.' Beszélgetés Forgács Péterrel" [My job is contemplation. In conversation with Péter Forgács], *Magyar Narancs* 7, no. 20 (1994): 30–31; Gusztáv Schubert, "A démon fényképészei. Privát Magyarország" [Photographers of the Demon. Private Hungary], *Filmvilág* 40: 8 (1997): 4–5; András Forgách, "Zárt kertek pusztulása. Forgács Péter és a film" [The decay of close gardens. Péter Forgács and the film], *Metropolis* 3: 2 (1999): 58–74.

5 *Lapok a családi albumból* [Pages of a family album], Budapest, Tölgyfa Gallery, September 11–October 27, 1989; and András Bán: "Lapok a családi albumból" [Pages of a family album], in *A fénykép varázsa* [The magic of the photograph], ed. Mihály Gera (Budapest: Műcsarnok, 1989), 371–382 (exhibition catalog).

6 András Bán and Péter Forgács, eds., *Vizuális Antropolófia kutatás munkafüzetek* [Series of Visual Anthropology Research], I–V. Vol. I. *Perneczky Géza tanulmányai* [Studies by Géza Perneczky] (Budapest: Művelődéskutató Intézet, 1984–1985, 1984). Vol. II. ed. András Bán, *Családi fotó* [Family Photo] I. (Budapest: Művelődéskutató Intézet, 1984), Vol. III. Jacques Maquet, *Bevezetés az esztétikai antropológiába* [Introduction to the anthrpology of esthetics] (Budapest: Művelődéskutató Intézet, 1984), vol. IV. ed. Anna Wessely, *Kritikai beszámolók a fotográfia történetéről* [Critical Reports of the history of photography] (Budapest: Művelődéskutató Intézet, 1985), Vol. V. Michael Kuball, *Családi mozi* [Family movie] (Budapest: Művelődéskutató Intézet, 1984).

7 Of the studies commissioned during the research, those that were published include György Somogyi, "Műbírálat" [Art review], in *Fotóművészet* 33: 3–4 (1990): 83–88; and György Szegő, *Privátfotó szimbólumszótár* [A dictionary of symbols in private photographs] (Budapest: Theater Art Fotó, 1998).

8 Antonella Ottai and Valentina Valentini, *Formato famiglia* (Rome: Paese Sera, 1981); Catherine Hanf Noren, *The Camera of My Family* (New York: Alfred A. Knopf, 1976); Richard M. Chalfen, *Turning Leaves: The Photograph Collections of Two Japanese American Families* (Albuquerque: University of New Mexico Press, 1991).

9 See, for example, the two conferences entitled *Vizuális kultúra* [Visual culture], organized by Zsolt Bátori and Attila Horányi (Magyar Iparművészeti Egyetem [then Hungarian University

of Applied Arts, today Moholy-Nagy University of Art and Design], May and November 2004); *Enigma* 11, no. 41 (2004), a special issue entitled *Vizuális kultúra* [Visual culture], edited by Zsófia Bán; or the Visual Culture section of www.m-e-m.hu, edited by Sándor Hornyik. A counter-example: *Ex-Symposion* 9, no. 32–33 (2000), a special issue entitled *Dokumentum* [Document], edited by Attila Horányi, Antal Jokesz, and Katalin Tímár.

10 Michael Lesy, *Time Frames: The Meaning of Family Pictures* (New York: Pantheon Books, 1980).

11 The term was invented by Richard Chalfen. See his *Snapshot Versions of Life* (Bowling Green, OH: Bowling Green State University Popular Press, 1987).

12 Lesy, *Time Frames.*

13 Tibor Szücs, "[Statement]," in *Sajátfotó. Képnapló* [Own photograph: Picture diary], ed. Barnabás Bencsik (Budapest: Trafó, 2000), 20.

14 András Bán and Gábor Biczó, "Kutató tekintet" [Searching gaze], *Magyar Lettre Internationale* 9: 38 (Autumn 2000): 25–27.

EVENTfulness

Family Archives as Events/Folds/Veils

Suzana Milevska

This paper was imagined as an attempt to deconstruct the understanding of photography archives as supposed spaces for the guarding of authenticity and truth about certain events. I want to address the process of "unveiling of the truth" through the researching of photography archives and to question the possibility of such unveiling. I will focus on the difference between the state (or public) archives and personal archives, while stressing the importance of the gendered perspective of dealing with family photographs for the deconstructing of state archives in various art projects.

My interest in "an-archiving" the archives stems from the need for a gendered interpretation of the archives. Therefore, I will present a few projects that dealt with the unveiling/revealing/re-veiling of truth by Liljana Gjuzelova. Her series of four projects, *Eternal Recurrence* (Fig. 1), was developed from 1996 to 2006 and was presented as slide, video, sculpture, or text installations in various spaces. All projects were based on family albums and the private archive of her father, Dimitar Gjuzelov, dedicated to the sensitive and complex historic case of his prosecution and execution at the end of World War II.

1. Liljana Gjuzelova, *Eternal Recurrence*, 1997.
Installation. Courtesy of the artist.
Photo: Robert Jankuloski

This text is actually more an attempt at an-archiving of the notion of archives in the Balkans. The aim of this presentation and of the collated visual material is to challenge and deconstruct the problematic understanding of institutional archives as places dedicated to guarding and preserving the truth of written documents and visual imagery. Instead of focusing on the archive as the repository of some absolute truth (e.g., about national identity), I attempt to "perform" an archive of the singular personal truth as a way of acquiring knowledge and making art that is specific to the Balkans.

To an-archive the archive in the Balkans is to base the interpretation of various archives of images on assumptions radically different from those explored in archiving in scientific/historic, political, and social terms. Although it would be an overstatement to claim that it is a-scientific, an-archiving does aim to deconstruct the scientific belief in truth, facts, chronology, and evidence.

Since I started investigating gender difference in the Balkans, photography and performativity, the research has produced an imaginary folder of events, thoughts, and images. While unfolding the old files, they created new folds. The folds/events thus enable rhizomatic relations and convergences to occur between different files, like multiple openings of a silkworm cocoon that "reveal and veil the unveiling of truth."[1]

The *Eternal Recurrence* project tried to reformulate the conceptualization of the archive as a means for production of knowledge into performing the archive.[2] It allowed the subject/artist who unfolds the archive to create new interpretations. It opens up new events and spaces for new folds that point to the possibilities of different interpretations of political power and authority. The archive *saves* and *preserves* its contents: documents, images, letters, "*traces*" are saved for future research and distribution. This effort assumes that this "investment" can protect memory, and ultimately the truth.[3] But the archive, being simultaneously an "introduction" into both the past and the future, does not itself have one single introduction, because there is no one single entrance to the archive—a true beginning. One has to deal with multiple and erratic beginnings, in a temporal or spatial way.

On the one hand, even an organized and vigilant researcher who has made all sorts of necessary preparations may overlook an important piece of evidence because of the vastness, and idiosyncratic order, of the archive, whether official or private. Therefore, the desired *event*, the encounter between the researcher and the sought document/image, might never occur. On the other hand, an important *event* may take place unexpectedly; an image or document may appear by accident. The multiple *entrances* to the archive make contingent the *event* of its entering. An archive is always a labyrinth with many dead ends and no shortcut exits, which both confuses and seduces.

Most of the national archives in the Balkans allow entrance to their well-kept premises, but only the most valued contents of the Balkan archives (the "big historic truths" about the origins of nation, national identity, nation-state, territory, national heroes, or ethnic minorities) are treated as relevant. Regardless of the relevance of the issue of representation of gender difference from a linguistic, anthropological, cultural, psychoanalytical, or feminist academic perspective, the Balkan archives' authorities treat this issue as if it was of no scientific value.

It is important to stress that bureaucratic rigidity in historic, national, library, and museum archives in the Balkans is the result of strong political influence and of strict control over the management and leadership of archives. Although the directors are given responsibility and power to lead these institutions ostensibly in the name of some "inherent" idea of the

"national interest," in practice these appointments are often an extension of governmental politics.

The notion of gender difference in the Balkans is inevitably intertwined with the question of identity and difference that is more recognizable in family archives. The discussion about the representation of women who position themselves within these conflicts requires a discussion about the relation between state power and these representations. Although the regime of representation is still controlled by the authorities, it turns out to be unstable and always marked by a certain crisis. Thus I propose looking at the representation of gender difference in the Balkans as if it were a "*dangerous supplement*" to, and a source of, this crisis.[4]

The complex rhizomatic structure of the an-archived archive defies any linearity in terms of the selection, gathering, historical periodization, and systematization of the images and their authors. The existing correspondences and contradictory relations among all these images and, most importantly, certain additional relations among all of these different images and concepts emerge during the research itself and the process of an-archiving. On the one hand, this archive seems to include everybody. However, the deconstructed *archive* does not employ the simple method of adding and including neglected or excluded images. It is actually an attempt to apply simultaneously the same two movements of deterritorialization—one through which the subjects would have to be isolated from the majority, and another through which they needed to rise up from their minority status.[5] It is clear that the majority of images portrayed men, and not all representations of women were relevant for discussing gender difference.

To elaborate this double movement of deterritorialization when reflecting on individual images or artists and their projects, I stress the way in which the images I select exemplify the *becoming* of *gender difference*. I try to explain how they differ from the majority of archival images that I encountered, and how one can interpret the difference between them. The images of women and images created by women, either historic or contemporary, are created in different contexts: documentary, ethnographic, anthropological, or artistic. All in all, this archive gathers images that, while saying something about gender difference in the Balkans, often resist definite classification and systematization. The

grand narrative about the "big" heroes begins to intertwine itself with stories about "less" important ones. The "grand" truths begin to intertwine themselves with the "small" ones; this raises the question of whether there can be such a thing as a "small truth," and if the discourse on gender difference can be qualified as a kind of *truth*.

The hierarchical notion of archive claims to protect the origin and authenticity of identity. Therefore it is important to explore the possibilities for a restructuring of the hierarchical archive into an archive of difference and to relate them to the crisis of representation through a discussion of photographic representation. It deals with the intrinsic *"crack within the truth of sign"* that affects any representation of truth, since this crisis[6] inevitably affects the signification of the archive.[7]

The issues of crisis in the representation of gender difference in the Balkans are still overlooked or seen as unimportant. In order to challenge the preconception that gender difference in the region is stereotypically determined by the already known and established orders and regimes of representation, I suggest that looking at various archival visual materials can create a unique archive that can an-archive the existing archival structures and emphasize the ambiguous rhetoric of gender difference within the field of representation.

Starting from the deconstructive premise that difference is something "historical" coexisting within identity from its outset, it should be emphasized that gender difference in the Balkans is not something new. Instead, I look at gender difference as something that has *always already* been there, as an ever-plausible and needed supplement to fill the intrinsic "lack" in the identity. This is not the same as to say that the *hierarchy* within gender difference has always been there. The valorization of certain biological/sexual differences between men and women is established within culture. Yet not all cultures have the same hierarchical order of valorization. Even if we agree that hierarchies have *always* existed within culture, they can still differ in kind and strength depending on cultural contexts. I want to argue that the images present in the Balkans, either gathered in a national archive or scattered in different places (homes, media, artists' studios, museums, etc.), are a compound of an amazing array of unexpected representations of gender and cultural difference.

2. Liljana Gjuzelova, *Eternal Recurrence* 4, 2006. Video (DVD, 40 minutes).
Courtesy of the artist.

The production and circulation of these images and art objects in the
Balkans is necessarily connected with *becoming-gender-difference.*[8] They invite
various research projects that can help to defy the clichés about this region and
produce new and different interpretations. *Becoming* means to deterritorial-
ize, and this is what these images and projects do: they destabilize the known
regimes of representation, and they disorganize the strict social and political
orders.[9] Often state power cannot recognize the imaginary and symbolic order
that is developed within this imagery according to a different set of rules and
with a different strategy.

One of the most important questions is, how are the highly appreciated
and concealed truths about the origins of nation, state, or language related to
the problematic nature of gender difference? In other words, have these "big
truths" not *always* been marked by gender difference as a kind of "supplement"?
Gender difference understood as a "supplement" to difference and national and
cultural identity does not merely supplement what is present but marks the

3. Liljana Gjuzelova, *Eternal Recurrence* 2, 2001. Installation. Courtesy of the artist. Photo: Stanimir Nedelkovski

emptiness of these structures.[10] Gender difference destabilizes the "fixed" and "pure" structure of identity from the outset.

The negative paradigms attached to subjectivity through confrontation and sublation overlook the fact that gender difference has been present historically. This means that the conceptualization of a linear historic formation of subjectivity and gender difference is problematic. There is a production of discourse of gender difference not necessarily overburdened by an essentially negative understanding of subject formation. This discourse stems from other norms and relations towards state power, and regimes of representation that ultimately come forward through art and visual culture.

One such project is Liljana Gjuzelova's *Eternal Recurrence 4*. It is a video-art piece documenting her performance of October 17, 2004, on Zajchev Rid—the fourth project from the *Eternal Recurrence* series, and, at the same time, a summary of the previous three. The first one was presented in a private

4. Liljana Gjuzelova, *Eternal Recurrence* 4, 2006. Video (DVD, 40 minutes).
Courtesy of the artist.

house in Magir Maalo (1997), the second at the Museum of the City of Skopje (2001), and the third at the Open Graphic Art Studio (2003).

The process of investigating and discovering some of the circumstances still enveloping the tragic execution of Dimitar Gjuzelov, her father, with different interpretations—a process later instigated by the opening of political dossiers in the year 2000—led to Gjuzelova producing art projects on this topic and presenting them at exhibitions, which she began as early as 1995. Significantly, she is not making a detailed report on the constant re-examination of the results of her continuous quest for the historical truth surrounding those horrid events. Instead, she attempts to get close to the persona of her lost parent and talk about the heartbreaking fate of her entire family.

The differing versions of her father's last day and his execution on Zajchev Rid, a hill on Skopje's northern outskirts, are what led Gjuzelova to draw a slightly open circle on the supposed resting place of the body: that is how the video begins. (Fig. 2) The process of marking the unknown grave in red paint

with a slightly open circle emphasizes the impossibility of bringing this story to closure—the impossibility of closing a dossier that still abounds with unanswered questions, confusing data, and absurdities.

The emptiness; the uncertainty and despair in the long years of re-examination, prosecution, and exile that led to serious human rights violations; as well as the burden of "inherited guilt" left to the whole family have been, from the very beginning, the recurrent motifs in these projects. Through the medium of video, all the historical, personal, and artistic fragments come together in one complex narrative structure. Some of the photographs, the personal letters, the Dimitar Gjuzelov manuscripts, and other documents from the family archive have already appeared in the previous works. Together with the newly found documents—such as the last letter Gjuzelov wrote to his daughter—and the documentation from the other three projects, these fragments generate the *Eternal Recurrence 4* video.

Each of the three previous projects, though resulting from the same relentless desire to comprehend this absurd Balkan saga, has a different media structure. The first project, for instance, entitled *Eternal Recurrence... oblivion, confrontation, returning, removals, roots*, was an installation consisting of a metal case, an empty photo album, photographs stacked at the bottom of the case, and a slide show. A vital element in this piece, presented in a private house in the Magir Maalo neighborhood, was the mapping out of the Gjuzelov family's eviction after the father's execution. *Eternal Recurrence 2* was an installation of sculptures at the Museum of the City of Skopje in which Gjuzelova used the reference to Egyptian mummies to capture the theme of the repetitive nature of history. (Fig. 3) The third installation, called *Writing Myself*, exhibited at the Open Graphic Studio, was a kind of spatial letter consisting of texts written on paper objects hanging freely about the room. (Fig. 4)

All of Gjuzelova's works, in fact, talk about a constant revealing of truth that has no body. The unraveling of new layers and veils might appear to be accosting the final truth. It is, however, no more than an uncovering of further layers, as a result of the skeptical belief that there is no single truth, and that the different versions emphasize the improbability of its existence as such.

Realizing that the different versions of his end only increase the absurdities and the painful memories, Gjuzelova focuses on an imaginary dialogue

with her father. That is why in this last piece she sets a different goal: an attempt to fathom the unique truth about the persona of the absent parent and to discuss how his fate affected the whole family. She is "writing out" her sincere video-letter, filling it with intimate detail, without much accusation and with deep empathy—despite being aware of the different and conflicting opinions on the historical truth regarding her father's political engagements. With her first-person narrative, Gjuzelova allows the audience to get in touch with the times in which *democracy* was a luxury, a different opinion was not an option, and guilt was considered hereditary. They were times in which the victims of *great narratives* were little people, primarily wives and children of "agents" of "great truths."

Through her five video "chapters"—*Eternal Recurrence*, *Writing Myself*, *Three Endings*, *Balkan Misunderstandings*, and *Reunion with the Father*—Gjuzelova reveals the little truths surrounding a great tragedy. The odor of hyacinths and mold in Madzir Maalo, the battle for room and sky, the squeaky door and barred window, the sealed radio, the fear of direct questions, and the importance of the small crochet hook in the mother's long struggle for survival and the raising of her two sons and daughter are only some of the narrative fragments of the mosaic structure. Thus the artist writes herself and the rest of her family into history, which usually makes room only for "great truths."

Several voices appear in the video: the voice of "history" through the reading of the verdict; the voice of infancy; the voice of the poetic version through the poem by Bogomil Gjuzel, the brother; the voice of the curator of the projects through the reading of a fragment on the third project; as well as the voice of Gjuzelova herself. All these voices make up the multiple aspect that in the *Eternal Recurrence 4* video project stands as a metaphor for the multiple nature of truth.

Even though the eternal return is never a return to the same, and does not imply repetition of the same *event* (Gilles Deleuze), even though with every repetition certain variations, which confirm the possibility of movement, occur, this story should be seen as a warning that any chance of a return to any even remotely similar stories should be prevented.

Notes

1 Jacques Derrida, *Rogues: Two Essays on Reason,* trans. Pascale-Anne Brault and Michael Naas (Palo Alto, CA: Stanford University Press, 2005), 131.

2 I refer to art projects such as *Double Life*, *Triangle*, and *Searching for My Mother's Number* by Sanja Iveković, *Eternal Return* by Liljana Gjuzelova, and *Looking for a Husband with a EU Passport* by Tanja Ostojić.

3 Jacques Derrida, "Différance," *Margins of Philosophy*, trans. Alan Bass (London: Prentice Hall, 1982), 18.

4 Jacques Derrida, *Of Grammatology,* trans. Gayatri Chakravorty Spivak (Baltimore: Johns Hopkins University Press, 1976), 144–157.

5 Gilles Deleuze and Félix Guattari, *A Thousand Plateaus,* trans. Brian Massumi (Minneapolis: University of Minnesota Press, 1987), 291.

6 Derrida, *Margins,* 10. The crisis of representation as conceived in Jacques Derrida's deconstruction is an outcome of the crisis within the arbitrary structure of the sign and the troubled relation between the signifier and signified.

7 Derrida, *Margins*, 11. If the word "history" did not in and of itself convey the motif of a final repression of difference, one could say that only differences can be "historical" from the outset and in each of their aspects.

8 Deleuze and Guattari, A *Thousand Plateaus*, 291. The movement of *becoming-gender-difference* partly derives from Derrida's *différance,* and the *"becoming"* part derives from Deleuze's concept *becoming-woman. Becoming* for Deleuze is above all an affirmation of difference. The flux of becoming opposes any fixed identities. The multiple processes of transformation that are at the heart of any becoming, allow a new kind of subjectivity to emerge. In order to circumvent the concerns that the privileging of *becoming-woman* can again lead towards a woman being caught in male configurations, I suggest the concept of *becoming-gender-difference* instead of *becoming-woman.*

9 The feminist critics of Deleuze's concept of *becoming-woman* claim that by privileging this concept, the woman is interpreted as "other" and is still subjected to the man who determines the norm of becoming. For a more detailed feminist critique of Deleuze's concept *becoming-woman*, see Dorothea Olkowski, *Gilles Deleuze and the Ruin of Representation* (Berkeley: University of California Press, 1999).

10 Derrida, *Of Grammatology*, 145.

FAMILY ALBUM

Visualizing Male Homosexuality in the Family Album

Logan Sisley

This paper explores the work of artists and writers who retrospectively seek out representations of their sexuality in the spaces of the family photograph album. Narratives embedded in the album have traditionally excluded the presence of homosexuality, so any reading practice concerned with the retrospective account of gay identities must be sensitive to the visualization of absence. I briefly analyze the structural absences of the family album, then reflect on several artistic interventions within it. The relationship of homosexuality to these absences is introduced with reference to Simon Watney's autobiographical essay, *Ordinary Boys* (Fig. 2), motivated by his confrontation with images from his childhood. I then examine Christopher McFarlane's series, *This is a photograph of me* (Fig. 1), before turning to Glenn Ligon's photo-essay, *A Feast of Scraps*, which combines gay pornographic images with family photographs.

It should be noted that this paper addresses these issues only as they bear on male homosexuality. I also look at the work of artists from North America and a writer from England, and while the general comments on family albums are relevant to the works discussed, other variations exist in different contexts. I would also note that while the model of family photography put forward is dominated by convention, it is not a wholly fixed cultural practice.

Was my upbringing any
different than that of my
Brother's or Sister's ?
Was my Mother more domineering,
and my father more passive
with me than Robert and Andrea.
Were the chromosome
that made up my DNA
so different from those of
my Brother and sister.
If so , then why are we still
alike in many ways.
How can I look so much like
my Mother, and act so much
like my Father, but be so different.

1. Christopher McFarlane, *Family Photo* from the series
This is a photograph of me, 1991.
Courtesy of the artist.

Its representations shift along with the social changes that surround it. This discussion also largely refers to a period prior to the proliferation of the digital camera and Internet photography sites.

While it is frequently noted that all albums look much the same, that the imagery is banal, trivial, and redundant, it is the ordinary in the life of the family that is generally absent from the album.[1] Daily events such as work, school, or mealtimes are not, on the whole, deemed worthy of commemoration. However, the *first* day at a new job, or the *first* day at school, or a meal marking a special event may well be included. Philip Stokes has identified several key prominent motifs: the family standing outside the house, the garden archway, the family motorcar, and most of all, children and their games.[2] Dave Kenyon also notes the overwhelming presence of babies, rites of passage, important possessions, hobbies, official photos, and pets.[3] Events such as Christmas, holidays, and weddings all frequently appear.

If the conventions of family photography record certain things, they also seek to exclude images that do not fit with its ideal. Discussing snapshots

of children in particular, Anne Higonnet writes that the unspoken rules result in there being "no tantrums, tears, or bruises, no mess, no pleading, no failures, no conflicts, no resistance, few if any expressions except smile."[4] Kenyon too argues that albums "leave important aspects of experience out of our account—the everyday drudgery, the unpleasant or threatening experience, illness, discord… What is more, their absence disguises the realities of the domestic power struggles which go on around us."[5]

The family album presents a public face insofar as it is generated in the knowledge that it may be viewed outside of the family in which it is produced. Lurking behind this facade is a myriad of secrets, stories, problems, joys, and emotions that the conventions of the album are incapable of recording, except obliquely.

The album provides a context for the single image, making it possible to compare one instant with others. The search for meaning in a single found snapshot may involve speculation about other images that might follow or precede it. The narrative framework that the album provides is as restricted as the photographs themselves, repeated time and again from album to album. Simon Watney is painfully aware of the limitations in the family album's capacity to represent a broad spectrum of family activities and ambitions. He sees the "determination to put a brave face on things" as evidence of "our more or less desperate desire to be happy: a dumb, clumsy, inchoate awareness that *somehow* life could be better than it is."[6]

The album is frequently structured to demonstrate a narrative not only of the passing of time but of the family's improvement over time. The family may be photographed alongside the new car or in front of the new house to indicate increasing prosperity. Even when such prosperity is absent, the happy times, or the appearance of them, are emphasized.

While the album primarily records a collective narrative—that of the family group—it also offers a means of structuring the past to individual members of that group. The relevance of the album usually depends on the continued relationship to a member of the family in which it was produced, a person who can identify the faces and places and retell the associated stories. Snapshots and albums are discarded when contextual information regarding the images becomes lost, often through bereavement. While all family albums may be of

2. Simon Watney, *Ordinary Boys,* 1991.
Courtesy of the artist.

historical documentary inter-est, only those with a personal investment in a particular set of images will treasure them above others. Different members of the same family, with similar claims to the album, will also view the images very different-ly. Their different experiences over the course of time and their different requirements of the images in the present mo-ment will elicit different read-ings of the album.

Many writers and artists interested in family photogra-phy have turned their attention to the family album in a more personal or autobiographical manner, due in part to the lack of access that researchers have to family photographic collections. In the anthology on family photography *Family Snaps,* several writers share a desire to make up for a perceived absence within a family album narrative. Watney's essay "Ordinary Boys" is one such piece, in which the absence is that of his homosexuality.[7] It is a uniquely personal reading of his own childhood album, which is deeply embedded in an adult moment. Looking upon the pho-tographs of himself as a small boy for the first time in many years, Watney is struck with disbelief. He had forgotten the times the photographs represented, along with the person he was and the childhood world he inhabited.

There is a photograph of the young boy learning to read, on holiday, and in the presence of an unidentified woman. Watney states that he became aware that he was gay at around the time this photograph was taken. Given this self-knowledge, he is shocked to discover that "the picture reveals nothing of the terrible secret that drove me so deeply into myself for so many long irrecov-erable years—years that, without photographs, do not exist."[8] While the family photographs record the years otherwise forgotten, they do so with difficulty.[9]

Watney suggests that his struggle in reconciling himself with the person in the photographs is a common experience, evidence of "some kind of dysfunction between one's sense of oneself and one's parents' expectations"[10]—expectations that are articulated through family photography. It is an act of reproduction, both mechanical and ideological. The album has traditionally been mortgaged to heterosexual reproduction, just as the notion of family documented in the album is seen as the actual site of heterosexual reproduction. This is not made explicit but is implied.[11] The parents' fantasy of the child that is recorded in the album is a heterosexual fantasy, intent on its own reproduction.

The photographs do reveal a boy who looks "fine," like a regular English kid of the time. Yet the image Watney held of his childhood self was that of a grotesquely fat and unattractive boy. He believed this because he thought he was bad, due to the sexual secret he held within. His own view is in stark contrast to that presented by the camera.

Although much of Watney's essay is concerned with articulating the album's incapacity to record the childhood secret of his homosexuality, when looking at one image he wonders if there may have been signs. Questions run through his mind about another boy pictured and their relationship—who was he and what did he feel for him? These questions remain unanswered. He has little recollection of the boy other than what he sees before his eyes. Watney notes early on in his essay that the photographs only offer a "fragile, ambiguous access" to the past.[12] His is not a quest for an absolute account of his growing up, nor a demand for photographic evidence of his burgeoning homosexuality, but rather a negotiation between memories and images of the past and his contemporary reality. He enters into a dialogue with his younger self:

> Perhaps we spend our entire lives coming back to stare at pictures of the people we once were, mouthing the same reassuring messages that we could never hear when we most needed them? Perhaps this is secretly what family photographs are all about, always giving back the same forlorn and incompatible messages: "How happy I was" and "If only I'd known."[13]

The open-ended nature of Watney's return to his family album can be considered an example of what Annette Kuhn terms "memory texts," in which "layer upon layer of meaning and association peel away, revealing not ultimate truth, but greater knowledge."[14] Kuhn's notion of a memory-text is concerned with the ways memory shapes the stories we tell and with those things that spark our memories, but they are neither confessions nor autobiographies. Instead they "tread a line between cultural criticism and cultural production."[15] It is the "memory work" that makes storytelling possible rather than the content of the stories that is more important and more useful in the present. A feature of memory texts is that personal and collective remembering emerge as continuous with each other. However, it is clear from Watney's essay that the relationship between these two forms of memory is not without its tensions.

Watney hints at other modes of engagement with the album when he considers the albums that he has constructed as an adult, which record lives and stories traditionally excluded from "official" histories. His essay finishes with the comment that his extended family album has become more than a partial record of his life: "it has become an archive, one fragment of the much greater enterprise that is modern gay history."[16] Watney echoes Jo Spence's advocacy of photography as a tool to challenge mass-media stereotypes via the creation of an alternative representational practice.

Canadian artist Christopher McFarlane also uses photographs to negotiate a path through his memories in the series *This is a photograph of me* (1991).[17] He states that the work chronicles "the development of my homosexuality, or, at least my acceptance of it."[18] Like Watney, he tries to reconcile his memories of the past with the images taken at the time. Yet we do not find the same sense of disbelief—the title of the series is framed as a statement, not a question. *This is a photograph of me* is a series of photographs of the artist posed before a framed photograph on a white wall. The wall's blankness, evoking the gallery setting, prises the photographs out of a domestic space with which they are usually associated. This recontextualizing of the image presents it as worthy of contemplation. Gallery spaces are intended to allow prolonged consideration of an artwork, whereas the family album is frequently leafed through, one image following another in quick succession. In "Family Portrait," a snapshot of his family hangs on the white wall behind the artist's self-portrait. It is an infor-

mal shot taken outdoors, and the photographer has struggled to include all of the family in the frame. A sliver of Dad and one child escapes to the left of the image, while a stretch of grass dominates the right.

Throughout the series, text is placed beneath the framed photographs and beside the adult McFarlane. These articulate moments in the subject's burgeoning sexuality, reminiscences of the time depicted in the photograph in the background. In a sense, these words occupy the space between the historical and contemporary images of the artist, recalling feelings, thoughts, and memories not visible in the images.

> Was my upbringing any different than that of my Brother's or Sister's? Was my Mother more domineering, and my father more passive with me than Robert and Andrea. Were the chromosome that made up my DNA so different from those of my Brother and sister. If so, then why are we still alike in so many ways. How can I look so much like my Mother, and act so much like my Father, but be so different. (Fig. 1)

The artist seeks meaning, an explanation, an organizing account. In doing so he turns to the two opposing theories of sexual origin—upbringing and genetic makeup. The image of the family is offered up as a clue in the search for answers to the questions raised. Yet it is a mute clue. While photographs are frequently brought into play as evidence, this one denies fixed conclusions. McFarlane's text provides a range of possible "explanations" and theories that might satisfy the question, "What makes me gay?" However, the structure of the image works against any simplistic and unproblematic response to such musings. There is a refusal to translate the indexical nature of the photograph into a notion of evidential truth. The combination of the past image and the photograph of the "present" self produce an indefinite space within which questions are asked but left unanswered.

Glenn Ligon's photo-essay, *A Feast of Scraps*, engages with a wider range of issues than McFarlane's series, but it shares a desire to reread a family album for a narrative of homosexuality.[19] His strategy is to insert gay pornography into the family album. *A Feast of Scraps* brings together these seemingly disparate

genres, each speaking to the other's absences; the pornography records the album's denial of an adolescent sexuality, while the album enables the lives of the porn models to be re-imagined and re-told. No information is provided about those pictured in the family snaps, so the viewer can only speculate.[20] There is a blurred image of a young man in a soldier's uniform; there are portraits of well-dressed individuals, and others of embracing couples. A woman beams at the camera with a telephone in hand; "1947" is inscribed on the photograph in the space above her head. Numerous groups are pictured in celebration; one such group is focused on a man poised to cut a cake. Tucked under the corner of this photograph is another, of a baby, its placement suggesting some relationship to those in the group shot. One snapshot of a smartly dressed woman appears as a fragment with roughly cut or torn edges, begging the question of what, or who, has been excised.

A Feast of Scraps is concerned with exploring the possibilities of rereading or reframing the conventions of both pornography and family photography. The artist notes that porn is "notorious for how quickly you can wear it out."[21] One magazine soon replaces another. Seriality is implied in Ligon's understanding of the way pornography functions. Each image (and, as we are reminded by Ligon, each man) only provides a quick thrill and soon becomes redundant (unlike the family album, which is intended for preservation). Ligon found the porn photos at a shop called the Gay Treasures bookstore, which he describes as "full of things that we have thrown out, boxes and boxes of images that chronicle our histories and desires. 'A Feast of Scraps.'" This statement propels the reader back to the project's title. A feast implies abundance, extravagance, excess; a feast is no ordinary meal. Its scraps, however, imply poverty—they are the remnants, the leftovers, the fragments, from which Ligon creates a feast. Ligon discovered packs of fading color photos from the 1970s, many of which he sees as replaying stereotypes of the black male as close to nature, sexually aggressive, or enormously endowed. Despite their problematic origins, he believes the pornographic snaps still have something to say to him. "We can still use the images, inhabit and change them, read against their intended meanings, critique ourselves with them, place our stories alongside them, use them to talk about our histories and desires." The snapshots should not be simply discarded, as this serves to deny the lives of the models.

Ligon compares the anonymous faces of the porn models with "portraits of long-dead relatives you never met but in whose faces you can trace the contours of your own." They tell another strand of Ligon's history, which is absent from the pictures his parents took. He deliberately chooses pornography from the 1970s, as that is the decade when he discovered he was attracted to men. While there are family albums full of images from that period, these pictures only record:

> our unkempt afros, flowery polyester shirts, and pressed blue jeans, but they do not record my desire for my cousins. The photos of black men in Gay Treasures are the photos left out of my family albums, and when I look at them I see my cousins' faces and bodies and I remember my desire.

Pornography does not sit comfortably beside family snaps in *A Feast of Scraps.* While the family album has been mortgaged to heterosexuality through its constant repetition of images of heterosexual procreation and marriage, it has traditionally been devoid of explicit sexual reference. A certain shock effect is also generated through the juxtaposition of images of children and sexually explicit images of naked men, as images of children are frequently mobilized as symbols of innocence.

Doug Ischar notes that, up until the 1970s, photography figured in gay lives in two ways: as an instrument of oppression and control, via its use in medical and police surveillance, and in representations of homoerotic desire in its various coded forms.[22] The first of these groups leaves a troubling legacy, so it is perhaps not surprising that Ligon chooses the latter, despite its status as an illicit, marginal cultural form. His provision of an unfamiliar context for the porn shots questions how the images themselves record homosexual desire outside of the context of their own production. In rendering visible that which the album denies, the porn shots admit to the possibility of alternative readings. The viewer is free to scour the family snaps for other "signs" or traces of homosexual desire: a glance, touch, or gesture. The eye becomes tuned to how the pornographic images might (or might not) encourage or enable the tracing of homosexual/erotic "content" in the family snaps. Ligon has also added

text to the pages that hints at the inability of the images to tell the "whole story."[23] It is through the weaving of stories around the people and places represented in the images that the album comes to life. The inclusion of text echoes the ways in which family albums generate stories, comments, and judgments about those represented, animating the images and providing entry points for the stranger viewing the album. While these voices direct the viewer towards certain interpretations of the images, they also leave room for other interpretations. The texts accompany only the pornographic photographs. Conventionally, pornography does not generate the same narratives as the family snap. The models exist in a vacuum, without the biographical information to support such storytelling. Ligon's attachment of text only to the porn snaps is another example of his interplay between the two genres. Some texts echo the attitudes and remarks that circulate around the gay adolescent: "It's a process," "It's not natural," "Mother knew." Ligon employs negative stereotypes so that they may work against themselves.

A Feast of Scraps is the second work by Ligon to explore homosexuality. The first was the installation *Notes on the Margins of the Black Book*, in which he juxtaposed Robert Mapplethorpe's photographs of black men with critical texts addressing the works. Ligon has said that this work in effect "outed" him in the "public, professional world."[24] Richard Meyer interprets this remark as suggesting that:

> the procedure of coming out is not a simple declaration of sexual identity so much as an ongoing series of negotiations between the gay subject and the multiple social worlds in which he or she circulates.[25]

This notion of the out subject is one that does not assume any straightforward relationship between homosexuality and visibility, and no such assumptions are to be found in *A Feast of Scraps* either. It represents a process of negotiation; the pornographic photographs explicitly recognize homosexuality, while the conventions of the family album deny its presence. Ligon makes visible the problems inherent in the struggle to visualize homosexual desire within his family's album.

This study has outlined three attempts by gay artists and writers to draw out new narratives and meanings from a photographic practice from which they felt excluded. Despite the conventions of family photography that have largely denied homosexuality, the family album's own open narrative structure enables such stories to be inscribed. The album's contestability opens up the possibilities for Watney, McFarlane, and Ligon to explore alternative narratives. However, in doing so, they must negotiate the historical construction of homosexuality and its relationship to visibility. These projects make visible not only their own sexuality, but also the processes by which this comes to be read.

Notes

1 For example, see Richard Chalfen, "Redundant Imagery: Some Observations on the Use of Snapshots in American Culture," *Journal of American Studies* 4:1 (1981): 106–113.

2 Philip Stokes, "The Family Photograph Album: So Great a Cloud of Witnesses," in *The Portrait in Photography*, ed. Graham Clarke (London: Reaktion Books, 1992), 193–205.

3 Dave Kenyon, *Inside Amateur Photography* (London: B.T. Batsford, 1992), 25–43.

4 Anne Higonnet, *Pictures of Innocence: The History and Crisis of Ideal Childhood* (London: Thames and Hudson, 1998), 90. The camera may capture images of resistance—a hand raised to shield the face, a head turned to avoid the camera's gaze—but these are likely to be edited out of the family album. In this sense the album is seen to be doubly mediated. A first selection process takes place before the camera clicks, the second when the album is collated.

5 Kenyon, *Inside Amateur Photography*, 24.

6 Simon Watney, "Ordinary Boys," in *Family Snaps: The Meaning of Domestic Photography*, eds. Patricia Holland and Jo Spence (London: Virago, 1991), 30.

7 Watney, "Ordinary Boys," 26–34.

8 Watney, "Ordinary Boys," 28.

9 It must be noted here that to talk of visibility in regards to homosexuality is a complex and problematic task. Lee Edelman has warned that the rhetoric of visibility that has been prominent in the gay liberationist project can "easily echo, though in a different key, the homophobic insistence upon the social importance of codifying and registering sexual identities." A similar danger exists in seeking to render homosexuality visible within the family album. The mechanisms that enable the homosexual body to be identified in photographs may, working against the intentions of the viewer, actually reinforce the homophobic construction of the homosexual body as some-

how marked and identifiable. See Lee Edelman, "Homographesis," *Homographesis: Essays in Gay Literary and Cultural Theory* (New York: Routledge, 1994), 4.

10 Watney, "Ordinary Boys," 29.

11 Heterosexuality has been constructed as unmarked, or invisible. Even in the absence of the marked homosexual body, the unmarked does not function, to use Amy Robinson's terms, as "a euphemism for the absence of sexuality but rather as an occasion for its reinscription as heterosexuality." See Amy Robinson, "It Takes One to Know One: Passing and Communities of Common Interest," *Critical Inquiry* 20 (Summer 1994): 718.

12 Watney, "Ordinary Boys," 27–28. The fragility of family snapshots as a link to the past is also explored by Felix Gonzales-Torres, who has reproduced family snaps as fragmented, unstable jigsaw puzzles. See Nancy Spector, *Felix Gonzales-Torres* (New York: Guggenheim Museum, 1997).

13 Watney, "Ordinary Boys," 30.

14 Annette Kuhn, *Family Secrets: Acts of Memory and Imagination* (London and New York: Verso, 1995), 5.

15 Kuhn, *Family Secrets*, 3.

16 Watney, "Ordinary Boys," 34.

17 Type "C" color prints, 20' x 10'.

18 Christopher McFarlane, artist's statement, in *100 Years of Homosexuality* (Saskatoon, SK: Photographers Gallery, 1992), 41.

19 *A Feast of Scraps* is published in Andrew Perchuk and Helaine Posner, eds., *The Masculine Masquerade* (Cambridge, MA, and London: MIT Press, 1995), 89–100. This book is the catalog of the exhibition *The Masculine Masquerade: Masculinity and Representation*, MIT List Visual Arts Center, Cambridge, MA, January 21–March 26, 1995. The work was also exhibited as a room installation consisting of nine photo-collages in 1998 in the exhibition *Glenn Ligon: un/becoming*, at the Institute of Contemporary Art, Philadelphia. Ligon subsequently made another work looking at the family album, *Annotations*, a Web project commissioned by the Dia Art Foundation, New York. See http://www.diaart.org/ligon/.

20 The desire to imagine stories around either a single snapshot or a set of images whose origins are unknown confirms the family album's pivotal role in stimulating and structuring narratives. For example, it provides the basis for James Nocito's book, *Found Lives: A Collection of Found Photographs* (Layton, UT: Peregrine Smith, 1998), in which the author provides either quotes from other authors or his own thoughts to accompany uncaptioned photographs he has collected.

21 Glenn Ligon, *The Masculine Masquerade*, 89. This quote is taken from a text that precedes the images of *A Feast of Scraps* in the publication. The following quotes from Ligon are all taken from this source.

22 Doug Ischar, "Endangered Alibis," *Afterimage* 17: 10 (May 1990): 9. These two loose categories are also identified by Tom Waugh in *Hard to Imagine: Gay Male Eroticism in Photography and Film from Their Beginnings to Stonewall* (New York: Columbia University Press, 1996), although he considers the latter under its different guises such as sport, art, and illicit photography.

23 Other artists employ this strategy, including Christopher McFarlane, as we have seen, and Cathy Cade. In her project, *A Lesbian Photo Album: The Lives of Seven Lesbian Feminists*, she sought to document the lives of seven lesbians through archival and contemporary photography. Cade explains that she used a combination of word and image because "there were not always pictures of the important aspects of a lesbian's life; some photographs needed interpreting, and often the way a woman told her story was too wonderful to leave out." See Cathy Cade, "Lesbian Family Album Photography," in Tessa Boffin, Jean Fraser, eds.,*Stolen Glances: Lesbians Take Photographs* (London: Pandora Press, 1991): 116.

24 Quoted in Richard Meyer, "Borrowed Voices: Glenn Ligon and the Force of Language," *Glenn Ligon: un/becoming* (Philadelphia: Institute of Contemporary Art, 1998), 21.

25 Richard Meyer, "Glenn Ligon: The Limits of Visibility," *ART/Text* 58 (1997): 34.

Please Recycle!

On Ágnes Eperjesi's *Family Album*

Ágnes Berecz

As its maker and protagonist states, "this is a totally real, fictional album".[1] (Fig. 1) It is an album that "tracks the most poignant events" of the artist's life up to her eighteenth birthday and consists of pictograms of packaging materials taken from commercial goods. Eperjesi's album, with its "real-fictional" character, seems to be imprinted with ambiguity and opacity, with constant doublings, distortions, and repetitions. Hence it both models and reproduces, reflects and replicates, those family albums that we all own and hold dear.

Before looking at how it does all that, I would like to look at how it was made. As the artist put it:

> I decided to recycle small images destined for the wastebasket, images we discard without giving them the slightest attention. For years, I have been fascinated by packaging materials of all kinds. Pictograms printed on transparent packing material serve as raw material for my art, and I use them as I would film negatives. Placing these in the enlarger, I generate scaled-up images, complementary colors and inverted tonal values.

After reversing and modifying her original images, Eperjesi not only arranged them into chronological sequences, but also created a historical repertory of photography as a medium: from the medallion-shaped portraits of the grandparents to snapshots, the story of photography and the story of her family are fused—the album remembers and evokes both the history of its alleged medium and its assumed object.

In *Family Album* everything is a bit blurred and grainy, and the colors are off. Family history and its recycled image, reality and its representation, are never in sync: the grass is lilac, the dog is blue, and the grandmother is neon-colored, as if the artist, with a twist of self-referentiality, wanted to reveal the fictionality of what is in front of us. As in Warhol's silkscreens, where Marilyn's fabulous blondeness becomes the canary-yellow wig of a clown, the *Family Album* acts as a travesty of mechanical reproduction. The technical reversal of the commercial pictograms reiterates their recontextualization—their repositioning from the sphere of the commercial to that of cultural goods—while also echoing the process of remembrance. As remembering is as much about substituting one thing for another, repeating and distorting what was not even our own experience but a story heard from someone else, seen in a movie, or read in a book, the replacement of real family photographs with blown-up negatives of commercial pictograms functions not only as a device of the mnemonic practice but also as its model. The pictograms, like memories, are reversed and turned into something else. Thus they open up an endless chain of rethinking, revising, misreading, and imaginary substitution, bringing to mind the mistaken identification of Roland Barthes, who took the necklace of a Harlem matron for the precious bijou of her favorite aunt in *Camera Obscura*.[2]

Family albums structure the images of past, create chronological narratives out of fragments, and order memories. That is, they write, rewrite and erase, affirm, or fake that obscure and polyphonic story of secrets and lies, joys and traumas, oblivions, and memories that is the history of a family. Proving once again that photography's truth-claim is anything but justified, family albums look as we would like to see ourselves, often through the images of others. It is no wonder, then, that all family albums are alike, that one life unfolding on their pages seems just like another, and despite our cherished singularity we resemble one another more than we might wish to. Memories too, even the

most important ones, are similar to one another. As Eperjesi put it, "we slide back and forth between memories of our most intimate selves and prefabricated clichés." This sliding starts in and with the family, when one learns the stories of grandparents and parents, then learns the roles that, in a lifelong double-bind of appropriation and refusal, one plays when living life. Family memories are learned and created in the double dynamics of forgetting and recollection, by telling and repeating, looking and looking again at them. Caught between mirrors and masks, images and narratives, we slide from one role to another, just as Eperjesi does when working with recycled images. A pictogram taken from the wrapping of a Vileda sponge represents those processes of social conditioning and self-fashioning through which one appropriates memories and social roles from others, while constructing her own identity. The images of *Family Album* simulate the repetition-structures inscribed into practices of identity formation and remembrance.

Seen from this angle, the use of recycled packaging seems more than reasonable. Why would one use real photographs if they are prone to all sorts of appropriations; if they can only function as props; if, as Victor Burgin observed, "the wholeness, coherence, identity, which we attribute to the depicted scene is a projection, a refusal of an impoverished reality in favor of an imaginary plenitude"?[3] Why would one use photographs if, as Barthes pointed out, "not only is the photograph never, in essence, a memory... but it actually blocks memory, and quickly becomes a counter memory"?[4] Eperjesi's gesture of substituting her family pictures for iconic commodity signs of the global market economy is a critical strategy, a questioning of the medium's claims to represent history and to capture memory. *Family Album* is based on the recognition that photography cannot be more than a code to a meaning which is located elsewhere, outside of its frame, yet it cannot refuse the possibility of iconic figuration.

The *Album* recognizes the impossibility of its own task and transforms itself, as well as the mnemonic process, into an apophatic discourse. Its apophatic character is shared by many other literary or visual works dealing with family photography and memory, yet Eperjesi's *Album* has a special place among them. Georges Perec, in his *W, or The Memory of Childhood*, describes his own childhood photographs without ever actually showing them. He cannot speak about anything but clothing and gives an annoyingly detailed account of outfits, hats,

155

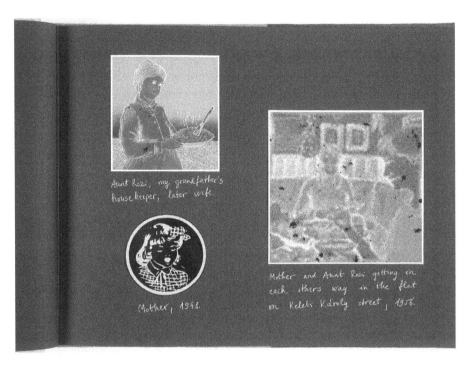

1. Ágnes Eperjesi, *Family Album,* 2004.
Photo: Bryan Whitney

and shoes, unable to connect the image to any trace of personal memory. In *Atlas,* Gerhard Richter merges sentimental family photographs of the 1930s with the images of Buchenwald, framing the family pictures as "souvenirs of a past that was left behind forever."[5] In his slide projection *One Moment in Time (Kitchen),* Jonathan Monk, the Berlin-based English artist, uses such fragmented descriptions as "Dad as the captain of a sailing ship," "You wearing stupid glasses," or "A landscape somewhere" as a substitute for actual family snapshots that were displayed in his mother's kitchen. Tacita Dean's *Floh,* a book composed of found family snapshots of strangers, escapes the autobiographical impulse. It refuses authorship and subjecthood when positioning the sequence of found photographs as a floating narrative of signs whose referents are undisclosed.[6] Fiona Tan's *Vox Populi: Norway,* a project commissioned by the Norwegian Parliament, is a collection of private photographs taken from the albums of Norwegian families.[7] All of these projects, including Eperjesi's,

2. Ágnes Eperjesi, *Family Album,* 2004.
Photo: Bryan Whitney

are balancing acts that display the ambiguities inscribed into the medium of photography, exposing it within the binaries of presence versus absence, anonymity versus individuality, private versus collective. Yet none of them offers to show the photographic through the use of non-photographic images as Eperjesi does.

Eperjesi's images are schemes and pictograms, designed to evoke archetypal images of people and things. The originals of the *Album* are already appropriated, modeled after images of family albums, private archives, and magazines; sculpted after scenes and sights of everyday life. Pictograms, family photographs, and snapshots share the banality and the repetitiousness of copies and simulacra: seeing them, we always have the impression of seeing them again—they are all without originals. If photography is a multiple without original, that is the ultimate copy, as is suggested by, among others, Rosalind Krauss, then pictograms seem to fall into the much-debated category of simu-

We move into a new flat, 1969.

Our pride, the television set.

3. Ágnes Eperjesi, *Family Album,* 2004.
Photo: Bryan Whitney

lacrum.[8] The simulacrum, as Gilles Deleuze understood it, "is built upon a dis-
parity or difference, it internalizes a dissimilarity,"[9] harboring "a positive power
which negates both the original and the copy, the model and the reproduc-
tion."[10] Eperjesi's work proposes a multilayered negotiation between original,
copy, and simulacra—a negotiation that is itself defined by acts of repetition,
enlargement, quoting, and recycling.

Because they are defined by replication, both photographs and pic-
tograms, just like memories, are treacherous and replaceable. Those who
made albums of and for their families from about the 1960s until the recent
emergence of digital photography—that is, in the age when family albums
functioned as unique repositories of personal and collective memory—knew
that well. Thus, in order to avoid confusion, they added captions. The of-
ten handwritten text created a material trace of its writer, but primarily
explained and attributed the image, making it clear that the old man with

158

With my best girlfriend, Mazzi.

Grandpa Jenő's house in Békéscsaba after reconstruction.

My kindergarten class, 1970.

4. Ágnes Eperjes, *Family Album*, 2004.
Photo: Bryan Whitney

the beard is Grandpa Jenő and not the neighbor. And what could illustrate better how much texts do to alter what we see than the way Eperjesi's images change their context through language? Despite being pictograms and symbols meant to speak for themselves, Eperjesi's pictures prove that nothing speaks for itself and an image is always half-empty: the picture of a family riding bicycles (Fig 5) also appears in one of the artist's self-portraits with an entirely different meaning. (Fig 6) According to the caption of *Family Album*, the two adults and a child are the parents and the younger brother of the artist, yet in *Self-portrait,* they appear to change their identity: "My new boyfriend gets along fine with my daughter / I hope it's not just a show for now". With a complicated and incestuous switch between genders and generations, the artist turned into her own mother, her younger brother became her daughter, and her father was her boyfriend, as if in a true Freudian family romance.

159

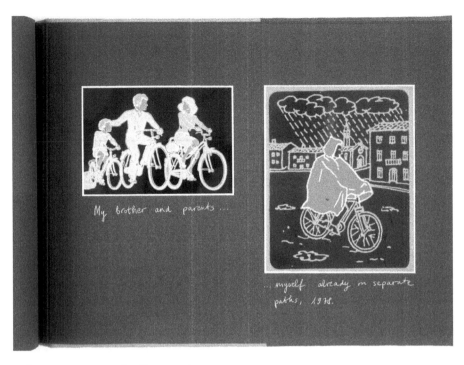

5. Ágnes Eperjesi, *Family Album*, 2004.
Photo: Bryan Whitney

Family Album's handwritten notes not only give a specific meaning to what is in front of us, but like signatures, they also authenticate the half-empty image and function as devices of personalization. The ordered chain of images in *Family Album* could suggest a family history without textual support, but the work could not become a visual biography without the text. It is through her manuscript that Eperjesi can appear as the protagonist of the story and the co-author of the anonymous pictogram designers, partially shedding the role of the household waste-manager, the tireless collector of cellophane pieces and wrappers. And it is by means of captions that *Family Album* becomes a cultural artifact able to reconstruct both personal and collective histories.

Eperjesi's places and stories take us to the half of Europe where, in 1948, dairy plants of grandfathers were nationalized by totalitarian administrations; where, in the 1960s, television sets were cherished as family treasures; where, in the spirit of collectivism, several generations of families had to share their

own apartments with strangers; and where the moving of one generation to a state-sponsored housing project was a dream come true. The *Album* eminently illustrates Pierre Bourdieu's remarks about family albums as things that express the essence of social memory.[11] In Hungary, where, as the critic Péter György reminds us, most of the traumas and major historical events of the twentieth century were suppressed through a collective, state-administered amnesia, and not only under the Socialist regime, *Family Album*'s engagement with the impossibility of historical recollection and its overlapping of private and collective history transgresses quietly—one is almost compelled to say, in private—the taboo of history and the politics of forgetting.[12] Nevertheless, the *Album*'s cultural, social, and geographical specificities and its capacity to deal with collective history are constantly undermined. Like other, real albums, this one also avoids representations of violence and trauma. There are no images of persecutions, re-

6. Ágnes Eperjesi, *Self Portrait* (from the series of Self Portraits 1-14), 2003. C-print + text on aluminium board, 63 x 48 inch

My new boyfriend gets along fine with my daughter. I hope it's not just a show for now.

Is it me or my mother talking?

7. Ágnes Eperjesi, *Self Portrait* (from the series of Self Portraits 1-14), 2003.
C-print + text on aluminium board, 50 x 48 inch

volts, or revolutions: collective and private histories appear separated. In 1956, it is
only Mom and Aunt Rozi who are getting in each other's way in the flat, instead of
the Soviet tanks and the Hungarian rebels who were getting in each others' way on
the street. (Fig 1) The *Album*'s potential to reflect history is also undermined by its
images' unknown or nonexistent origin, their simulacra-like character. Questioning the remembrance and the construction of narratives, *Family Album* confronts

162

its viewer with the question: how can culturally, geographically, and historically specific—that is, singular—stories be told via pictograms that were designed to circulate in the space of a global, transnational economy?

The pictograms made for mass consumption are turned not only into a vehicle of the production of the singular subject, but also, despite their technical inversion, into a material trace of the epoch. In *Family Album* history is not only enacted in private through the life of the author and her relatives, but it is literally objectified in the appropriated wrappers. Through the enlarged and reversed wrappers, Eperjesi defies the auratic appearance of the photographic image and precipitates its dematerialization in the age of electronic reproduction while also bringing into play another aspect of history, the material history of stuff. *Family Album* seems to introduce a materialist practice of memory and history, even though its medium and the things it represents belong to different historical epochs. The recycled commodity signs of the newly installed market economy and the implied visual and material world of socialist Hungary produces a gap between the very material of representation and the world that appears on the *Album*'s pages, demonstrating that, as Anette Kuhn put it, "the past is made in the present."[13] The image of the new flat, with its spacious design and sumptuous kitchen appliances, is nothing like the Hungarian apartments of the late 1960s (Fig. 3), and the futuristic design of Grandpa Jenő's house after reconstruction can exist only in Eperjesi's book. (Fig 4) Enhancing the arbitrariness of memory production, the *Album* plays on these historical, temporal, and material disjunctions, stages the difference between the time of events and the time of their retelling, and disrupts its own proposed chronology.

While it evokes the artistic strategies of the historical and neo-avant-gardes, including the found object, the Duchampian ready-made and postmodernist appropriations, Eperjesi's *Album* does not simply operate as an attempt to merge high and low, destabilize authorship, or comment on the politics of representation. The acts of repetition involved in her appropriation mirror those "rites of repetition"[14] that are the basis of remembrance and also of the construction of family narratives. Also, Eperjesi brings into question the economic aspects of appropriation, its sabotage-like effect and capacity to break down the chain of both production and consumption. The *Album* is interested in the culture of use; its critical potential lies precisely in its ability to address

the modes of production and consumption, as well as their material history, simultaneously. *Family Album* is neither a collage, nor a series of photographic doublings or mimetic adaptations, but a sequence of technical, historical, and material reversals and splittings. Akin to the way children deal with the material world—as observed by Walter Benjamin in *One-Way Street*—Eperjesi exposes the capacity to transform bits of cultural detritus into new things. Thus she practices a kind of recycling that never replicates the world as it is, but rather reminds us that things might be other than they are.[15]

Acting as a scavenger and an archaeologist of the everyday, Eperjesi converts the debris of mass-market culture into visual autobiography, producing a work that could also be considered an example of trashcan culture or rubbish theory.[16] Building memories out of rubbish instead of photographs, as was stated already, is part of Eperjesi's acknowledgment of photography's incapacity to deal with memory. It is a recognition shared by many, most famously by Siegfried Kracauer. When linking trash, photography, and memory, Kracauer stated, "from the perspective of memory, photography appears as a jumble that consists partly of garbage."[17] Discarding photographs and preserving a piece of trash while returning it to the universe of usable and valuable goods seems not only a good idea, but also an economically and environmentally advisable one.

And who would care about the content of the household trash more than those women who are also in charge of putting together family albums? Eperjesi's recycling and appropriation shares a lot with the domestic economy and waste management of the households of the Soviet bloc, where women had to learn how to preserve everything in case it might be useful for something else. The material scarcity of the war years and then of the socialist era prolonged the pre-consumerist culture of recycling that, well before the emergence of environmental consciousness of today's market economy, necessarily treated as reusable the bits and pieces of everyday life. A constitutive experience in Eperjesi's work and subject formation, this form of recycling compliments those gender-specific analogies of *Family Album* that could be found among the fancyworks, scrapbooks, family albums, and memory books of millions of other women, both in Hungary and elsewhere. The laborious transformation of everyday objects, like the preservation of family history, is not only gender-specific work, but is also characterized by multigenerational experiences and practices.

In *Family Album*, domestic life and family photography are brought together in a single act. Overlapping the family album as a medium of private, domestic life with the wrappings, the material residues of domestic and household goods, Eperjesi merges the spaces and concepts of domesticity. Preserving and treasuring the packaging like photographs of carefully edited family albums, she focuses on the material aspects of memory: whether it is the reminiscence of consumer culture or family life, in Eperjesi's practice memories are materialized and appear in bodily forms. Collecting, keeping, and recycling wrappers as photographic images were once collected, kept, and occasionally recycled, she brings together the pre-digitalized form of family photography with patterns of pre-consumerist recycling while also modeling their simultaneous disappearance. *Family Album* "is a totally real, fictional album," that is, a fictional private document, but also a not-at-all fictional discourse. While remembering, repeating, and working through, as Freud might say, Eperjesi has created a discursive object that is historically specific, yet acknowledges the impossibility of historical representation; that is an autobiographical confession, yet through its opacity resists prevalent industries of ego-history; and that contains not a single photograph, yet is still able to speak about the photographic.

Notes

1 Ágnes Eperjesi, *Family Album,* 2004. Edition of 28, numbered and signed, 26 x 35.5 cm, 18 pages, 52 original C-print, hand-bound. Unless otherwise noted, all references to Eperjesi's text are retrieved from

http://www.sztaki.hu/providers/eper/works/recycled_pictures/index_family_album.html

2 Margaret Olin, "Touching Photographs: Roland Barthes's 'Mistaken' Identification," *Representations*, no. 80 (Fall 2002): 99–118.

3 Victor Burgin, "Looking at Photographs," in *Thinking Photography*, ed. Victor Burgin (London: Macmillan, 1982), 147.

4 Roland Barthes, *Camera Lucida: Reflections on Photography,* trans. Richard Howard (New York: Hill and Wang, 1981), 91.

5 Benjamin H. D. Buchloh, "Gerhard Richter's Atlas: The Anomic Archive," *October* 88 (Spring 1999): 136.

6 Tacita Dean, in collaboration with Martyn Ridgewell, *Floh* (London: Steidl, 2001).

7 Fiona Tan, *Vox Populi: Norway* (London: Book Works, 2005).

8 Rosalind Krauss, "Reinventing the Medium," *Critical Inquiry* 25: 2 (Winter 1999): 289–305.

9 Paul Patton, "Anti-Platonism and Art," in *Gilles Deleuze and the Theater of Philosophy*, eds. Constantin V. Boundas and Dorothea Olkowski (New York: Routledge, 1994), 149.

10 Gilles Deleuze, *The Logic of Sense*, trans. Mark Lester with Charles Stivale, ed. Constantin V. Boundas (New York: Columbia University Press, 1990), 53.

11 Pierre Bourdieu, *Photography: A Middle-Brow Art* (Palo Alto, CA: Stanford University Press, 1990), 30.

12 Péter György, "Az emlékezettörténet társadalomtörténete" [The social history of memory], *Élet és Irodalom* 49, no. 51 (2005).

13 Annette Kuhn, "Remembrance," in *Family Snaps: The Meaning of Domestic Photography*, eds. Jo Spence and Patricia Holland (London: Virago, 1991), 22.

14 Martha Langford, *Suspended Conversations: The Afterlife of Memory in Photographic Albums* (Montreal: McGill-Queen's University Press, 2001), 36.

15 Walter Benjamin, "One-Way Street," in *Reflections: Essays, Aphorisms, Autobiographical Writing*, trans. Edmund Jephcott, edited and with an introduction by Peter Demetz (New York: Schocken Books, 1978), 68–69.

16 Michael Thompson, *Rubbish Theory: The Creation and Destruction of Value* (Oxford: Oxford University Press, 1979).

17 Siegfried Kracauer, "Photography," *Critical Inquiry* 19: 3 (Spring 1993): 425–426.s

OBJECT/PHOTO/REALITY

From Photo to Object

Personal Documents as History-Writing in the Works of Christian Boltanski and Ilya Kabakov

Éva Forgács

The use of real objects—and junk in particular—in art is the most visible sign of the reassessment of not only the aesthetic hierarchy (traditionally with "beauty" on the top) but also the way the Western narrative has been reconstructed since photography turned it upside down. While oil painting was from-the-top-down narrative—that of divinities, kings and queens, famous battles, and outstanding individuals or, at least, the life of the mainstream bourgeoisie—the photo, ever since the coated photographic paper and Kodak's first portable box camera were marketed in the late 1890s, was grassroots narrative, from-the-bottom-up, anyone's private image-making. Levels of reality that had not been accounted for throughout history became visible and documented. Any individual with a camera could, by clicking a button, turn a previously unnoticed and unacknowledged segment of the world a part of collective memory.

Photography has chipped into the unified Great Narrative by breaking it up into splinters of individually created narratives in art. Private photographic documentation of daily life was now possible. The two different approaches, the aesthetic and the documentary, inevitably blended in many photographic images. It would be far beyond the scope of this paper to explore the analogy

169

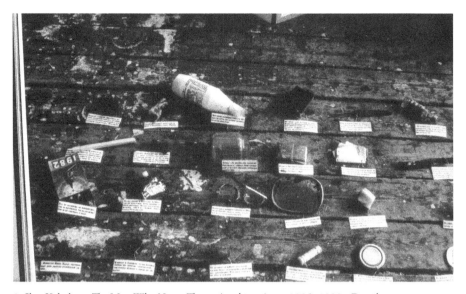

1. Ilya Kabakov, *The Man Who Never Threw Anything Away,* 1985–1988. Detail.
Courtesy of the artist.

between the emergence of photography and sociology, the study of the social reality on the ground as opposed to the narrative of great heroes. It would also surpass this paper's boundaries to discuss the use of photography for the documentation of the society, or the connection between the vivid interests of mass societies' alienated citizens in each other's private pictures. The process has most probably been mediated by such semi-documentary, semi-artistic photographic activities as photojournalism, as well as the ubiquity of images in the print and now the electronic media.

Another reason why the artistic photo and the photo as personal document merged is, as Susan Sontag and Roland Barthes pointed out in their respective essays,[1] inherent in the medium. Photography, capturing a nanosecond of the present as it is becoming past as soon as the camera is clicked on it, is about transition. It is inseparable from the awareness of passing away, and the melancholy and anxiety that pervade our secular culture with regard to the fact of death.

The French artist Christian Boltanski was one of the first to exploit this double implication of photography. In 1970 he exhibited a family photo of a

thirteen-year-old boy under the title *The Last Photo of Paul Chardon*, playing on the double meaning of the word "last" both as "the latest" and "the final." Inspired by the casual clumsiness of family snapshots, he took pictures from a friend's family album and re-photographed and enlarged them to a uniform size. He presented them as a piece of art that consists of a series of framed photos, suggesting monotony as well as a systemic rhythm. Breaking up the homogeneity of the photographic material, he then started to mix objects among photos. In *Reference Glass Cases* he displayed photos of himself, a few artworks he had made, and photos of some of his works as a future historic presentation documenting his personality and activities. His project explored that objects have the same documentary value as photos and bespeak transition as he made visits to the Musée de l'Homme in Paris. In an interview he said:

> ...it was there that I saw large metal and glass vitrines in which were placed small, fragile, and insignificant objects. A yellowed photograph showing a "savage" handling his little objects was often placed in the corner of the vitrine. Each vitrine presented a lost world: the savage in the photograph was most likely dead; the objects had become useless—anyway there's no one left who knows how to use them. The Musée de l'Homme seemed like a big morgue to me. Numerous artists discovered the human sciences (linguistics, sociology, and archeology) there...[2]

In 1973 Boltanski sent out letters to sixty-two natural history museums and a few curators, suggesting that they purchase and exhibit all the belongings of a person in the neighborhood who had recently died. He wrote that the museums should present the objects, which "surrounded a person during their life, and which, after their death, remain the witnesses of their existence..."[3] He photographed the objects that had belonged to an Oxford resident, and once again created a tableau of equal-sized, framed images like *D. Family's Album.* (Fig. 3)

He made a limited-size, fictitious version of this project in his *Clothes of François C.,* where he photographed various items of clothing put into equal-size boxes under glass. The boy was alive and well, but Boltanski exploited the

effect of the photos, that, exactly as someone's belongings, point to the absence of the person. Objects, because of their banality, material reality, texture, and accidental, non-artistic character, are even more evocative and poignant than photos.

At a time of growing awareness of the possibility to manipulate photos, the power of family snapshots lay in their spontaneity and their apparently purely improvised character. Boltanski recognized that objects, in their bare, indifferent physicality, are even more innocent and unintentional than snapshots: a pair of used, soiled socks can be a testimony far more vivid than a composed photographic image.

In many of his works, the former Soviet artist Ilya Kabakov came to realize the same documentary and narrative function of things. By using not just banal objects but mostly pieces of garbage "accurately labeled, with a five or six digit number glued on [them],"[4] he extends his horizon to an entire historical era: life in the Soviet Union, the experience of which he does not want to sink into oblivion. (Fig. 1-2) Putting a label on a thing is like clicking the camera. It freezes the object, and instantly puts it in historical perspective. As the example of one of his *Ten Characters* (1986–1988), *The Man Who Never Threw Anything Away*, demonstrates, what Kabakov is intrigued by is the perspective that will have been gained in time, posterity that is, when someone will be remembered as "a man who never threw anything away." What is at stake is, in fact, to be remembered;—to be saved for posterity. This is also the aim of family photography.

To this end, both artists have written verbal snapshots, which also function as photos. For example, in 1990 Boltanski wrote, in the form of "found texts," fictitious recollections of himself "collected" under the title *What They Remember*. He lists a hundred possible views on himself, imagining being put in perspective by posterity. Thinking "back" on himself through the eyes of others, he pictures his life as an already completed narrative. The textual fragments, like uniformly framed photos, are parts of the puzzle that should add up to "the real Christian Boltanski." For example:
"He loved spaghetti, I remember once in a pizzeria near the Boulevard Saint-Germain he ate two platefuls in one sitting."
"As a child he hardly ever spoke and he seemed to be a bit disturbed."

"He was extremely nervous, slept badly, but nobody ever managed to get him off his habit of drinking ten coffees a day."

Ilya Kabakov's version of putting himself in perspective is his installation *The Rope of Life*, dates from the same year, 1990. He wrote an introduction to it: "I decided to depict my life in the form of a rope, and arrange all the events in my life, one after the other, on it." The eight-meter-long rope, uncoiling on the floor, has pieces of garbage attached to it with white labels for "fragments of a biography."[5]

Kabakov's autobiography, like Boltanski's *What They Remember*, is a written mosaic of snapshots. Even the dimensions of the two works are similar: Kabakov's narrative includes 109 entries.

While Boltanski constructs a shadowy narrative out of the photographically recorded fragments of the life of a concrete family, and uses the belongings of a concrete individual also as fragments of a personal narrative (although in his later work he constructs a much more general historical narrative), Kabakov uses fragments of fragments: junk, leftover, dysfunctional parts of former objects, which are more

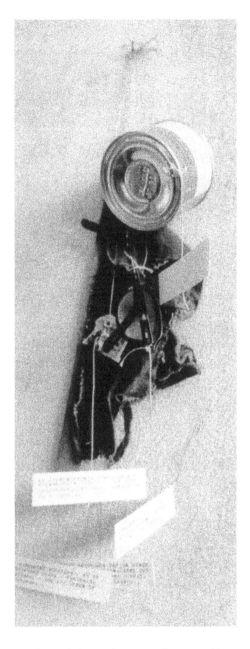

2. Ilya Kabakov, *The Man Who Never Threw Anything Away*, 1985–1988. Detail.
Courtesy of the artist.

3. Christian Boltanski, *D. Family's Album, 1939-1964,* 1971. Detail.

of an ethnographic than an individual reference, belonging to the Musée de l'Homme rather than to a family album. These non-individuated pieces offer a historical narrative, putting the Soviet man into the same perspective as the Eskimo in a showcase.

The difference is that here *garbage* functions as collective memory. Kabakov is attached to the broken, dirty, and useless fragments as the true documents of life in the Soviet Union. "To deprive ourselves of these paper symbols and testimonies is to deprive ourselves somewhat of our memories," he wrote. "In our memory everything becomes equally valuable and significant. All points of our recollections are tied to one another. They form chains and connections in our memory which ultimately comprise our life, the story of our life. To deprive ourselves of this all means to part with who we were in the past, and in a certain sense, it means to cease to exist."[6]

174

The compelling narratives of both Boltanski and Kabakov have been created in order to overcome oblivion—not only generally, but also in the very specific cases of traumatic historic facts. "So natural is the impulse to narrate," Hayden White writes, "that narrativity could appear problematical only in a culture in which it was absent—or, as in some domains of... contemporary Western culture, programmatically refused."[7] Narrative was long refused, among other things, on the Holocaust, and, within the Soviet Union, on most aspects of the Soviet reality. Both Boltanski (in a body of work not discussed here) and Kabakov bring these arrested narratives back to life.

For Boltanski, as if demonstrating Roland Barthes's concept of photography, every image is potentially the last one, or can be viewed as such, either of one person or of a group of people. For Kabakov the object of anxiety is not something threatening that has not yet occurred, but something that already materialized: the Soviet state, and human life in it; a truth that should not disappear without being properly documented. It is the scandal of that existence, and the sense that human lives made under those circumstances, that needs to be documented.

Kabakov extends the narrative to the whole culture, suggesting that its emblematic image, consistent with the role of garbage in individual life, is the dump. He writes about it as a collection of memories, a replacement of a monumental collection of photographic images:

> The... dump is full of twinkling stars, reflections and fragments of culture... it's an image of a certain civilization which is slowly sinking under the pressure of unknown cataclysms... The feeling of vast, cosmic existence encompasses a person at these dumps; this is by no means a feeling of neglect, of the perishing of life, but just the opposite—a feeling of its return, a full circle, because as long as memory exists that's how long everything that is connected to life will live.[8]

Notes

1 Susan Sontag, *On Photography* (New York: Farrar, Straus and Giroux, 1977), originally published as a series of essays in the *New York Review of Books* starting in 1973; Roland Barthes, *Camera Lucida*, trans. Richard Howard (New York: Farrar, Straus and Giroux, 1981), originally published in Paris (Editions du Seuil, 1980).

2 Quoted by Lynn Gumpert in Lynn Gumpert and Mary Jane Jacob, eds., *Christian Boltanski: Lessons of Darkness* (Chicago: Museum of Contemporary Art, 1988), 32.

3 Lynn Gumpert, *Christian Boltanski*, 40–41

4 I. Kabakov, *Ten Characters* (New York: ICA-Ronald Feldman Fine Arts, 1989), 43.

5 Ilya Kabakov, *The Rope of Life and Other Installations*, Fred Hoffmann Gallery, Santa Monica, CA, January 13–February 10, 1990.

6 Ibid.

7 Hayden White, "The Value of Narrativity in the Representation of Reality," in *On Narrative*, ed. W.J.T. Mitchell (Chicago and London: University of Chicago Press, 1984), 1.

8 Ibid., 45.

Home Museum

An Installation by Katarina Šević and Gergely László

Hedvig Turai

"It was not until 13 years after the war in Yugoslavia that Serb citizens could first enter Croatia without a visa. Many Serb citizens took this opportunity already in the first year to go and see the properties or holiday homes they had left behind. When they got there, many of them found that their property now belonged to new owners or was in ruins. Often, the local communities and the army joined forces in ruining Serb people's property."[1] This was also how the Ševićs repossessed their small holiday home in Zuljana, Croatia. (Fig. 1) The first thing Katarina Šević and her partner Gergely László did was to clean the house. When the two artists began to tidy up the house, at first, carried away by their own action, they threw away most of the things they found.[2] Tidying means rearranging and sorting things, creating a new order or attempting to restore the old. Soon, the artists realized that what was rubbish for them may have been part of someone else's life, and that the act of cleaning up had consequences. They classified the artifacts using the methods of archaeological classification, dated them, and then exhibited them under the title *Home Museum*.[3]

In everyday life, cleaning the house means getting rid of the superfluous, the dirty, the repulsive. Scientific archiving is based on very similar principles:

1. The house in Zuljana, 1970s

to keep what is significant, what is to be preserved for posterity, and to dispose of what is not valuable and is not needed. As the criteria by which something is deemed significant or insignificant are continuously changing, history has shown that sources, documents, and objects that had once been considered insignificant, and therefore survived almost only by accident, turned out to have value as evidence. Therefore, if one wishes to be really prudent, it is not easy to decide what to throw away. Repossessing their property, the cleaners of the house turned into the preservers of the artifacts, the traces. Accepting and taking stock of these objects also implies that the building had a pre-Šević period and will also have a post-Šević period. The small holiday home is also tied to the seasons: during certain periods of the year it was full of life, while in others it went into hibernation. The war kept the Šević from visiting the area where their holiday home was, but the life and decay of the house continued—without them. It was like when someone gets locked out of their house, from their own life, but life and decay goes on inside without them. It is as if someone had a chance to see what happens after they die.

We can also interpret cleaning as a study or analysis of the past. The remains whirling in the present must be arranged relative to the various layers of the past, effectively tied to them. And by doing so, we must prevent them from breaking into the present again; the traumatic experience must be hindered from imposing itself upon the present. What Katarina Šević and Gergely László did was this kind of conscious tidying-up; they did not succumb to melancholy, to the bittersweet mood of the memories stirred by the objects. They chose to use a scientific method, namely, the archiving of the artifacts, followed by the objective method of analysis and classification used in archaeology and archaeological museums.[4] The exhibits on display are accompanied by documents, such as applications for a construction permit, postcards, family photos in which the house appears, and private letters, including one in which Đorđe Šević says: "To me it [the house] began to mean something like a painting to a painter—as if it were my own creation. It would be hard for me to accept if someone lived in it for whom it is no more than a property they possess. For me it is a work of art."[5]

The house is only the background in the family photographs; when they were made the focus was on the human characters—Katarina, her cousins, and members of the family were the central figures. (Fig. 2-3) But now, the perspectives have changed; figure and ground have swapped places. The ground has also become a central character, and every small object that has survived has become an evidence of something—and so has gained significance. Like the family photos, the private letters and the postcards have also turned into documents, historical evidence. Their documentary value, their authenticity, comes from the fact that they are amateur family photos. They were not intended to become documents; the fact that they were taken as amateur family photos guarantees that they were not manipulated. The photo is a material proof, it is authentic, and, as Roland Barthes says, it has the power to establish facts. "From a phenomenological viewpoint, in the Photograph, the power of authentication exceeds the power of representation."[6] It is a direct print of reality. It is not self-evident that we attribute this realness, this power of authentication, to the photograph. As John Tagg describes it in his book, *The Burden of Representation*,[7] this power came to exist as a product of the relationship between photography and institutions, photography and the state. The history of

2. Katarina and her cousins in front of the house in Zuljana, around 1985

photography is closely related to the history of other institutions. This means that the photograph is not only the obscure object of nostalgia and melancholy, but is a part of history, and the way we think about it is a product of particular contexts, powers, and purposes. John Tagg describes how institutions needed to keep files in order to be able to exercise authority and power.[8] They had to identify people, primarily for purposes of criminology, in prisons and mental hospitals, and photographs were also used for that purpose. And museums can be added to this list. These institutions, including museums, are important elements of the power structure for exercising control over the society and for administration. Photography, historiography, and the museum all use a documentarist, realist rhetoric when they pretend that they present to us a transparent reality without intervention or interests. According to Tagg, "Realism offers a fixity in which the signifier is treated as if it were identical with a pre-existent signified and in which the reader's role is purely that of consumer. It is this

3. Katarina Šević and Gergely László in front of the house in Zuljana, around 2005

realist mode with which we are confronted when we look at the photograph as evidence. In realism, the process of production of a signified through the action of a signifying chain is not seen. It is the product that is stressed, and production that is repressed."[9] Family photographs have a melancholic story in which we are looking for our past, our roots, and we believe that we have found reality, while in fact, we produce fictions, we relate the unknown past with the present, and we feel nostalgic about the future in advance. But the photograph also has a much more matter-of-fact and less poetic story, in which it is considered as a direct imprint of reality, and as such, it is connected to the strictest order, administration, and power. The aspect of the family, sentiments, and looking for our own past meets the strict rules of filing and museums.

The meaning of simple objects changes in the exhibition area. In Joseph Beuys's display cases, every trivial industrial object gains a higher value and acquires the meaning associated with being part of the great artist's life and of the

4. *Home Museum.* Installation, 2006. Detail.

individual mythology the artist creates for himself. Marcel Broodthaers created his own fictions, his museums using the rational scientific documentary method of classification. Christian Boltanski's objects and photographs displayed in museum display cases demonstrate the futility of the archiving effort.[10] He investigates, collects, and classifies—apparently, he intends to secure memory and his own eternal life.[11] According to Ernst van Alphen, "Boltanski turned himself into the archivist of his own work. [...] he was the archivist of his own childhood. These reconstructions, however, fail utterly *as* reconstructions, for they prove incapable of reconstructing either his childhood or his artistic career. Instead, all we see is useless objects. The frame of the museological vitrine or the archaeological museum—in short, the archival mode of representation—withdraws objects from the contexts in which they originally belonged." This means that, as Alphen continues later, "Boltanski helps us understand why the museum can be such an effective tool, or perhaps I should now say weapon, in killing memories. Like archives, museums, especially historical museums, confront the viewer with de-contextualized objects. In this de-contextualization

the objects become 'useless' and they evoke the 'absence' of the world of which they were originally part. It is in this respect that the archival museum can become a 'morgue of useless objects.'"[12] Many contemporary artists[13] choose the framework of the archive and museum discourse when they deal with history,[14] especially the Holocaust.[15] And when they do so, they also call attention to the frames that we cannot regard as "natural," and to the process of how we interact with history.

5. *Home Museum.* Installation, 2006. Detail.

Katarina Šević and Gergely László's *Home Museum* also fits into this circle of thought. (Fig. 4) Using the terms of Hal Foster, they too, are led by their "archival impulse."[16] This form of exhibition invites the spectator to make the connection on his or her own between the events of the past and material (including photographic) legacy, and perhaps to reconsider their earlier views and not to take for granted and consider as objective the forms of presentation—in other words, to think instead of accepting as finally given what they "have to" think.[17] Katarina Šević and Gergely László follow the conventional "scientific" methods of museology: they date the artifacts and photographs, number them, and present them to us in a chronological order. This is despite the fact that the curators of *Home Museum* select the exhibits according to their own criteria, classify the objects, and turn into stories and museum artifacts such objects as a disposable razor, a soap box, a broken plastic kefir cup, and a decaying book, artifacts they excavated when they returned after the war. The exhibits of *Home Museum* also include the archaeological finds of the future: they toy with the idea that a plastic soap box will one day become a rarity, an artifact. (Fig. 5) They redirect our gaze to the display cases of the "grand," official, state historical museums, and to the objects in them. We come to suspect that this home museum is like those… or rather, are those like this? In this respect, the exhibition is a continuation of what Katarina Šević did before, in a more playful manner, for example by

183

trying to give us a formula of how to look at the objects of an exhibition and behave in a museum.[18]

The name "home museum" also evokes "home medicine chest," "home-made *palinka*" (brandy), "homemade jam," and "home blessing." These are things that are made, kept, or done at home, using domestic methods, but at the same time, with more care and with a more prudent use of materials than things mass-produced in factories where professional methods are applied. Its maker has a closer, totally personal relationship with something made domes-tically. And in fact, some products are prepared professionally when they are made at home; that is, homemade is sometimes better than what you get in shops. The history of home museums also goes back to *Wunderkammers*, but in this small home museum there are such "treasures" and "rarities" as a worn-out stew pot, a broken razorblade, or an unidentifiable pile of dirt. The *Home Museum* is also something of an institutional critique; it is contrasted to the state museum, personal history contrasted to official grand history. It reminds one of the "museum" of conceptual art, which offered an alternative to state museums and commercial galleries, and can be small enough to fit into a folder. Yet what distinguishes *Home Museum* from all of these is its tone—the absence of melancholy, personal mythology, and combative opposition. The research of the private sphere is related to the broader, trauma-filled common history of Yugoslavia; the community sphere is intertwined with the private sphere. Poli-tics enters the small house, the *domus*.

The house in Zuljana was one of the scenes of Katarina Šević's child-hood. And, as in an ordinary historical exhibition, letters, photographs, and di-ary entries try to clarify, document, and even replace fading memories. Gergely László digs into the ruins of the house—he effectively takes over Katarina's memories—and this is how he becomes part of the history that he did not ex-perience personally. The ways in which the past they explore belongs to them are different; *Home Museum* is the product of cooperation. They also make reference to Đorđe Šević's feelings because, as is clear from the passage quoted above, the father sees the house as a work of art; thus it must be in the museum! Nevertheless, Katarina Šević and Gergely László are not sentimental or mock-ing. The makers of *Home Museum* do not complain; they do not search for truth or seek compensation. They do not play on the melancholy mood of the

photos, the feeling of fading away in them. They do not express their sadness, their feeling of loss. The dispassionateness of the archaeological museum is the perfect setting for all this; all they have to do is classify the objects and arrange them for the exhibition accordingly. Katarina Šević does not mythologize her life or the role of the artist; she returns to the house in Zuljana without tears in her eyes.

We can speak of a real loss in connection with the house, because due to the war, theŠevićs, who are Serbs, were able to return to their holiday home in Croatia only after several years. By then the house had been ransacked; the building once built on the ruins of a building was now in ruins itself—a typical story in the Balkans. Dubravka Ugrešić—a writer who is half-Serbian and half-Croatian, and lives in emigration—invented Simonides of the Balkans, the new metaphoric figure of memory.[19] Cicero tells us that Simonides of Ceos invented memory. According to the story, Scopas, a nobleman of Thessaly, invited Simonides, the poet, to a banquet he held at his palace and commissioned him to write a poem to preserve the memory of the banquet. During the banquet, Simonides had to leave because two young men wanted to speak to him, and while he was away, the roof of the palace collapsed. Everyone inside was killed, and their bodies were crushed beyond recognition. Not even their relatives could identify them, and so they could not be buried. Simonides, however, *remembered* who had sat where; thus he was able to identify the bodies. Dubravka Ugrešić adapts this story to the former Yugoslavia, and continues it like this: while Simonides is identifying the guests of the banquet, the rest of the walls of the palace crumble and kill Simonides too. Afterwards, the witnesses can only remember what they saw during the second collapse. And this is how it has been going on for centuries. Everyone remembers only his or her own past, and not that of others.

People who left the Balkans continue Simonides' work obsessively.[20] Katarina, who is Serbian and has not lived in her home country for a long time, encountered the war and the scene of her childhood holidays while tidying up the house. She is forced into the deep layers of the past, and by dating the objects, she writes herself and her family into history. She can only find fragments and ruins, and by preserving them she also preserves the traces of other people. By doing so, she perhaps symbolically breaks the chain in which everyone remem-

185

bers only his or her own past. She does not intend to do justice, nor does she want to make her loss greater than others'. Museums, in a seemingly impartial way, present and conserve the past, but in fact, the museum is the medium of terminating and forgetting and, in extreme cases, of final elimination.[21] While she remembers, Katarina also preserves, and she does so in order to be able to forget, to close the past and work it through, which is also a problem of her identity, for once she was part of a great common Yugoslav past; that is where she comes from, and that is what constitutes her identity today. And since she is inclined to irony and a bit of sarcasm, she chooses to use the right framework for her purpose: she uses everything the critical literature on the museum and archives discusses, namely, that the museum is a frame that presents us a story in an objective manner, it is made up of real found objects; yet it is obviously constructed, it is real and fictitious at the same time, and the private and public spheres are intertwined in its space.[22] And all this is done by a Serbian artist who left the Balkans. She is one of those about whom Petar Ramadonović says: "We, Ugrešić and I, and others who left Yugoslavia unable to take sides, can neither remember nor forget Yugoslavia—the former Yugoslavia, a former 'we.' Of course, the roof and the walls of Scopas's Balkan House do not cease collapsing. We continue to be caught inside—inside the forgetting, inside the confusion of this disaster without a key. But we also continue to turn away."[23]

English translation by Zsolt Kozma

Notes

1 Quoted from the brochure of the exhibition.

2 Ibid.

3 The opening of the exhibition was a satellite event of the conference in the atrium of the Hungarian Academy of Fine Arts in Budapest (November 8-24, 2006), curated by Eszter Lázár.

4 This is how the artists described their method: "We divided the artifacts into three categories: Category 1: X-1971. The building whose walls are still there today was built by Đorđe Šević on the ruins of a house constructed about 150 years ago. Artifacts in Category 1 are ones that we estimate to have survived from the times before the new house was built. Most of them were found in the soil during weeding. Category 2: 1971–1990. The new house was built in 1971 on

the ruins of the old one. The only wall of the old house that survived became part of the new building. We classified as Category 2 object artifacts that are most likely to have been owned by the Ševićs. Category 3: 1990–2002. This category includes objects that have been collected since the war broke out. Unfortunately, we disposed of many of the artifacts, consequently, only a few items are displayed in the museum." Ibid.

5 From a letter displayed in the exhibition.

6 Roland Barthes, *Camera Lucida* (London: 1981), 88–89. Quoted by John Tagg, *The Burden of Representation* (Minneapolis: University of Minnesota Press, 1993), 1.

7 Tagg, *Burden*.

8 Tagg, *Burden*, 3–4.

9 Tagg, *Burden*, 99.

10 Christian Boltanski, "Research and Presentation of All That Remains of My Childhood 1944–1950/1969," in *The Archive: Documents of Contemporary Art,* ed. Charles Merewether (London: White Chapel; Cambridge, MA, The MIT Press, 2006), 25.

11 Ibid.

12 Ernst van Alphen, "A vizuális archívumok és a holokauszt" [Visual archives and the Holocaust], *Enigma* 11, no. 42 (2004): 12.

13 Just a few random examples: Gerhard Richter, Ilja Kabakov, the Atlas Group, Akram Zaatari, Fred Wilson, Ydessa Hendeles, and Sigrid Sigurdsson.

14 Hal Foster, "An Archival Impulse," *October* 110 (Fall 2004).

15 Van Alphen, "A vizuális archívumok."

16 Foster, "Archival Impulse," 3–22.

17 Mark Godfrey, "The Artist as Historian," *October* 120 (Spring 2007), 142.

18 Katarina Šević and Zita Majoros, *Fitness Center* (installation, Stúdió Galéria, Budapest, 2001).

19 Dubravka Ugrešić, "The Confiscation of Memory," *New Left Review*, no. 218 (July/August 1996): 38–39.

20 Petar Ramadonović, "Simonides on the Balkans," in *Balkan as Metaphor: Between Globalization and Fragmentation,* eds. Dusan I. Bjelic and Obrad Savic (Cambridge, MA, and London: MIT Press, 2002), 358.

21 Van Alphen, "A vizuális archívumok," 12.

22 Foster, "Archival Impulse," 5.

23 Ramadonović, "Simonides on the Balkans," 363.

Contributors

András Bán is an art critic and Associate Professor at the University of Miskolc where he has taught visual anthropology since 1993. He has published extensively on contemporary art and photography and regularly organizes exhibitions. Since 2008 he has been the director of the Miskolc Museum of Art, MIMA, and is the founder of the Miskolc Institute of Contemporary Art (MICA) as well as the Pedagogical Museum of Contemporary Art. His main works include *A fényképezésről* (On Photographing, 1984); *Fotóelméleti szöveggyűjtemény* (An Anthology of Photographic Theory, with László Beke, 1983, 1997); *A video világa* (Video World, with László Beke, 1983); *Körülírt képek: Fényképezés és kultúrakutatás* (Traced Images: Photography and Cultural Studies, 1999); *A vizuális antropológia felé* (Towards a Visual Anthropology: Selected Studies, 2009). He has been editor of the journals *Fényképészeti Lapok* (Journal of Photography, with László Lugosi-Lugo) 1981–82 and PIK (Journal of Post Intellectual Studies, with Krisztina Erdei, Szilvia Nagy and Dániel Sipos) since 2009.

Zsófia Bán is Associate Professor of American Studies at Eötvös Loránd University, Budapest where she teaches literature and visual culture studies. Her research areas include word and image studies, gender in art and literature, photography and memory, trauma in art and literature, as well as cultural memory. As a critic and essayist, she has published extensively on contemporary art and literature, most recently a comparative study on the work of Péter Forgács and Péter Nádas in the catalogue for the Hungarian Pavilion at the 2009 Venice Biennale. She is also a fiction writer. Her books include *Words and Images of Postmodernism in the Late Poetry of William Carlos Williams; Amerikáner* (essays on cult works in American culture) and *Test Packing* (essays on art, literature, travel and memory).

189

Ágnes Berecz (PhD, Université Paris I, Panthéon-Sorbonne, 2006) teaches modern and contemporary art history at the Pratt Institute, at the Department of Graduate Studies of The Fashion Insitute of Technology and at The Museum of Modern Art in New York. The New York correspondent of the Budapest-based art monthly, *Műértő*, she is currently writing a book about the cultural politics of painting in postwar France. Her writings have been published in *Art in America*, *Artmargins* and *Praesens* as well as in European and US exhibition catalogues. Her most recent work includes "Painting Lessons: Hantaï and His Critics" in the Winter 2008 issue of *Art Journal*, "Grand Slam: Histories of and by Georges Mathieu" in the *Yale University Art Gallery Bulletin,* and "Close Encounters: On Pierre Restany and Nouveau Réalisme," forthcoming in the catalogue of the exhibition *New Realisms, 1957–1962* in June 2010 at the Reina Sofia in Madrid.

Géza Boros is an art historian in Budapest, working for the Ministry of Culture. His research interests are in Hungarian sculpture and political monuments after 1945. His publications include *Emlékművek '56-nak* (Memorials for '56, Budapest: Institute for the History of the 1956 Hungarian Revolution, 1997), *Statue Park* (Budapest: City Hall Publishing House, 2002) and a volume of his collected writings, *Emlék/mű. Művészet – Köztér – Vizulitás a rendszerváltozástól a millenniumig* (Memorials: Art – Public Space – Visuality from the Politicial Transition through the Millenium, Budapest: Enciklopédia Publishing House, 2001).

Eva Forgacs is adjunct Professor of Art History at Art Center College of Design in Pasadena, and the Otis College of Art and Design in Los Angeles. She had taught at the László Moholy-Nagy University in her native Budapest, and was Visiting Professor at UCLA and the College of Santa Fe. She was co-curator (with N. Perloff) of *Monuments of the Future: Designs by El Lissitzky* at the Getty Research Institute in 1998. Her books include *The Bauhaus Idea and Bauhaus Politics* (Pécs: Jelenkor, 1991; Budapest: CEU Press, 1995), *László Fehér* (1998), and the co-edited volumes (with T. O. Benson) *Between Worlds: A Sourcebook of Central European Avant-Gardes* (The MIT Press, 2002), and, (with Susan S. Suleiman) *Contemporary Jewish Writing in Hungary*, University of Nebraska Press, 2003. She has published essays and reviews in journals, edited volumes, and catalogues.

190

Marianne Hirsch is Professor of English and Comparative Literature at Columbia University and Co-Director of the Center for the Critical analysis of Social Difference. Most recently, together with Leo Spitzer, she published *Ghosts of Home: The Afterlife of Czernowitz in Jewish Memory*. Among her many other publications, she is the author of *Family Frames: Photography, Narrative, and Postmemory*, *The Familial Gaze*, a special issue of *Signs* on "Gender and Cultural Memory," and *Teaching the Representation of the Holocaus*t. She has also published widely on cultural memory, visuality and gender, particularly on the representation of World War II and the Holocaust in literature, testimony and photography.

Heinz Ickstadt is Professor of North American Literature at the Kennedy Institute of North American Studies, Free University Berlin, since 1978; Prof. em. since 2003. Among his many publications are a history of the American novel in the twentieth century (*Der amerikanische Roman im 20.Jh.: Transformation des Mimetischen*, 1998), and essays on late nineteenth-century American literature and culture; on the fiction, poetry and painting of American modernism and postmodernism; on American fiction and poetry of the city as well as on the history and theory of American Studies. Some of these were collected in *Faces of Fiction: Essays on American Literature and Culture from the Jacksonian Age to Postmodernity* (2001). He also edited and co-edited several books on American literature and culture, and a bi-lingual anthology of American poetry from its beginnings to the present. He was president of the German Association of American Studies from 1990 until 1993, and president of the European Association of American Studies from 1996–2000.

Rob Kroes is Professor emeritus and former chair of the American Studies program at the University of Amsterdam, until September 2006. Honorary Professor of American Studies, University of Utrecht. Ph.D. in Sociology, University of Leiden, the Netherlands (1971). He is a past President of the European Association for American Studies (EAAS, 1992–1996). He is the founding editor of two series published in Amsterdam: *Amsterdam Mono-graphs in American Studies* and *European Contributions to American Studies*. He is the author, co-author or editor of 37 books. Among his recent publica-

tions are: *If You've Seen One, You've Seen The Mall: Europeans and American Mass Culture* (1996), *Predecessors: Intellectual Lineages in American Studies* (1998), *Them and Us: Questions of Citizenship in a Globalizing World* (2000), and *Straddling Borders: The American Resonance in Transnational Identities* (2004). With Robert W. Rydell he co-authored a book entitled *Buffalo Bill in Bologna: The Americanizationn of the World, 1869–1922* (2005) His most recent book is *Photographic Memories: Private Pictures, Public Images, and American History* (2007).

Suzana Milevska is a theorist and curator of visual art and culture based in Skopje, Macedonia. Currently she teaches art history at the Faculty of Fine Arts – University Ss. Cyril and Methodius in Skopje. From 2008–2009 she taught art history and analysis of Styles at the Accademia Italiana Skopje and she was its Dean. From 2006 to 2008, she was the Director of the Center for Visual and Cultural Research at the Euro-Balkan Institute in Skopje where she taught Visual Culture in Gender Studies. She holds a Ph.D. in Visual Cultures from Goldsmiths College in London (2006). In 2004, she was a Fulbright Senior Research Scholar at the Library of Congress. Her research and curatorial interests include postcolonial critique of hegemonic power in art, gender theory, feminist art and socially engaged art. Her most recent project "The Renaming Machine" consists of a series of exhibitions and conferences discussing the politics of renaming and overwriting memory in art and visual culture. In 2005, she curated *The Workers' Club*, an exhibition and conference at the International Contemporary Art Biennial at the National Gallery in Prague and in 2004 she was the national curator for the 1ˢᵗ Thessaloniki Biennale *Cosmopolis*. Recently she published her book *Gender Difference in the Balkans* (Saarbrucken, Germany: VDM Verlag, 2010).

Nancy K. Miller is Distinguished Professor of English and Comparative Literature at the Graduate Center, CUNY. Her most recent books are *But Enough About Me: Why We Read Other People's Lives* and the co-edited collection, *Extremities: Trauma, Testimony, and Community.*

Jay Prosser is Reader in Humanities at the School of English, University of Leeds. He is author and editor of books and articles on autobiography, photography and American fiction. *Love and Empire: A Family Story*, his memoir on the Baghdadi Jewish and Chinese diasporas and the British military intervention in Malaya in the 1950s–60s, is near completion.

Logan Sisley holds a B.A. in Art History from the University of Otago and an M.A.(Hons) from the University of Auckland, New Zealand. He lived in Scotland for several years where he worked at the Scottish National Gallery of Modern Art and Edinburgh College of Art. He now lives in Dublin, Ireland, where he is Exhibitions Curator at Dublin City Gallery The Hugh Lane. He has edited books on Hugh Lane, Francis Bacon, and contemporary Irish painting. He also assists in the management and development of Studio 468 in Rialto, a community-based artists' residency program. He has spoken at international conferences on themes including archives, family photography and tourist landscapes.

Leo Spitzer is the Kathe Tappe Vernon Professor of History Emeritus and the Brownstone Professor of Jewish Studies (2010) at Dartmouth College. He was also Visiting Professor of History at Columbia University. Besides *Ghosts of Home: The Afterlife of Czernowitz in Jewish Memory*, his recent books include *Hotel Bolivia: The Culture of Memory in a Refuge from Nazism*, *Lives in Between: Assimilation and Marginality in Austria, Brazil and West Africa* and the co-edited *Acts of Memory: Cultural Recall in the Present*. He has also written numerous articles on Holocaust and Jewish refugee memory and its generational transmission.

Hedvig Turai is an art historian and critic. Her main interests include Holocaust and visual culture, politics and art and gender issues. She regularly publishes in the Hungarian monthly art journal *Műértő,* her writings have been published in *Artmargins, Judaism, Third Text, Springerin*. Other publications include a monograph on the Hungarian painter Margit Anna (2002) and as editor, two special issues of the Hungarian journal *Enigma* presenting theoretical and critical writings on the Holocaust and contemporary art.